DATE DUE

Art and Archaeology in China

Distributed by The MIT Press, Cambridge, Massachusetts / London, England

Edmund Capon

Art and

中國之藝術與考古

Archaeology in China

*Publication made possible through
the generosity of Mobil Oil Australia Limited*

First published 1977 by
THE MACMILLAN COMPANY OF AUSTRALIA PTY LTD
107 Moray Street, South Melbourne 3205
12 Berry Street, North Sydney 2060

Associated companies in
London and Basingstoke, England
New York, Dublin, Delhi & Johannesburg

ISBN 0 333 22937 1

Printed in Great Britain by
Westerham Press

Contents

Preface

In recent years the world has been enthralled by archaeological revelations in China: exotic jade burial suits, stirring bronze models of "horses which sweated blood", life-size pottery tomb figures and even the near perfectly preserved body of a noblewoman who died some 2000 years ago. The world has responded to these discoveries with an interest and awe befitting such evocative relics.

The exhibitions which travelled to Europe and America were unhesitatingly acclaimed as remarkable and we are indebted to the Government of the People's Republic of China for having made their treasures available in these exhibitions, one of which is now to be shown in Australia.

My involvement with the Australian exhibition originated with a request to assist with the preparation of the catalogue. Circumstances then permitted the production of this introductory book which was completed, in an inordinately short space of time, largely through the extraordinary efforts and efficiency of Derek Birdsall, the designer, and Gregory Vitiello, who edited the book.

Such a book is inevitably limited. Its scope has been determined in principle by the contents of the Chinese Archaeological Exhibition to be shown in Australia. It is, therefore, intended only to provide an historical and cultural background to the arts of early China, and to introduce some of the recent finds which have so dramatically brought ancient China to life.

My thanks are due to the various Museum authorities and private collectors for illustrations, to the Australia Council and the Australian High Commission in London for their constant assistance, and to Guy Pearse who has been responsible for so much work in the management of both the London and Australian exhibitions.

Finally, the publication of this book was only made possible through the generosity of Mobil Oil Australia Limited.

Edmund Capon

Foreword

The sustained interest which the world has shown in China during the past decade is in no small measure due to the remarkable discoveries made by Chinese archaeologists. The exhibition of a selection of these relics in Europe, Japan and North America, now followed by the exhibition in Australia, is an emphatic reminder of the great cultural and artistic traditions of China. At the same time it is also an impressive demonstration of modern Chinese archaeological methods. We are indeed privileged to have the opportunity of seeing these treasures.

It may seem surprising that a modern socialist country should concern itself with the past in such a way, and yet the recognition that modern China has grown out of China of the past is not only indisputable fact but also an acknowledged feature of modern political ideology. This book also discusses this fascinating question, and the role played by art, history and culture in the modern People's Republic.

The arrival of the exhibition of archaeological treasures from the People's Republic of China in Australia is a signal event. Not only does it bring to the Australian people a selection of rare and beautiful objects which have justly been admired throughout the world, but it is also a significant demonstration of the spirit of goodwill between the two countries and their concern to enrich and enliven cultural interchange. This beautifully illustrated book provides an historical and artistic background to this event. Edmund Capon's text, not a caption to the illustrations but a lucid and distinguished essay on the historical and cultural context of archaeological work and art treasures in China, gives it a quality of lasting value as an introduction to the culture whose high achievement is illustrated in this exhibition.

Dr S. Fitzgerald
Former Australian Ambassador to The People's Republic of China

中國與西方

China and the West

Vague notions of that vast inaccessible country known as China had been current in European countries long before Marco Polo made his epic journey to Cathay in the 13th century. The Greeks and Romans knew of the 'Seres', or Silk People, as a source of rare and beautiful silks, a mysterious unseen supplier of exotic goods to which no Occidental travelled. Hence the idea grew that China was some kind of fabulous and fantastic land that was more myth than fact (*plate 2*). The fabled 'Silk Route' across the vast tracts of central Asia was a tenuous thread along which the silks so prized in the Mediterranean countries travelled, not directly at first, but via the markets of staging towns en route. However, the merchants of Rome quickly and accurately assessed the potential and established direct contacts. One enterprising Roman even, it seems, managed to travel to China and his account now stands as the earliest surviving report from China in a Western language. This anonymous adventurer describes Thin (China) as somewhere beyond Chryse (Burma) and a source of raw silk, silk thread and silk stuffs which are brought overland through Bactria. However, China's isolation was already acknowledged for he continued, "It is not easy to get to Thin, and few and far between are those who travel from it".

During the expansive T'ang dynasty there is an endless catalogue of merchant adventurers who traded their offerings, from Sassanian metalwork to dancing girls, for the precious silks. The capital of the Chinese Empire, Ch'ang-an (modern Sian), is repeatedly described as one of the great cosmopolitan capitals of the ancient world and its markets were filled with traders of Turkish, Persian, Armenoid and Semitic stock (*plate 3*). The silks they returned with furnished and dressed the wealthy courts of Mediterranean and Near Eastern countries. Although it seems that Chinese silks became almost commonplace at times, for as the 4th-century Roman historian, Ammianus Marcellinus, somewhat caustically remarked, "the use of silk which was once confined to the nobility is now spread to all classes without distinction, even to the lowest". Inevitably, Europe came to hear of China and her silks, although little material seemingly filtered past the eastern Mediterranean. Nevertheless, gossip, hearsay and fragmentary evidence were sufficient to establish in the European mind the seeds of enquiry and imagination. The absence of facts and accurate observations of this extraordinary and distant land, known only for its silks, only served to enhance the mystery.

However, Europe at the time was heavily involved in its own particular manifestation of gloom and destruction, the so-called Dark Ages. As Europe descended further into this abyss so her concern for and interest in the mysteries of the East diminished, to such an extent that when William de Rubruck (or Rubruquis), a Franciscan friar and noted traveller of the 13th century, took letters from Louis IX to the Great Khan in 1252, he was amazed to find Chinese serving in the Mongol court at Karakorum who were both civilized and intelligent – probably very much more so than their masters of the time.

It was, of course, Marco Polo who first revealed to Europe some of the secrets which lay eastwards beyond the Great Wall. Never before had a Westerner travelled to the very heart of the Chinese empire, mingled with her people and above all served, for no less than seventeen years, at the Court. Marco Polo was overwhelmingly impressed by what he saw rather than by what he felt or thought. It is pertinent to bear in mind that he did not, it seems, endeavour to associate closely with the people of China, nor did he learn their language, their customs, history or philosophies. His reports were more like those of an evocative camera and he had abundant material, for he lived only at the Court. It was the Court of the Mongol overlords of China and not, therefore, strictly a Chinese Court, but as so often occurred with invaders they too adopted Chinese styles in habit and government.

Marco Polo eventually reached Shang-tu, site of the Great Khans' summer residence to the north of the Great Wall in eastern Mongolia, where he was so impressed by the marble palace, "the rooms of which are gilt and painted with figures of men and beasts and birds, all executed with such exquisite art that you regard them with delight and astonishment". His description of the Khan's palace continues with unabated enthusiasm, ". . . at a place in the Park where there is a charming wood he has another Palace built of cane, of which I must give you a description. It is gilt all over, and most elaborately finished inside. It is supported on gilt and lacquered columns, on each of which is a dragon all gilt, the tail of which is attached to the column whilst the head supports the architrave . . . when erected, it is braced against mishaps from the wind by more than two hundred cords of silk".

In spite of his detailed descriptions which in all probability were perfectly accurate, his reports were received with considerable incredulity. How could any Tartar city be grander than Venice or any Tartar chieftain efficiently maintain control over an empire so vast as that described by Marco Polo? After his return and the publication of his *Description of the World*, he became regarded as an incurable romantic and although his book was widely received and read it was considered a work of fiction – in fact it attracted the name *il milione* – from the million marvels it described. The simple fact is that people did not believe him, and thus his 'fictional' description of China created in people's minds the notion of legend that subsequently surrounded the country.

On the other hand the Chinese were quite unshakeable in their belief that any civilization and culture beyond the confines of the Great Wall was essentially barbarian. These two diametrically opposed views existed until circumstances forced a more objective appreciation in the 19th century.

The name Shang-tu was also transliterated into a name which perhaps more than any other conjures evocative images of Cathay, that of Xanadu. Literally translated, it means "superior capital", and it did of course inspire, in true romantic fashion, the 18th-century poet Samuel Taylor Coleridge to open his famous Kubla Khan:

In Xanadu did Kubla Khan
A stately pleasure-dome decree:
Where Alph, the sacred river, ran
Through caverns measureless to man
Down to a sunless sea.
So twice five miles of fertile ground
With walls and towers are girdled round:
And there were gardens bright with sinuous rills,
Where blossomed many an incense-bearing tree.

This echoes the prodigious wealth, both material and natural, that was so characteristic of the popular view of China in medieval Europe. Polo removed himself into the realms of fantasy in his descriptions of "pears of extraordinary size, weighing ten pounds each", and of "peaches of an extraordinary size that one of them will weigh two pounds troy weight". But he captured the most exaggerated imaginations in his description of the monsters that were to become synonymous with China: "huge serpents, ten paces in length, and ten spans in the girth of the body. At the fore-part near the head they have two short legs, having 3 claws like those of a tiger, with eyes larger than a fourpenny loaf and very glaring. The jaws are wide enough to swallow a man, the teeth are very large and sharp, and their whole appearance is so formidable that neither man, nor any kind of animal, can approach them without terror" (*plate 1*).

Marco Polo's revelations of China enjoyed enormous popularity but not more so than one of the most extraordinary literary frauds of all time. *The Travels of Sir John Mandeville* was an immensely fanciful chronicle of journeys, principally in China, but, it seems, totally fictitious. That such an enterprise could succeed and for long be regarded as an 'authoritative' work is testimony to the general mysticism which surrounded the East. However, it should be said that Mandeville's travels did borrow extensively from more reliable narratives, such as that of Friar Odoric (14th century) whose manuscripts carry descriptions of bound feet, the long fingernails of the scholarly gentlemen and of cormorant fishing – all eccentricities likely to raise the European eyebrow.

Soon after publication of the Mandeville fantasy, the Mongol dynasty fell prey to the expanding world of Islam, and China once again closed her doors behind the introspective Ming rulers. There were virtually no contacts between the West and China for about two centuries, until the early 16th century, and thus the incredible Mandeville fables remained the acknowledged source book on China for some 200 years!

It was the Portuguese who, in 1514, first penetrated the coasts of China and succeeded in establishing an intermittent trading relationship (*plate 4*). Unfortunately, their arrogant and almost piratical behaviour did not endear them to the Chinese, whose subsequent reluctance to negotiate was seen as intolerable aloofness. This initial chapter in commercial relations between China and Europe therefore commenced in an atmosphere of suspicion and ill-feeling; it was a foundation which regrettably was to set the pattern for negotiations during succeeding centuries. The misunderstandings between these early European traders and the Chinese led to the imposition of almost intolerable restrictions upon the visitors' movements and activities. Events tended to confirm rather than deny the myths and legends which so concealed the truth about China. The occasional traders, Jesuit missionaries and diplomatic emissaries who were granted brief audiences at the Court returned to Europe with nothing more than the most tantalizingly brief glimpses of that hidden world. The limited trade, principally porcelains painted in under-glaze blue (see *plate 4*), which emerged from later Ming China and were proudly displayed in the great houses of the European aristocracy and wealthy merchants were prized as rare objects from a distant and inaccessible land (*plate 5*). Soon silks were added to the consignments of porcelains and stimulated a new wonder at the craft and ingenuity of the Chinese people (*plate 6*). In 1515 Lorenzo Corsalis wrote from Malacca of the 'silks, damasks, satins and brocades of extraordinary richness'. The implication being that the sophisticated European of the 16th century was considerably surprised that these odd-looking people with 'little bits of eyes' (Corsalis again) were capable of producing goods of great quality and beauty. These fleeting glimpses of material China tended only to enhance the generally held view that here was a veritable cornucopia of riches.

This trickle of tangible goods nonetheless precipitated an important, but gradual, change in attitude on the part of the civilized European. After all, objects of such beauty, imagination and technical achievement could hardly have been produced by a backward and barbaric people. Perhaps, they thought, here was a civilization and culture which might justifiably demand some consideration. The intermittent emissaries who travelled to Peking in the 16th century generally returned empty-handed, but with reports of a rich, varied and eccentrically different land, all of which echoed those first chronicles of Marco Polo. But more and more of such reports were sprinkled with impressions of the order, the manner and the apparent philosophies of these obedient, restrained and seemingly unflappable people.

Strangely, it was the outburst of missionary enthusiasm which accompanied the European spirit for adventure and exploration in the 16th century that was largely responsible for more accurate impressions of China becoming available. By far the most successful of these early missionary adventurers was Matteo Ricci who arrived in China in 1582, and died in Peking in 1610. He did more than any man of his time to understand the ways of the Chinese people; he learnt the language, studied Confucius to the extent that he would happily swap anecdotes from the *Analects* with the literati class, and became absorbed into the pensive quietude of the literary man's style. Of course he also tried, as his faith decreed, to further the cause of the Catholic Church, but in this he did not succeed. Most of all he was a European who sought

to understand the Chinese in their own environment, and he was thus able, in some small measure, to share his knowledge, understanding and experiences with other Europeans. Possibly it was he who introduced a more studied and intelligent interest in China, one not composed merely of exotic embellishments. China had now become the focus of attention for a large body of European artists, poets and philosophers.

> Enough of Greece and Rome. The exhausted stone
> Of either nation now can charm no more;
> Ev'n adventitious helps in vain we try,
> Our triumphs languish in the public eye.
> On eagle wings the poet of tonight
> Soars for fresh virtues to the source of light,
> To China's eastern realms: and boldly bears
> Confucius' morals to Britannia's ears.
>
> (William Whitehead 1759)

But it was still difficult to stimulate an objective interest in China. The fascination inspired by such rose-coloured reports and romantic images conjured by Europeans who never set foot in the Middle Kingdom in many ways only served to increase the cultural and intellectual gulf between Europe and China – between reality and illusion. There was still so little that was tangible, so little real contact and such scanty evidence that the Europeans simply had to exercise their imaginations in order to fulfil their enquiring minds. Seriously interested philosophers and writers, such as Liebnitz, A. H. Francke, Quesnay and even Voltaire, had learned of Confucius and his works through the Jesuit missionaries who had travelled to China to spread Catholicism. But they too became so obsessed with Chinese philosophy and thought that they were unable to break down the barrier of unreality. To them even, China still remained more of an idea than a fact.

It is important to remember, in the cultural context, that China's isolation from the rest of the world profoundly affected – or to be strictly accurate, did *not* affect – her artistic independence. While Europe and the mercantile nations were busy communicating through trade, expansion, imperialism and sheer adventurism, they were at the same time forging a vast and complex range of sometimes significant, sometimes insignificant, cultural and artistic liaisons. Apart from those generally recognized periods of substantial commercial contact with the outside world, that is the Han, T'ang and Yüan dynasties, China's associations were minimal until the late 18th century. Thus all the while her artistic tradition was developing in an outstandingly independent manner. Of course those earlier commercial contacts left their mark; Central Asian decorative motifs on Han silks, the introduction of Buddhism and a new concept of figurative sculpture, T'ang dynasty ceramics and silverwork in imitation of Sassanian metalwork styles, for example. But such was the strength of the native tradition that all

influences and inspirations were accepted and almost immediately 'sinicized' into a form and style that quite correctly became instantly recognized as 'Chinese'. Even the significant, but sporadic, forays into the 'export art' trade in the 16th and 17th centuries did not in any way alter or influence the general cultural identity (see *plates 6, 7*). Her unbroken cultural and artistic traditions may be irregular at times but they have a clearly identifiable continuity that is unmatched in any other civilization.

The 18th century was a period of ominous significance for China. Circumstances conspired to build up the pressure against her insularity and quickly the cracks in that implacable façade began to appear. Culturally China was becoming deeply introspective and consequently decadent. In her artistic endeavours it was a question of reiterating old themes, styles and concepts but with ever-increasing emphasis upon technique and craftsmanship; a case of form determining content (*plate 8*). That spirit of intellectual and artistic adventurism which accompanies, in fact stems from, a confident and vibrant society, no longer existed.

However, the barricades were still there, the Emperor maintained his mandate as the 'Son of Heaven' and an outward appearance of calm and powerful serenity emanated from the Dragon Throne. The ageing Ch'ien-lung emperor (reigned 1736–95) was still able to infuriate the famous Embassy of Lord Macartney in 1793 with his persistent court etiquette. The depths of strength and tradition established over centuries of aloof isolation from the rest of the world still held firm; under the rule of the K'ang-hsi (reigned 1666–1722) and Yung-cheng (reigned 1722–35) emperors China achieved a wealth in material prosperity and territorial possessions which she could, with some justification, claim to be the envy of the world – not that she ever subscribed to banal comparison. The 'fat' of these achievements was sufficient to succour the Empire during the early period of decline in the late 18th century. Imperial China still had an air of lofty ideal and material grandeur, but what kept the country intact so far as the Western world was concerned was the extraordinary concept of romantic isolationism that had compounded over the centuries.

Suspicions as to the possible fallibility of the Chinese had first been aroused in Europe, and England in particular, by Captain Anson who ventured to Canton in 1742 and whose reports on the Chinese hierarchy in that city were anything but reverent. A contemporary description by Richard Walter of the treatment received by Anson concluded that the "magistrates are corrupt, their people thievish and their tribunals crafty and venal". At the same time there was without doubt profound suspicion on the part of the Chinese towards the European trader; an attitude stemming in some degree from those first unfortunate confrontations with the Portuguese merchants some two centuries previously.

Macartney's ill-fated embassy, commissioned by George III but paid for by the East India Company, confirmed Anson's views that the

Manchu rulers of China and their hierarchy were no easy people to deal with. Macartney's objective was to obtain permission to trade from certain northern ports, including Tientsin, and to establish depots there. What followed their arrival in Peking to negotiate these strictly commercial aims could only be described as pantomime. The Ch'ien-lung emperor required Macartney to *kowtow*; this he refused to do and simply knelt on one knee as he would have done before his king (*plate 9*). The Emperor thereupon explained that this was not the sort of conduct he expected before him, that "our celestial empire possesses all things in prolific abundance", and that the trade concessions which the Europeans enjoyed in Canton were a privilege which could not be extended.

Macartney rightly concluded that: "China . . . may, perhaps, not sink outright; she may drift some time as a wreck, and will be then dashed to pieces on the shore, but she can never be rebuilt on the old bottom . . ."

Thus aggressive Western commercial interests were to remain confined to the very limited concessions they had already acquired in the Canton region. These were based on the thoroughly out-dated theory that foreign countries could only have relations with China as tribute states, and clearly this embodied an attitude of intolerable and totally unrealistic superiority on the part of the Chinese.

When the inevitable confrontation came, in the early 1830s, the Chinese found themselves up against the sharp edge of the interests of a fast expanding and uncompromising European financial and business community, with Britain in the forefront. At that time the China trade revolved around the export of tea, and the importation of cotton and opium from India, all controlled by the British-owned East India Company (*plate 10*). The importance of the opium trade was peculiarly significant; firstly as the vehicle for the prolonged commercial assault on China, and secondly as evidence of the social pressures and general demoralization of China. Although frequent edicts banning the importation and distribution of opium in China were issued by the Manchu government, the trade flourished. Official connivance grew as the trade grew, and the corruption embodied in these developments reflected the general corruption and demoralization that was debilitating the Chinese government and its administration.

The East India Company was at the hub of the trade, but their virtual monopoly of the Asian market was terminated, in the interests of reform and free trade, in 1834. Lord Palmerston, then British Foreign Secretary, sent Lord Napier to Canton as Superintendant of Trade. Having had neither commercial, diplomatic nor Chinese experience, the choice of Napier was perhaps injudicious! He was greeted with a quizzical aloofness by the Chinese and promptly relied on his frigates to make the required impression. This brief confrontation was a prelude to the much more serious opium wars of 1839–42.

Much has been written of the opium wars as classic examples of European, and British in particular, gun-boat diplomacy in the interests of colonialism and commercial exploitation, of their introducing the subjection of China to a semi-colonial status, and of their signalling the final death-knell to the Chinese Imperial system. In many ways, all these claims are true, but the opium wars must be seen in perspective – as the precipitate event in a long campaign. Of all the countries with commercial interests in China, Britain was the most dynamic partner and, through her Indian possessions, also controlled the opium supply. Had neither British interests in China nor the opium trade existed, the eventual outcome would still have been the same. In a situation in which Western expansion was faced with Chinese inertia, confrontation was inevitable.

For China, the outcome was disastrous. The Nanking treaty of 1842 ceded Hong Kong to the British, along with five other ports, and in addition the Chinese agreed to massive indemnities for the costs of the wars. Implicit in the Treaty was the termination of the notion that Western countries dealt with China as tribute states. The Manchu government yielded to Western pressures in order to maintain some semblance of control; otherwise there can be little doubt that Britain, America and the European countries would have pursued an even more ambitious military programme. The Nanking treaty set a pattern, and the Americans and French followed with commercial treaties which made further inroads into Chinese autonomy.

The effect of these events within China was no less devastating. The influx of foreign trade created pockets of great wealth among the Chinese merchants operating in the treaty ports and among officials who were receiving constant bribes and payoffs. This merely increased and aggravated social and economic inequalities in China, which soon found itself possessing the classic ingredients for insurrection: a corrupt and archaic leadership, foreign commercial intervention and a vast majority of impoverished and exploited people. China, by the middle of the 19th century, was rapidly disintegrating with the interests of three broad contending parties at stake: the inept but intransigent Manchu government, the European mercantile nations with a callous disregard for anything but profit, and the mass of Chinese people who fought for their survival while Western and Chinese politicians and traders squabbled and profiteered.

The halcyon days of the European's romantic vision of China were now drawing rapidly to a close. Culturally China was no longer the source of inspiration for European designers, cabinet-makers, poets and philosophers, merely the country which produced eccentric knick-knacks, over-ornamented porcelains and brightly coloured silks which were by that time being imported on such a scale that they became commonplace. The aura of mystery and beauty that had once surrounded the East was now submerged in a torrent of tawdry chinoiserie (*plate 11*). It is important to remember that, so far as Europe was concerned, China had really existed for just some three centuries and even the most avid sinophile of the mid-19th century had no inkling of the great cultural and artistic traditions of China (*plate 12*). The real

history of China still lay buried beneath the soil, or secreted away in the vast Imperial collections and libraries.

The history of the second half of the 19th century in China is a complex entanglement of internecine conflict, social and political disintegration and increasing foreign intervention, both commercial and military. The forces set in motion by events earlier in the century gathered a momentum that was irresistible. The secret societies, with their roots in the peasant village communities, flourished and became organized into serious pockets of resistance. At first, the Manchu government and its administration were targets, but as foreign encroachment increased so they turned their attentions to the invaders.

In a last ditch attempt to stave off the inevitable, the thoroughly ruthless and decadent Empress Dowager saw possible salvation in harnessing these anti-foreign emotions and unleashing them against the Western powers. This culminated in the Boxer Rebellion of 1900 in which Chinese troops, militia and peasants, with the support of the Manchu government, attacked foreign legations and properties, principally in north China, and particularly in Peking. Once again, the strength and efficiency of the well-oiled European military machine was far superior, especially when joined by the Russians who had taken over Manchuria. The damage caused to European property and interests was substantial, but the signing of the Boxer Protocol which concluded these hostilities in September 1901 was far more damaging to the Chinese. Not only were considerable territorial concessions allowed, but it permitted a degree of direct Western control in certain areas, and finally a shattering indemnity of some $330 millions was negotiated in respect of damaged and destroyed property. Clearly the end of the Ch'ing dynasty, and as it happened the dynastic system, was in sight. That it staggered on for nearly a decade after this humiliation is testimony to the immense reluctance on the part of the Manchu government to accept fundamental change. And, of course, it remained in the interests of the foreign interventionist powers to maintain a weak and incompetent government which could be manipulated and bribed.

The final collapse of Manchu rule, and the establishment of the Republic in 1911, although greeted with scepticism by some, was assuredly seen by the majority as the dawning of a new age. History to some extent defers, for as we now know China continued to battle both within herself and with her commercial and military invaders for nearly the next forty years. But the spell of the dynastic system had been broken, and the realities of conflict had finally brought home to the Western world the reality of China. Scholars, historians, archaeologists and students in ever-increasing numbers sought to understand the peculiarly independent nature of China. The interest and imagination of the world was captured by the Imperial collapse, the great leaders such as Sun Yat-sen and Mao Tse-tung and their tenacious fight to maintain China's independence, and the myriad of complex ideological and political struggles that were occurring. These events stimulated a widespread genuine concern for the future of China.

The discovery of Chinese archaeology at the beginning of the century opened up whole new aspects and suddenly the West became aware of another civilization. As archaeologists, adventurers and historians followed in the wake of the railway engineers across north China so a vast, rich and profound cultural fresco was unveiled. The artistic achievements of the past three centuries, which principally focused upon porcelains, silks and lacquers, were no longer seen as the products of an insular and industrious people living and working in an eccentric and distant land, but as the natural successors to an artistic heritage stretching back over three or more millennia.

The traditional concepts of the history of China, born out of three centuries of spasmodic and often fruitless contact and confrontation, suddenly became out-dated. As China was brought kicking and screaming into the 20th century so the West too was obliged to re-consider her traditional assessment of that country. The role played by art in that essential re-consideration was a vital one, because it was largely through the discovery and subsequent appreciation of her ancient art and material culture that the West became aware of Chinese civilization. As this vast historical panorama unfolded, it made explicit some of the values, the eccentricities and the peculiar characteristics of Chinese society which had so baffled early European visitors, and perhaps caused so much antipathy and strain. The essential historical foundations upon which the fabric of later Chinese civilization had been based now became clear. Broadly speaking the Western reaction, again principally stimulated by the concerns of archaeologists and historians, was to adopt a very much more serious and objective view of China. In the vanguard of this major re-appraisal was undoubtedly the appreciation of Chinese art.

As Western and, to a lesser extent, Chinese and Japanese art historians pieced together the story of Chinese art following the archaeological revelations of the early part of the century the strength, continuity and independence of the tradition became evident. To characterize succinctly an artistic tradition as profound as that of China is an unenviable task; but certain underlying traits may be detected by a comparison with related, but distinct, cultures.

This theme was tackled by the philosopher Liang Sou-ming in *Civilization and Philosophy of the Orient and the Occident* in which he compared the West, China and India as embodying three distinct ways of life, characterized by struggle and rationalism, adjustment and intuition, and by self-denial and religion respectively. The word adjustment, the quality attached to China, implies the maintenance of ideas and concepts, and amending them to suit the conditions, fashions and attitudes of the day. Perhaps the best, and most appropriate, expression of this notion is in the traditional Chinese concept of the bamboo that bends but never breaks. The same theme may also be detected as one of the essential underlying characteristics of the arts of China; a feature which provides her artistic traditions with a continuity stretching from the 5th millennia B.C. to the present day. This continuity is unmatched by that of any other civilization, and is dependent

upon certain conditions: firstly, a basically hieratic and formal structure; secondly, independence; and thirdly, a tendency to conservatism.

In a sense, these qualities are interdependent, as the early Western historians of Chinese art were to discover. The hieratic, but conventionalized, decoration on ancient bronzes of the Shang and Chou periods are subjected to a rigid organizational pattern. The consistency of this approach meant that formalism became an inherent characteristic of Chinese art, and one of those essential elements which contrived to stave off any real penetration by external or non-Chinese influences.

Certainly in the periods of Chinese expansion, such as the Han and the T'ang dynasties, foreign styles and artistic ideals were noted in China. But they were immediately absorbed into the Chinese pattern. The example of Sassanian metalwork and its subsequent re-interpretation in Chinese pottery and silverwork of the T'ang dynasty is a classic, and much quoted, example of the ability of the Chinese artist and craftsman, throughout the ages, to stamp a peculiarly Chinese quality on even imported forms and styles. In this way the independence of China's artistic tradition was maintained.

Thirdly, the continuity of China's cultural and artistic heritage may seem to be indicated through the overwhelming conservatism of its stylistic and ornamental repertoire. The notion of harking back to ancient ideals is a most striking aspect of the history of China and one which is well illustrated by the ever-present influences, until the beginning of the 20th century at least, of the Confucian ideal. The strange monster masks, formalized dragons and other hieratic designs which ornament much later Chinese art, particularly porcelains and cloisonné enamels, have their roots in the designs on ancient bronze vessels (see *plate 8*). Even in the 18th and 19th centuries, when Western concepts of naturalistic, or semi-naturalistic, decorative designs were beginning to make a presence in the arts of China, those traditional and ancient motifs continued to hold their place. Similarly, there was, at that time, a thriving industry producing reproduction bronze vessels in imitation of the Shang and Chou prototypes.

Thus it was that the independent nature of Chinese art became apparent to the Western world in the early years of this century. Its overriding concepts of formalism and archaism, so fundamental to that tradition, are not qualities generally associated with Western art appreciation, based on Renaissance and post-Renaissance values, in which naturalism and the representation of the human figure dominate. The human figure, it is noticeable, has played an insignificant role in the history of art in China.

One final point may be made concerning the nature of Chinese art, particularly vis-à-vis the general Western conception of art. It was Croce who said, "art is what everyone knows it to be". This could mean any material expression, in the visual arts such as we are primarily concerned with here, of an emotion or idea. But traditional Western scholarship has tended to differentiate between the fine arts, which we restrict to paintings and sculpture, and the decorative arts, which include principally the applied arts in which the material or object was firstly functional, and secondly a vehicle for artistic expression. No such distinction can be made in any consideration of the arts of China. Painting, of course, has a long tradition in China, but one which is independent of the mainstream of her primarily ritualistic art. Sculpture, with the exception of purely iconographical works in the service of the Buddhist faith, and the human representation have had but a meagre role to play. So it is the so-called 'minor arts', ceramics, metalwork, textiles, lacquer, and perhaps architecture, which characterize and maintain the distinctive identity of the arts of China.

At a time, around the 5th millennia B.C., when China was acquiring the basic elements which identify a civilization, a social structure, agriculture, the domestication of animals and notions of burial and after-life, such advances were already familiar to man in other parts of the ancient world. Her civilization is by no means the oldest, but whereas those of Babylon and Assyria have long since passed into oblivion, that of China still exists. The fruits of her artistic endeavours in the 20th century are the direct descendants of the painted pottery vessels made in the neolithic village communities some 5,000 or more years ago.

Bibliographical references

Cronin, A. J., *The Wise Man from the West*, London 1935. For the fullest account in English of Matteo Ricci and his life in China.

Fox, G., *British Admirals and Chinese Pirates; 1832–69*, London 1940.

Greenberg, H., *British Trade and the Opening of China 1800–42*, Cambridge University Press 1951.

Honour, Hugh, *Chinoiserie. The Vision of Cathay*, London 1961.

Hudson, G. F., *Europe and China*, London 1931.

Martin, W. A. P., *The Siege in Peking. China Against The World*, New York 1900.

Morse, H. B., *The International Relations of the Chinese Empire. The Period of Conflict: 1834–60*, London 1910.

Owen, D. E., *British Opium Policy in China and India*, Yale University Press, 1934.

Polo, Marco, *Description of the World*. The best English edition is that prepared by Sir Henry Yule and revised by Henri Cordier, London 1903. A more readable version is a translation by R. Latham, Harmondsworth 1958.

Purcell, V., *The Boxer Uprising. A Background Study*, Cambridge University Press 1963.

Staunton, Sir George, *An Authentic Account of an Embassy from the King of Great Britain to the Emperor of China*, 2 vols., London 1797.

Steiger, G. N., *China and the Occident: the Origin and Development of the Boxer Movement*, Yale University Press 1927.

Tan, C. C., *The Boxer Catastrophe*, New York 1955.

Waley, Arthur, *The Opium Wars Through Chinese Eyes*, London 1958. Reprinted Stanford, Calif. 1968.

Walter, Richard, *A Voyage Round the World*, London 1748. This includes a description of Anson's confrontation and fruitless negotiations to restock and refit his ship at Canton. This incident is also recounted in M. Collis, *The Great Within*, London 1941.

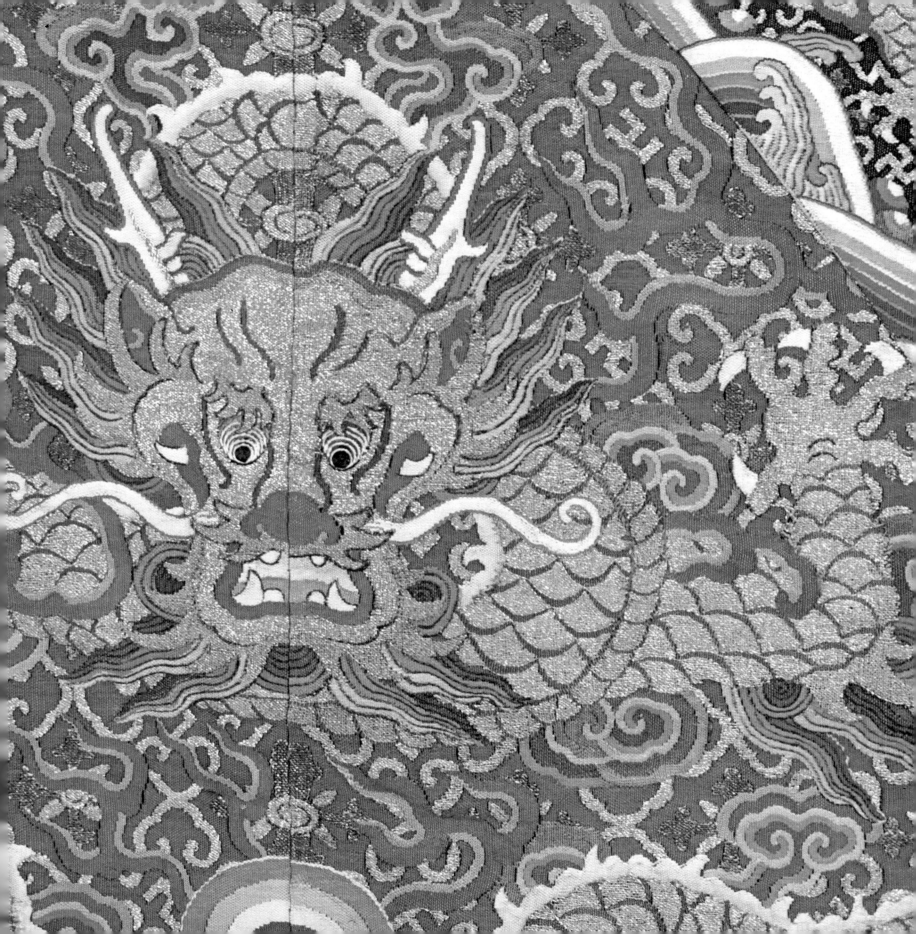

1 (overleaf)
The dragon; symbol of the Emperor
and synonymous with China. A detail
from an Imperial k'o-ssu (*silk*
tapestry) *dragon robe.*
18th century
Victoria & Albert Museum

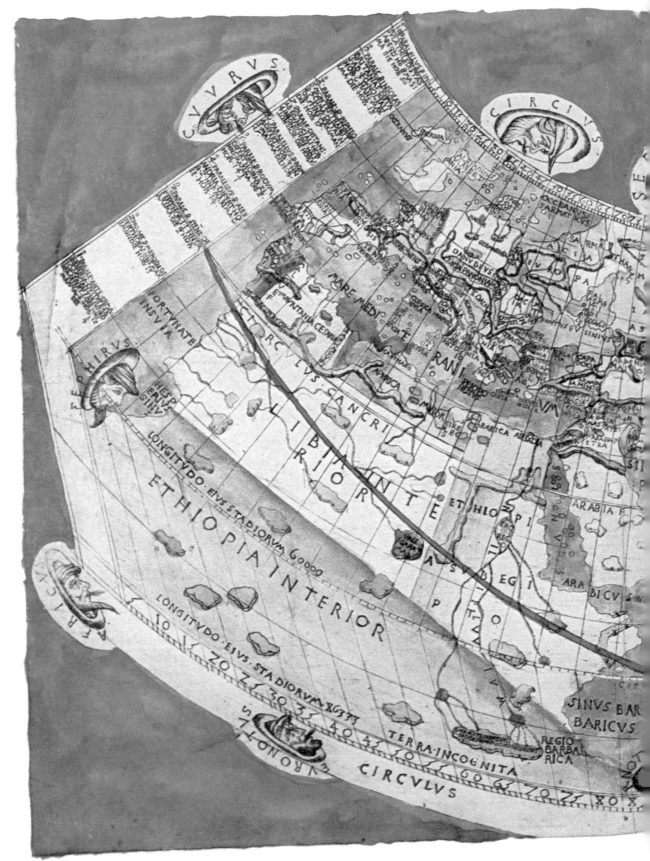

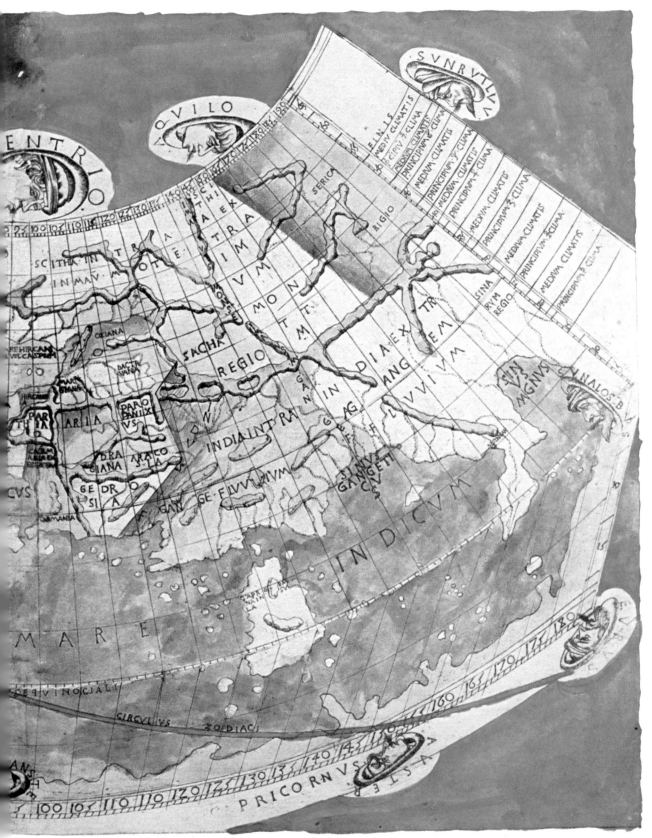

2

Ptolemy's Map of the World; from a reconstruction of the 2nd century original, dated 1462, preserved in Ptolemaei Geographia Beroaldus. 34.5 × 54.3 cms
British Museum

3

Pottery tomb figure of a Semitic merchant;
covered with a pale green glaze.
The distinctive facial features, beard and
mode of dress distinguish the figure as a
foreign merchant.
T'ang dynasty : A.D. 618–906
Height : 24.5 cms
Collection of Mr. Neil F. Phillips, Q.C.,
Montreal

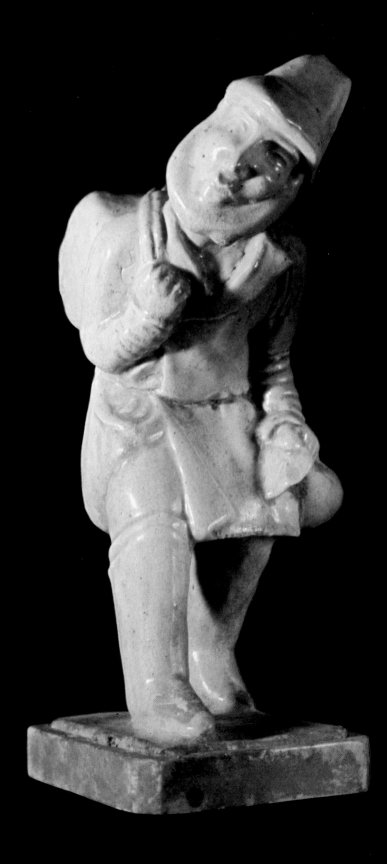

4
*Blue and white porcelain bottle, with an
inscription in Portuguese bearing the date 1557.*
Ming dynasty: dated 1557
Height: 25 cms
Victoria & Albert Museum

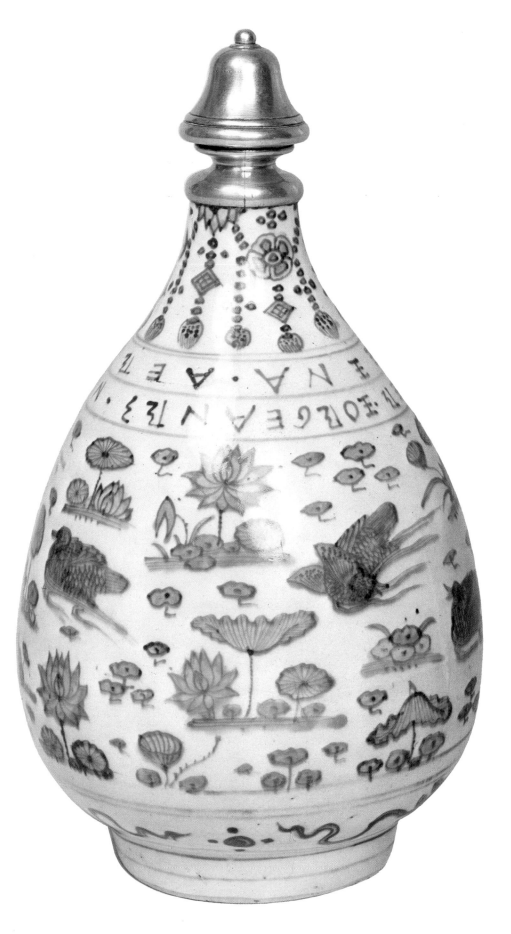

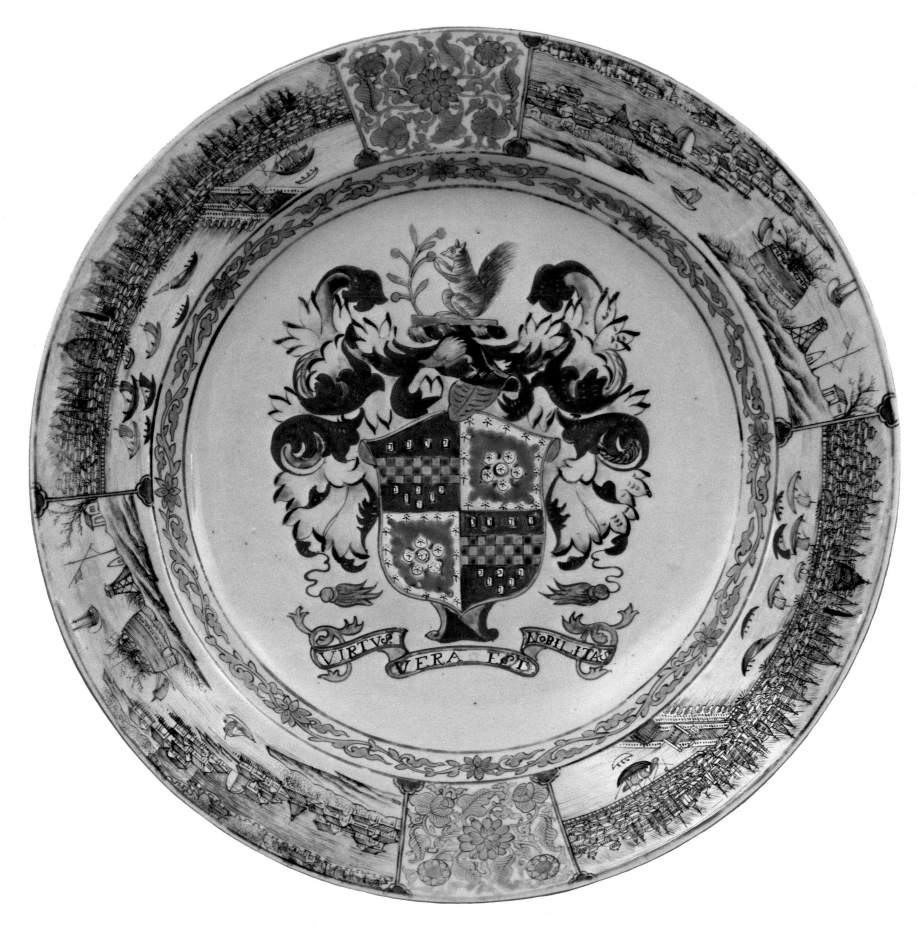

VIRTVS VERA EST NOBILITAS

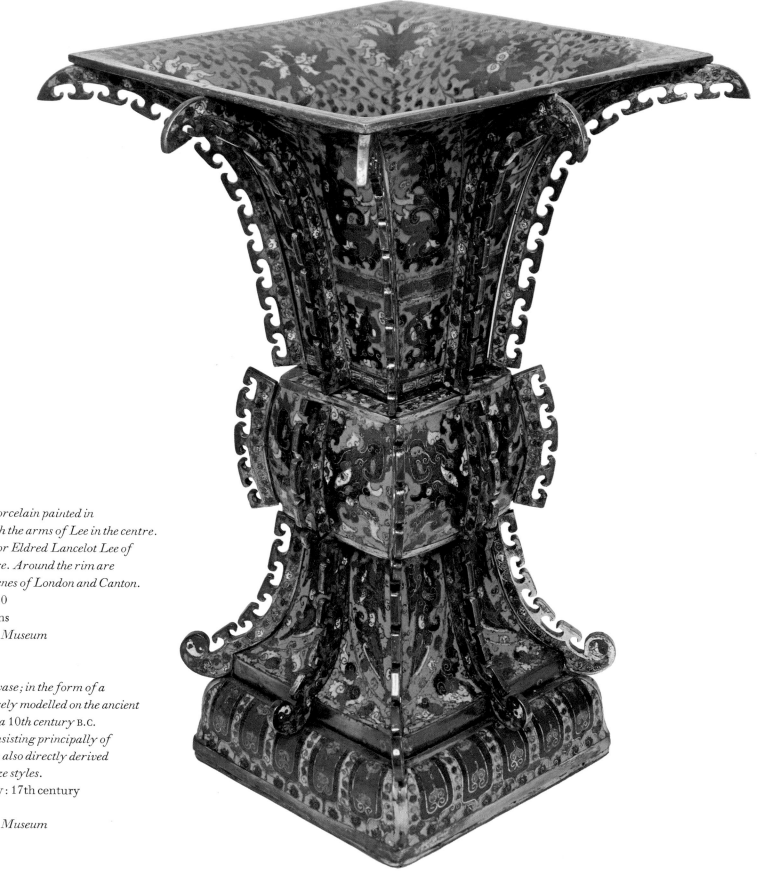

7
Armorial plate; porcelain painted in
enamel colours with the arms of Lee in the centre.
Reputedly made for Eldred Lancelot Lee of
Coton in Shropshire. Around the rim are
painted in black scenes of London and Canton.
Chinese: circa 1730
Diameter: 25.5 cms
Victoria & Albert Museum

8
Cloisonné enamel vase; in the form of a
tsun *vessel and closely modelled on the ancient*
bronze type of circa 10th century B.C.
The ornament, consisting principally of
t'ao-t'ieh *masks, is also directly derived*
from ancient bronze styles.
Late Ming dynasty: 17th century
Height: 53.5 cms
Victoria & Albert Museum

9

*Painting, ink and slight colour on paper,
depicting Lord Macartney and his Embassy
at the court of the Emperor Ch'ien-lung
(reigned 1736–95). The members of the
Embassy are enumerated in the painting and
identified in the top right of the picture.*
Painted by William Alexander, circa 1793
34.5 × 50.3 cms
India Office Library

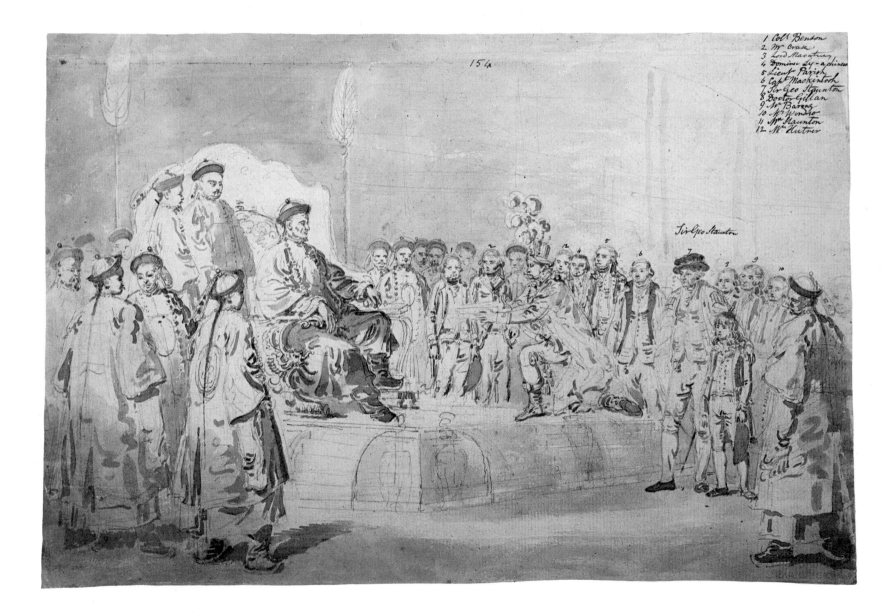

10
'*View of Canton*', oil on canvas, by Youqua.
Signed in Chinese in the sail of the junk on the
far left.
Circa 1855
80 × 148 cms
Peabody Museum, Salem, Mass.

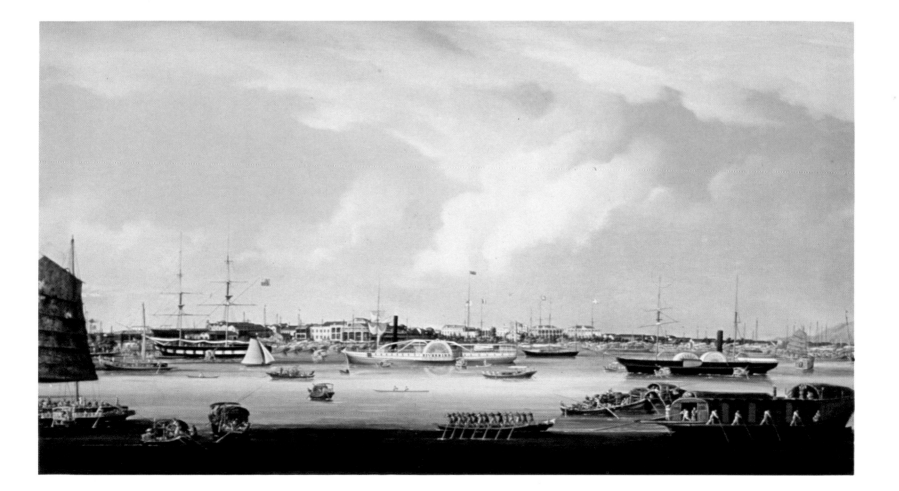

11

The Banqueting Room at the Royal Pavilion in Brighton; one of the most imaginative, exotic and graciously absurd expressions of 'chinoiserie' in England. The exterior is Indian. Designed originally by Humphrey Repton, the final result is principally the work of John Nash, and was commissioned by the Prince Regent (George IV). Construction was completed in 1821.

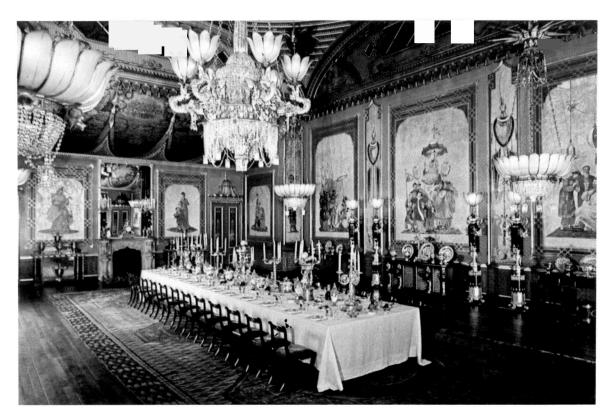

12

View of the interior of one of the residences in the Forbidden City, Peking. Principally furnished with 18th century material, and characteristic of the 19th century Europeans' vision of 'China'.

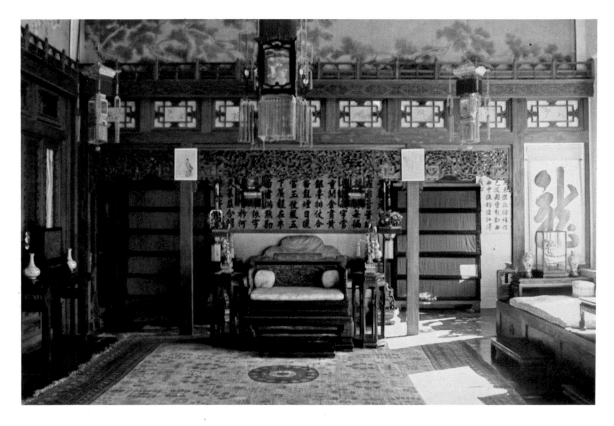

中國之考古

Archaeology in China

Perhaps the most amazing aspect of modern Chinese archaeology which has, in recent years, aroused such interest throughout the world is simply the sheer quantity of material. Every day, farmers, soldiers, construction workers and engineers seem, by chance, to uncover yet another hoard of archaeological treasures. Stories of the commune-worker who, while tilling a field in Hunan province, turned up a late Shang bronze have a delightfully romantic ring to them; but such are the facts. Over the past five years, the Western world has been enthralled by fragments of news concerning finds of fabulous jade suits or life-size pottery figures, and their curiosity was fulfilled by the two major exhibitions of Archaeological Treasures from the People's Republic which toured Europe and America. Substantial though the exhibitions were, they can give no more than a selective glimpse of the treasures and riches which still lie buried beneath the arid landscapes of north and west China, the fertile plains of the Yellow River basin or the lush hills of the south.

The archaeological revelations of recent years which have emerged from China, wittingly or unwittingly, have coincided with her re-appearance and re-entry into the affairs of the world. However, before acknowledging the achievements and the relevance of modern Chinese archaeology, it is necessary to consider the history of archaeology in China.

In recent years, there has been much debate and criticism of the damage caused to ancient monuments and archaeological sites through the looting of historical material and art objects. In this respect China, perhaps, has suffered as much as, if not more than, any country. Prior to the Western presence in China there was remarkably little despoliation of burials, principally because the taboos concerning death and burial were recognised and strictly observed. Thus, ever since the grand and magnificent burials of the early kings of the Bronze Age Shang dynasty, there was a steady accumulation of artistic and historical wealth beneath the soil. Certainly there were instances of grave robbery, but they were isolated. For example, the *Chin Shu* (History of the Chin dynasty) records the plunder of the tomb of a late Chou king (3rd century B.C.) in A.D. 281. Amongst the material looted at that time was a series of bamboo slips – the famous *Bamboo Annals* – recording a completely revised and hitherto unknown chronology of ancient Chinese history. These invaluable historical relics were, according to the records, used by the tomb robbers "as torches to provide light whilst they looted the tomb of its treasures". It would seem that the waste and destruction caused by the illegal activities of such plunderers started early.

Nevertheless, this is an isolated example since there was no real stimulus for such activity in the form of a ready and constant market. It was not until the Sung dynasty (A.D. 960–1279) that China developed a keen sense of history and concern for the past – antiquities included. The motivation for this interest was the general conservatism of the period, during which the Court hierarchy attempted to re-establish China in the image of the great traditions of the Han and T'ang dynasties. The Emperor Hui-tsung (reigned 1101–1126) was a noted pioneer in collecting and studying ancient bronze ritual vessels. Through his interest, enthusiasm and patronage, volumes and encyclopaedias were compiled which listed the shapes, forms, decorations and functions of these vessels. And, in inimitable fashion, this interest stimulated a thriving industry for the making of facsimiles (*plates 13, 14*). Above all, the Sung antiquarian fraternity was interested in the inscriptions on these vessels since they were considered to be messages, possibly even instructions, concerning the maintenance and performance of the ritual which was so vital a part of the system of government in China. In this sense, the Sung scholar was not so much a connoisseur of art objects, but an historian concerned with the information and advice which might be gleaned from ancient relics. To this end, the study of epigraphy in all its various forms, such as inscriptions on vessels, documents or even directives listed on bamboo slips, was a paramount concern.

Bearing in mind the idealisation of the past which was so characteristic of the Sung period, there is a logic to this sudden interest in archaeology in China. But it remained the preserve of a small coterie of Confucian scholars working and advising within the Court. It was clearly quite unthinkable that they should indulge in the looting of, or breaking into, ancient Imperial burial sites. The ordinary Chinese had, at that time, no interest in such scholarly and ethereal pursuits, and in any event the age-old taboos concerning burial still firmly held sway. Of course, these burials contained far more than just bronze ritual vessels, for they were invariably furnished with a luxurious array of artifacts, many of which were produced solely for that purpose. These, it would appear, were of little or no interest to the early Chinese scholar of the Sung period, for they, unlike the vessels, were not generally embellished with the vital inscriptions. This reinforces the notion that early interest in archaeology in China was primarily, or almost totally, stimulated by an historical and not an artistic concern. In addition, the tomb furniture as such was made with a very specific purpose in mind and it was, therefore, beyond the scope of earthly interest.

It would be appropriate to add a brief word of explanation of the beliefs concerning death and burial in early China.

In classical Chinese literature, the dual nature of the human soul is constantly stressed. These two elements are interdependent, and thus remain inexorably bound, during life on earth, but separate upon death. One element ascends to heaven, beyond the realms of human concern. The second spiritual element, however, maintained its presence in the burial, and it was of the utmost importance that it should be sustained so as to remain and not stray.

This whole philosophy is graphically illustrated in the painted banner which was recovered, in 1972, from the 2nd century B.C. tomb of the wife of the Marquis of Tai at Mawangtui near Ch'ang-sha (*plate 15*). In order to entice the spirit to maintain its presence in the tomb, it was

essential, firstly, to prevent the decomposition of the body, and, secondly, to provide those worldly comforts which were familiar to the deceased. In pursuance of the first aim, the Chinese relied heavily on the legendary properties they ascribed to jade, which culminated in the extraordinary and now-renowned jade suits (*plates 16, 17*). To the Chinese, jade was the most precious of stones; its extreme hardness and subtle colourings symbolize the qualities of nobility, virtue and beauty. Before China entered upon her long and sophisticated Bronze Age, *circa* 1600 B.C., literary records refer to jade being held in the highest esteem and having obtained its position as the principal material for ritual paraphernalia.

Apart from jade objects, both functional like the suits and ritual such as symbolic tokens, the early tombs of Bronze Age, Han and T'ang China were also furnished with facsimiles of essential equipment. During the Shang dynasty (*circa* 1600 to 1027 B.C.), it was normal practice not to provide facsimiles but to bury the dead king or nobleman with the slain bodies of his servants, charioteers, horses and animals (*plate 18*). Many recent excavations of the great Royal burials of the early Bronze Age near Anyang in Honan province have provided material testimony to this grim practice. There is also evidence, in the form of still manacled skeletons, to suggest that slaves and servants were buried alive along with the deceased king.

In principle, the same rules, regulations and lavish wealth were applied to the royal burials of the early Chou period (1027 to *circa* 6th–5th centuries B.C.). Thereafter, the use of wood and ceramic substitutes for the more costly bronze vessels was preferred, and the introduction of these substitute materials coincided with a gradual reduction in the scale of Imperial burials. Slaves, servants, horses and chariots were no longer necessarily immolated along with their masters. After civil war and economic depression, the ruling classes lacked the means for perpetuating the traditions on that vast scale, but the introduction of the facsimile concept provided a tremendous impetus to the mortuary culture of China. From now on, much of the material that accompanied the dead to the grave was made for that purpose alone, and it would seem that the general attitude of the early historical scholars of China was that this material particularly was, therefore, sacrosanct – perhaps even more so than the earlier ritual bronzes, which were made primarily in the service of ritual rather than for burial purposes.

Thus, the somewhat pious attitude to mortuary objects was established and this was the principal reason for the reluctance to disturb ancient burials in China. Although historical scholars of the Ming and Ch'ing dynasties continued to study, analyse and compose enormous catalogues and encyclopaedias, the material they had at their disposal was principally that handed down in the Imperial collections, and their studies continued to be primarily concerned with epigraphy and the elucidation of historical fact. It may seem strange to us today but the popular and perhaps most instantly recognisable representative of Chinese mortuary art, the T'ang tomb figure, was virtually unknown in China at the beginning of the 19th century.

Thus, over a period of nearly six millennia the buried wealth of China had accumulated and lain more or less undisturbed. The advent of the 20th century dramatically changed the face of Chinese archaeology and, as with so many great revelations, its discovery was fortuitous. We have already recounted the events surrounding the gradual encroachment of Westerners and Western technology into China at the beginning of this century. From an archaeological point of view, the most significant event was the decision of the Chinese government to permit foreign involvement, including financing, in the building of new rail systems.

Among this network of railway lines was one which extended westwards from Loyang to Sian, thereby slicing through the very heart of ancient China (*plate 19*). The wealth of ancient bronzes, jades, tomb figurines and other mortuary objects which now grace museums throughout the Western world are there largely because of such construction work. That particular railway line cut through some of the largest and richest burial grounds of the ancient Imperial families of China. This extraordinary archaeological 'accident' set the pattern for so many later archaeological revelations, particularly those of the more recent past, as we shall see.

Perhaps the most unique discovery occurred in 1900 when workmen, who were repairing walls in the Buddhist cave temples at Tun-huang in Kansu province on China's borders with Central Asia, stumbled across a repository of ancient Buddhist manuscripts which had been walled up in the 11th century. The French archaeologist Paul Pelliot, who was heading an expedition in the area, heard of this discovery and made haste for Tun-huang. There he settled himself in the hushed gloom of the tiny cave and busied himself for some three weeks selecting what he considered was the best material.

Tun-huang is almost a culture in its own right: a rich and varied complex of Buddhist art and imagery dating from the middle of the 4th century, when it was not only an important monastery but also a vital staging post on the long and arduous trade route from China to the West. The Buddhist art of Tun-huang, ranging in date from the 4th century to the Sung period, has all the varied associations, styles, certainties and uncertainties of an art in transit. It was, therefore, a vital cultural link between the Chinese and Indian, Central Asian and peripheral cultures and peoples (*plate 28*). It was unfortunate that the discovery of this secreted treasure of artistic and documentary material should have occurred at a time when Western archaeologists were making persuasive and often ill-considered excursions into China. For, as a result, a vast corpus of vital literary and documentary material has been removed from its home, although it is undeniable that we in the West have benefited.

Perhaps the most poignant observation on Western incursions at Tun-huang was made by Arthur Waley in his *Ballads and Stories from Tun-huang*; "The Chinese regard Stein (who also led a number of archaeological expeditions to China and Central Asia) and Pelliot as robbers. I think that the best way to understand their feelings is to

imagine how we should feel if a Chinese archaeologist were to come to England, discover a cache of medieval manuscripts at a ruined monastery, bribe the custodian to part with them and carry them off to Peking".

Pelliot, like Stein, was a professional archaeologist, and both were in search of not only ancient treasures, but also documentary evidence for historical fact. Other archaeologists from Europe, Japan and America made expeditions to north and south-west China in the early years of the 20th century. None was successful in finding such a vast cache of unified material as that discovered at Tun-huang. But following in the wake of the railway engineers, they managed to accumulate enormous quantities of mortuary art: tomb figures, jades, ceramics, sculptures, bronzes, all of which now fill our museums and private collections.

Some of the most extraordinary work in this early archaeological denudation of parts of China was executed not by the archaeologists, but by engineers representing the European construction firms who subsequently became so fascinated by what they found that they turned archaeologists almost overnight. The Swedes Andersson (1874–1960) and Karlbeck (1879–1967) were geologist and engineer respectively, but between them were largely responsible for the magnificent holdings of early Chinese art now in the Museum of Far Eastern Antiquities in Stockholm. It may, thankfully, be some consolation to our more sensitive consciences that recent archaeological work in China has shown that these early 20th century adventurers hardly scratched the surface of Chinese archaeology.

The revolution which precipitated the downfall of the dynastic system in China in 1911, and which resulted in the establishment of the Republic in 1912, did not materially affect China's stability, prosperity or prospects. Neither did it in any way stem the flow of foreign commercial interest in China, nor the interest of foreign archaeologists in its art and history. The tomb figurines and other mortuary artifacts which the railway engineers had excavated in such quantities caught the imagination of Western collectors and created a substantial and constant demand. Thus, the grave robbers, supported by sundry entrepreneurs and dealers, continued to descend upon any recent discovery. There was no authority to stop them. Even during the early 1930's, when Chinese archaeologists commenced work on an official planned excavation of the Shang Royal tombs at Anyang, with Japanese assistance, there was no real attempt to stop the grave robbers from making their moonlight plundering excursions. How else did ancient bronze vessels and jades 'from Anyang' end up in museums throughout the world?

And yet unrelenting criticism of the Western collectors and museums who sought this material is unfair. More often than not they never ventured to China, were quite unaware of the circumstances under which archaeological material was being discovered and exported, and were only stimulated in their collecting activities by a profound admiration for the craftsmanship of early Chinese works of art.

Being fully aware of the cultural plunder that had occurred, and equally aware of the value of the study of historical material, the new government of the People's Republic promptly initiated legislation protecting cultural relics and monuments, and preventing the export of any work of art. This became law in May 1950, by which time the Academy of Sciences had already founded its Institute of Archaeology to supervise, co-ordinate and advise on all aspects of archaeological work throughout the country.

Now, when an archaeological 'find' is encountered, generally by peasants or workers, it is reported to the local archaeological bureau – normally the provincial museum. Having made its assessment of the importance of the site, the bureau submits a report to the Institute in Peking, which decides whether or not to excavate. In cases of particularly large and significant excavations the work would be undertaken by a special supervisory team from Peking, otherwise the work could be done by the local museum or archaeological bureau.

Events have proven this simple, straightforward system to be entirely successful. However, its success is dependent upon the co-operation, interest and understanding of the common people.

When the authorities were organizing cultural work and programmes in the early days of the People's Republic, they had to stimulate an interest and a concern for China's history, until then the preserve of a cultured minority. Out-dated taboos and attitudes still affected archaeological work in China. Therefore, the authorities had a complex task which had to be handled promptly and effectively, since most of the archaeological sites were encountered accidentally during the work of reconstruction.

With the few trained archaeologists as a nucleus, the country undertook a crash programme to train a small army of specialists who went out into the provinces to co-ordinate and oversee the ever-increasing amount of work. It was they, along with Party workers and cadres, who educated the Chinese people in a new attitude and responsibility towards cultural relics. Employing Mao Tse-tung's famous dictum, "Let the past serve the present", the masses of Chinese people were taught to appreciate the extraordinary craftsmanship of the artisan in early China. As old taboos were obliterated, the people took a positive look at their cultural and historical background. Every chance find of an ancient bronze or early T'ang tomb figure, was seen as evidence of Chinese history, rather than a frightening omen or the chance to make a quick profit.

After the people had come to accept the relics' value and relevance, the authorities could embark upon an intense programme of reparation and construction. Subsequently, when the Chinese people encountered archaeological remains, they took proper action, as evidenced by the vast quantities of properly documented material recovered since 1949.

As early as 1954, the Chinese were able to publish a full two-volume work on archaeological material recovered during construction work in the previous five years. A visit to any Chinese museum will provide further evidence that the campaign ensured that historical and cultural sites and artifacts were not overlooked or destroyed in the task of

reconstruction. In fact, one of the great problems facing museums and cultural authorities in China is the sheer quantity of material. The size of the problem may be dramatically illustrated by reference to the circumstances of the Honan Provincial Museum at Chengchou, where the staff reported that in the space of just five years, from 1966 to 1971, archaeologists had recovered over one million objects in that province alone.

In order to appreciate the practicalities and mechanics of modern archaeology in China, it is helpful to refer to specific examples. In recent years, the most outstanding of these must surely have been the discovery of the tombs of Prince Liu Sheng and his consort Tou Wan, who had been buried some 2,000 years ago in their exotic jade suits. Sadly, those magical properties which the ancient Chinese credulously attributed to jade had failed in their mysterious preservative qualities, and all that was left were the collapsed suits composed of hundreds of small rectangular jade plaques (*plate 20*). The Prince and his consort had long since departed – both body and soul.

The circumstances surrounding the discovery and entry of these two mausolea which so persuasively echoed the images of ancient China are worth recording. In June 1968, a detachment of the People's Liberation army was operating among the rocky limestone cliffs of Mount Ling (*Lingshan*) near the city of Man-ch'eng, in south-western Hopei province. While dynamiting certain areas, the soldiers suddenly, and amazingly, found themselves confronted with sections of a brick wall set deep into the rock. The probable significance of this discovery was immediately apparent and the local archaeological bureau alerted. Happily, the soldiers were aware of the possible implications of their find and did not continue with their activities.

Following prescribed procedure, the local bureau informed the Institute of Archaeology at the Academy of Sciences which thereupon assumed responsibility. Under the supervision of their trained staff, local soldiers, peasants and others assisted in the laborious and often heavy work of gradually removing the rock to reveal the brick facing wall (*plate 22*). While dismantling this wall, they noticed that loose stone chippings covered the ground within the immediate environs. It soon became apparent that these chippings were left over from the excavation of some kind of mausoleum which still remained hidden from sight. The discovery of similar scattered chippings some 100 metres to the north led the archaeologists to the site of the second tomb.

Behind the wall nothing more than a tunnel-like passage greeted the excavators. This gradually widened to approximately 14 feet before emerging into a vast underground cavern some 50 feet in length, 40 feet in width and 25 feet in height (*plate 23*). This in itself was awe-inspiring enough, but the real treasures of this archaeological revelation lay secreted behind a set of massive stone doors sealed with molten iron. But it already appeared that this was an Imperial burial of some significance, for in the minor side chambers the excavators had found the remains of a dozen or so horses, several chariots and a quantity of pottery vessels containing all manner of food and wine – all those material comforts which, it was thought, would ensure the continued presence of the spirit within the burial chamber.

Bronze vessels, painted pottery vessels and lacquer wares, all meant for luxury rather than practicality, were found piled in the central hall. Many of these bore inscriptions, such as "cup for use in the Chung-shan hall", thus providing the first fragments of real evidence for the identification of the deceased (*plate 21*). The final clues were found in the comparatively small burial chamber behind the sealed stone doors. Here the fragmented jade suits, magnificent inlaid bronzes, jades, gold and silver bowls, lacquers and silks were hardly recognizable as such, for they were little more than roughly piled mounds shrouded in dirt, dust and rock chippings. After the painstaking work of classifying, identifying, cleaning and restoring them, they revealed the richness and variety of this unique hoard. Also, the inscriptions were read, the ancient histories consulted, and gradually the picture pieced together.

Now that the work has been completed we can enjoy the sheer beauty and craftsmanship of these objects, and at the same time appreciate the conditions and style of Imperial life in Han China. Furthermore, we can obtain some vague impressions of social order, of priorities and of the conditions under which the people lived and were employed. The luxury and riches which surrounded the lives of Prince Liu Sheng and his consort Tou Wan are reflected in the wealth of exotic works of art recovered from these tombs. The scale of the impressive mausolea similarly reflects the position of members of the Imperial family vis-à-vis the people of Han China. (Liu Sheng was a son of the Emperor Ching who, on the 27th July 154 B.C., issued a decree stating that ". . . his Imperial sons, Liu Tuan be established as King of Chiao-hai and Liu Sheng as King of Chung-shan, and granted to the common people one step in noble rank.") Thousands must have been employed for many months, possibly even years, in hollowing out these burial chambers from the hard limestone rock; it has been estimated that using modern techniques the excavation and construction of the two tombs would have been a year's work for several hundred men. And Chinese archaeologists and conservation experts have estimated, with the tools and techniques of that time, it would have taken an expert jadesmith of the Han dynasty no less than ten years to fashion one jade suit.

The catalogue of finds made in recent years includes the jade suits from the Man-ch'eng tombs; the burials at Mawangtui near Ch'ang-sha (*plate 24*), which were discovered during hospital construction work, and which produced the almost perfectly preserved body of the wife of the Marquis of Tai who was buried in 168 B.C. (this macabre specimen is now on exhibition in a specially constructed museum at Ch'ang-sha); and the Yüan dynasty walls of Peking discovered by engineers while constructing a new gate and roadway.

In a modern socialist society which, after half a century of bitter despoliation, is reconstructing itself as an independent and self-reliant

nation, all forms of artistic and cultural endeavour would appear to be largely irrelevant. However, as Chairman Mao said, "Contemporary China has grown out of the China of the past; we are Marxist in our historical approach and must not lop off our history". In this context, history must include culture, archaeology and art, as invoked in Mao's well-known dictum, "Let the past serve the present". The implication is that history has a precise educational role. Thus, archaeological and cultural relics are less important as works of art than as historical documents. Today, the notion of aesthetic appreciation of ancient works of art is as unfamiliar in modern China as it is familiar to us in the West.

Two principal themes are propagated in this bias of interpretation. The first is the wisdom and craft of the peasant people of the time who were responsible for producing the bronze vessels, jades, ceramics and other works of art that we now so admire – "no simian hand has ever fashioned even the crudest of stone knives". This theme, of course, has its modern counterpart in the denunciation of elitism.

The second and principal theme to archaeological interpretation is the broader and more complex one of evaluating historical society, and drawing broad conclusions on the development and nature of society which are relevant to contemporary situations and conditions. The processes of historical analysis in modern China are generally focused upon a particular personality. The 'class contradictions' and 'class struggle' of his time are then examined to determine whether, under the conditions extant, he might be described as a progressive or a reactionary. And then, to quote Yang Jung-kuo, "what we affirm is only that which played a progressive role in history; as to things conservative we must firmly negate and criticise them". The recent campaign to criticize the works and directives of Confucius clearly illustrates this process and indicates the role of cultural relics in such policies.

The campaign drew attention to political and social developments which grew out of the disorder of the Warring States period when Confucius (551–479 B.C.) was propagating his thesis that good government was dependent upon the maintenance of ritual and class. At that time, the ancient order that had so dominated China during the Shang and Western Chou periods was disintegrating; geographical expansion, new cultural contacts and the gradual emergence of new institutional and social orders stirred men's imaginations. In an age of ever-increasing chaos, Confucius prescribed order through a return to the old, trusted values of a protected hierarchy practising a similarly protected, but out-dated system of government.

With the growth of the semi-autonomous war-lords, wealth and power were no longer the sole prerogative of the Court. The disintegration of central authority made it impossible for order to be restored on entirely Confucian lines, but his proposals nonetheless received widespread and increasing support. Firstly, there was a strong desire for order and peace which could be achieved through unity and self-discipline. Secondly, since the Chinese respected tradition, the Confucian ethic promised a dependence upon known quantities. And,

thirdly, he described a code of living based on moral principles which was perfectly embodied in the patriarchal nature of the Chinese family. But, of course, the Confucian ethic was totally dependent upon the maintenance of an elite; a small minority of aristocrats and officials who, in theory at least, possessed the seven virtues. Such concepts are abhorrent to the ideals of the People's Republic.

At the same time, the recent campaign also focused attention on another vital force extant in China during the later years of the Warring States period. This was the theory known as Legalism, a rigidly authoritarian concept which accepted the inflexible hierarchy which had once existed in early Bronze Age China.

Nevertheless, the Legalists were very much a product of their time, for the total social and governmental disintegration which had occurred during the Warring States period was catastrophic. The pre emptory and uncompromising stands taken by the Legalists in the 4th–3rd centuries B.C. were gradually acknowledged as the only way likely to restore order and unity. In the Legalist view it was a case of order before ritual, ability before hierarchy. It was, therefore, a totally practical, if tough and, in some instances, destructive ethic in complete contrast to the conservatism of the Confucian ideal.

Although Confucianism left its indelible impression on Chinese society, as successive dynasties were to evidence, it was the Legalist view which first won the day. In 221 B.C., the founding Emperor of the Ch'in dynasty, Shih Huang-ti, united China under the Legalist banner. He introduced an immensely strong centralized authority which sought to establish unity and re-construct China after the ravages of the Warring States period (*plate 25*). Respect for the revered writings of the classics and the codes of the Confucian ideal were at a low ebb. There is an obvious correspondence with the emergence of the People's Republic.

This then is the background to the anti-Confucian campaign in China which brought so much bewilderment to Western observers. The role of archaeology and cultural relics in this campaign was to provide interludes of material reality to an otherwise academic, or political, exercise.

We have already seen that the vast majority of archaeological work undertaken in China since 1949 was done through discovery during construction or reconstruction work. The anti-Confucian campaign required specific material to substantiate its cause and it was partially in these interests that excavation work in the area surrounding the tomb of Ch'in Shih Huang-ti commenced. Once again, the results were outstanding, for the recovery of literally hundreds of life-size pottery figurines of soldiers, guardians and horses not only provided the Chinese art and archaeological fraternity and the public in both East and West with yet another stunning artistic revelation, but also they lent credence and substance to the political objective (*plates 26, 27*).

This attitude towards ancient art objects leads to what many may consider an unusual use of such material in museum display. There is an undoubted emphasis upon archaeology, since the range of artifacts

recovered from such sites provides evidence for the illustration and definition of a society or community; whereas in the later periods, from the Sung dynasty onwards, only works of art, or functional objects now considered works of art, in Imperial service tended to be preserved.

The major provincial museums in China illustrate this strong archaeological emphasis and the displays invariably employ much diagrammatic material to illustrate and explain the historical context. For example, during the anti-Confucian campaign, the Shensi Provincial Museum in Sian exhibited ancient bronzes, jades, ceramics and lacquers from local sites, carefully and sparsely selected to illustrate the story being told in the accompanying pictures and diagrams. That is, the story of Confucius, that "crafty hypocrite who had honey on his lips and murder on his heart", and his philosophy to maintain the slave society; the oppression of the slave-owning aristocrats; the exploitation of the working people; and the story of peasant uprisings against the oppressors. Liuhsia Chih, perhaps the most famous of the rebel slave leaders, is represented as the 'Robin Hood' of ancient China, leading his gallant band of insurgents. The tale of his famous confrontation with Confucius and his face-to-face denunciation of the sage is told in vivid pictorial detail, with Confucius leaving, "his head hanging low, his face the colour of ashes . . .".

To the Western visitor, this is certainly an incongruous combination: magnificent Warring States bronze vessels with sophisticated interlacery patterns, fine jades with subtle carvings, richly painted pottery vessels, all exhibited adjacent to the vivid imagery of the modern political message. The concept of aesthetic appreciation may be lost amidst the intensity of political purpose, but nonetheless it provides archaeology with a valid role in modern Chinese society. Archaeological remains are historical evidence, not necessarily just objects of pleasure or wonderment for, as Chairman Mao has stated, "Marxism teaches that in our approach to a problem we should start from objective facts, not from abstract definitions".

Bibliographical references

Cheng Chen-to, *Chüan-kuo chi-pen chien-she kung-ch'eng-chung ch'u-t'u wen-wu chan-lan t'u-lu* (Illustrated catalogue of cultural relics unearthed at construction sites throughout the country), 2 vols., Peking 1954.

Hunan Provincial Museum and The Institute of Archaeology, *Ch'ang-sha ma-wang-tui i-hao han-mu* (the no. 1 Han tomb at Mawangtui, Ch'ang-sha), 2 vols., Peking 1973.

Mao Tse-tung, "The Role of the Chinese Communist Party in the National War", *Selected Works*, Peking 1967, vol. II, in which Mao Tse-tung discusses the Marxist approach to history.
"Talks at the Yenan Forum on Art and Literature", *Selected Works*, Peking 1967, vol. III.

Pelliot, Paul, *Les Grottes de Touen-huang*, 6 vols., Paris 1920–4.

Stein, Sir Marc Aurel, *Ruins of Desert Cathay*, 2 vols., London 1912.
Sand-buried Ruins of Khotan, London 1903.
Ancient Khotan, 2 vols., Oxford 1907.
Serindia, 5 vols., Oxford 1921.
Innermost Asia, 4 vols., Oxford 1928.

Waley, Arthur, *Ballads and Stories from Tun-huang*, London 1960.

Watson, William, *The Genius of China*, London 1973. London edition of the catalogue of the exhibition of archaeological finds of the People's Republic of China which also travelled to Paris, Vienna, Stockholm, Toronto, Washington, Kansas City and San Francisco. Another exhibition was shown in Tokyo, Amsterdam and Brussels.

周愛匜圖

13 (overleaf)
Illustration of a bronze kuang *from the*
1726 (*first*) *edition of the* Ch'in-ting ku-chin
t'u-shu chi-ch'eng; *folio* 18 *of the* Hui-kao
section of chüan 209 *of section* XXXII.
British Library

14
An archaistic bronze kuang *vessel with*
gold inlay, in imitation of an early Chou
(11*th*–10*th centuries* B.C.) *prototype.*
Sung dynasty: A.D. 960–1279
Height: 21 cms
British Museum

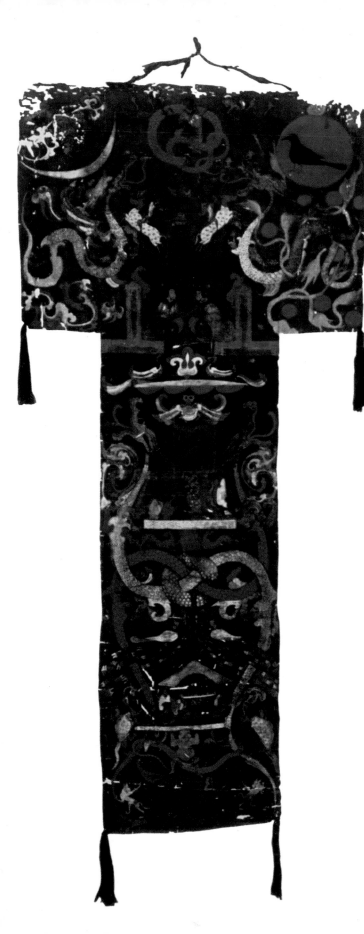

15
Painted silk funerary banner excavated in 1972 from the no. 1 tomb at a Mawangtui, Ch'ang-sha Hunan province; the burial of the wife of the Marquis of Tai, circa mid 2nd century B.C. *The banner depicts the transmission of the deceased, in the centre, to heaven. In the upper left corner is a crescent moon with a toad and a hare, both symbols of the moon; and in the top right corner, the bird, normally 3-legged, symbol of the sun (see also plate nos. 24, 63 and 68).*
Han dynasty: 2nd century B.C.
Length: 205 cms
China

16 (*overleaf*)
Detail of the jade burial suit.

17 (*overleaf*)
The jade burial suit of Prince Liu Sheng, excavated in 1968, from his mausoleum near Man-ch'eng in Hopei province. The suit was made from 2,690 pieces of jade; the smallest measures 1.5 × 1.0 cms, and the largest, 4.5 × 3.5 cms. Each piece was drilled with four holes, at each corner, and sewn together with gold thread.
Han dynasty: 2nd century B.C.
China

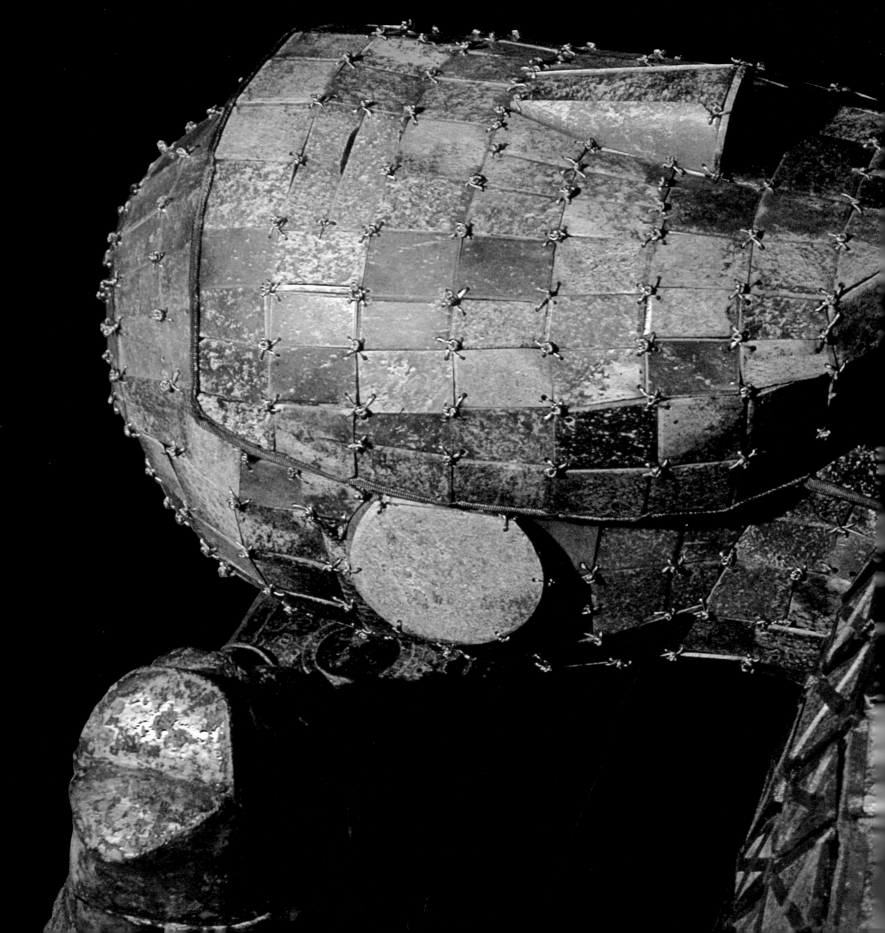

18

A burial pit with horses and chariots at the Western Chou site of Shang-ts'un-ling *in Honan province. The same principles for burial practice were applied in both Shang and Western Chou times.*

The Shang-ts'un-ling burials were excavated during 1956–7 and yielded no less than 234 tombs plus chariot and horse pits. This considerable cemetery proved to belong to the nobles of the feudal state of Kuo which was annexed by its neighbour, Chin, in 655 B.C. Three chariot pits were found, the larger of which contained 10 chariots and 20 horses, and the two smaller pits contained 5 chariots and 10 horses each.

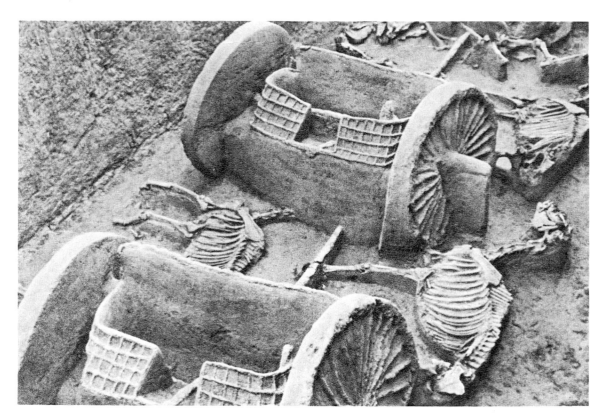

19

A view from the Loyang-Sian railway; originally constructed in the early years of this century by European engineers the line cut through the heart of ancient China. It was to a large extent as a result of this work that many ancient tombs were discovered, and revealed to the world the buried treasure of Bronze Age, Han and T'ang China.

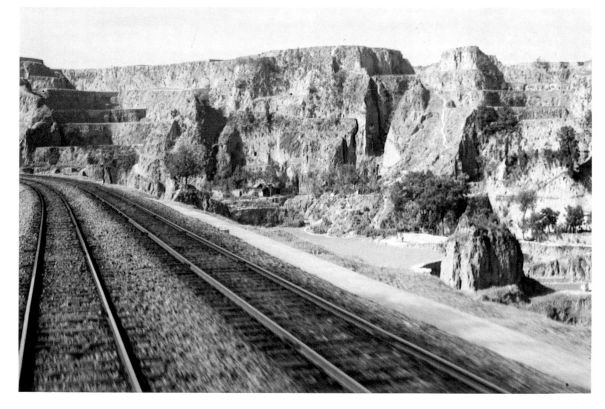

20

*The collapsed jade suit of Prince Liu Sheng
as it was found by Chinese archaeologists in
the tomb at Man-ch'eng.*

21

A bronze basin, or hsüan, *recovered from
Liu Sheng's tomb, bearing an inscription
which refers to 'Chung-shan'; the kingdom
over which Liu Sheng ruled in the 2nd
century* B.C. *The inscription begins 'chung-
shan nei-fu t'ung-hsüan . . .'; bronze* hsüan
for use in the Chung-shan palace . . .
Western Han dynasty: late 2nd century B.C.
Diameter: 27.9 cms
China

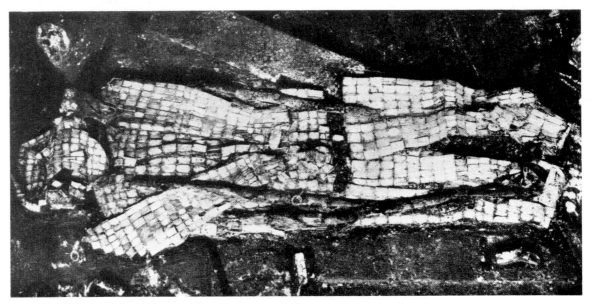

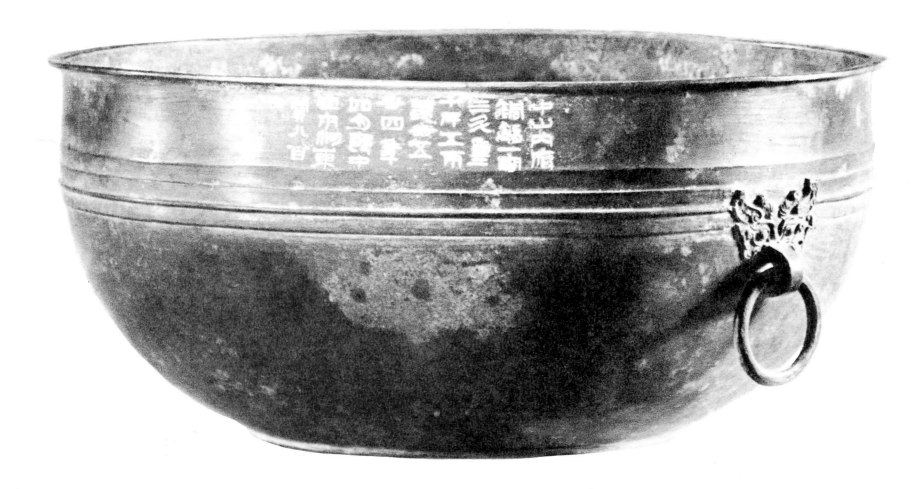

22

*The discovery of the mausoleum of
Prince Liu Sheng, showing Chinese
archaeologists dismantling the brick
facing wall which sealed the entrance to
the tomb.*

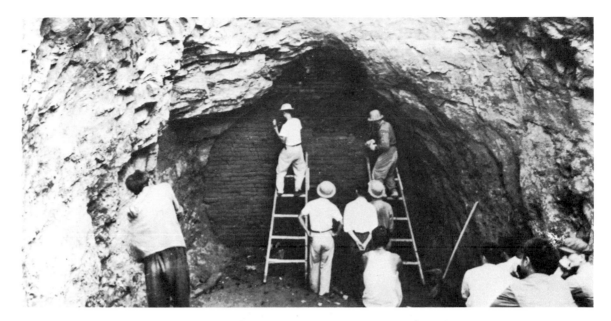

23

*The cavernous central chamber of
Liu Sheng's underground tomb;
measuring approximately 50 feet in
length 40 feet in width and 25 feet in height.
On the rear wall may be seen the stone
doors, sealed with molten iron,
which led to the actual tomb chamber.*

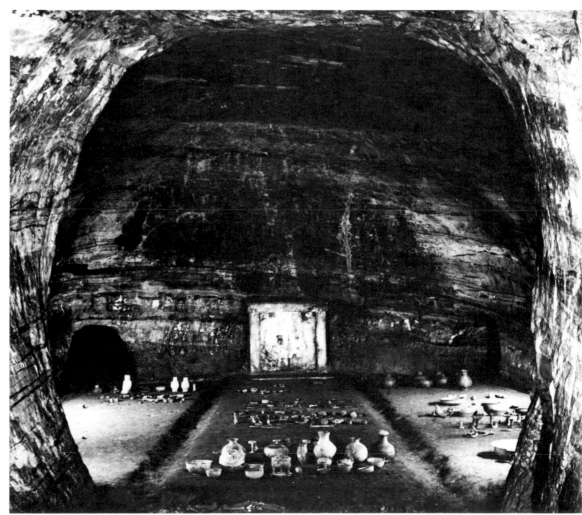

24

A general view showing the vast excavated burial of the no. 1 tomb at Mawangtui, near Ch'ang-sha. The deceased, the wife of the Marquis of Tai (2nd century B.C.), was wrapped in layers of silks and placed in a lacquered coffin, which was then encased in three further lacquer painted coffins. These were then placed in an enormous wooden tomb chamber, measuring 22 feet (6.72 m) long and 15 feet 9½ inches (4.81 m) in width, which fitted into the burial pit. Within this structure was also placed a range of tomb furniture and ritual paraphernalia, including silks, wooden tomb figures, nearly 200 lacquerwares (see plate 63), ceramics, bamboo slips, musical instruments and various foods and containers. In all, over 1000 pieces were recovered from the tomb, which was excavated in 1972. Two adjoining tombs have more recently been excavated but with less dramatic results (see also plates 15, 63 & 68).

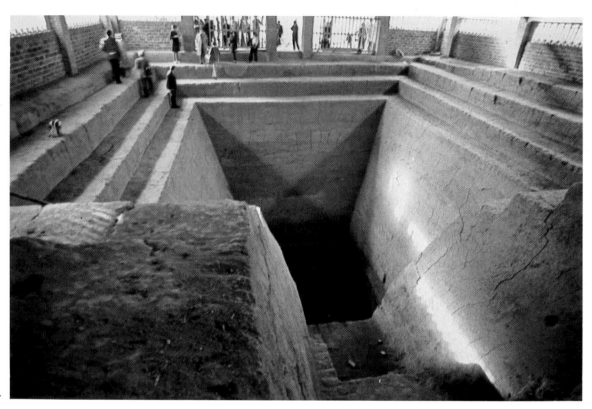

25

'The Ch'in establishes a dictatorship and a system of centralised government.' The founding Emperor of the Ch'in, Shih Huang-ti, is shown with accompanying maps, diagrams and ancient bronze weapons and relics, which illustrate the expansion of the state and subsequent control of the 'six states': Chao, Wei, Han, Ch'i, Yen and Ch'u.
A recent display in the Shensi Provincial Museum at Sian.

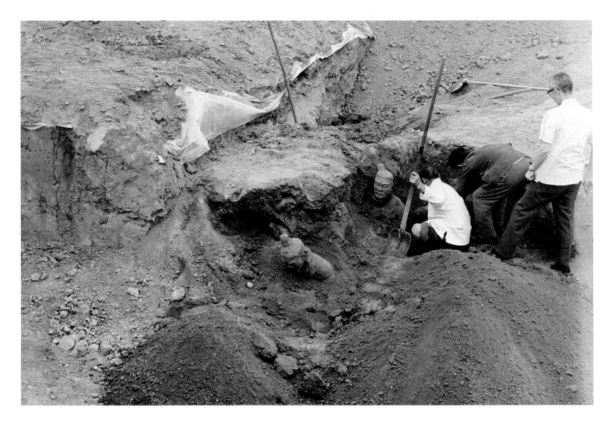

26/27
Excavation work in progress (early in 1976) on the burial pits adjacent to the tomb of Ch'in Shih Huang-ti, in present day Lintung County in Shensi province. The pit lies a short distance to the east of the Emperor's burial site, and covers an area of some 12,000 square metres. Many hundreds of life-sized pottery models of horses, soldiers and guardians have been recovered since work started early in 1974.
It is still not possible to estimate how many such figures were originally placed there. Early in the Han dynasty the burial was severely damaged, and its wooden superstructure destroyed by fire, during recriminations against the authoritarian Ch'in rule (see also plate nos. 53 and 54).

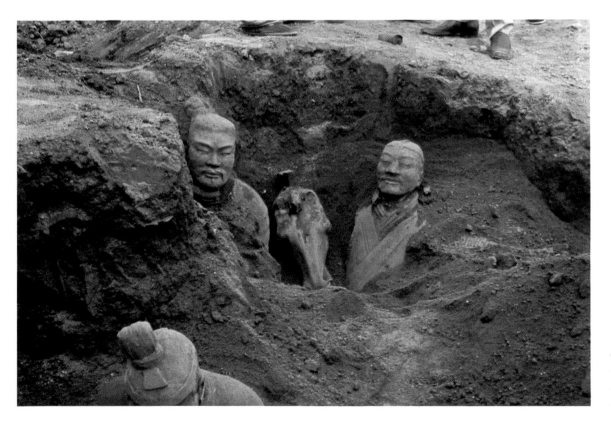

28 (overleaf)
Painted ceiling design from a Sui dynasty (A.D. 581–618) cave at the Tun-huang Buddhist cave temples in Kansu province. Strong Indian and Central Asian influences are apparent in the ornamental border patterns and in the scrolling floral motifs.

新石器時代

舊石器時代

Palaeolithic and Neolithic

The renowned Peking man was long recognized as one of the earliest, if not the earliest, examples of *homo sapiens* known to modern man. First discovered in 1929 at the village of Choukoutien some 26 miles south-west of Peking, the evidence suggests that Peking man roamed limited areas of north China at some time during the Middle Pleistocene period, at least half a million years ago. These first remnants of Peking man, which included a skull, had a rather unfortunate history and were subsequently 'lost' during the Second World War. Fortunately, more recent archaeological work has more than compensated for this loss, for a jaw and cranium of Peking Man were excavated, again at Choukoutien, in 1959 and 1966 respectively.

However, Peking Man may now have to be dislodged from his most ancient pedestal, for even in China – thus excluding the recent finds in central Africa – there is evidence of earlier man. Of these the most significant is the so-called Lan-t'ien man, *Sinanthropis lantienensis*, which was identified from a jaw found in 1963 and a skull found in 1964 at Lan-t'ien, near Sian in Shensi province. Not only does the morphology of the bones suggest that Lan-t'ien man was slightly earlier in the evolution of the human in China, but so also do the slightly inferior stone tools and implements which were found in company with his remains. The real significance of Peking Man is that his relics were supported by evidence of human activities, such as fire and toolmaking. Examples of both rudimentary stone tools and burned stones and earth have been discovered at the habitation cave at Choukoutien.

Lan-t'ien man probably dates to around 600,000 B.C., and Peking man slightly later. There is no evidence to suggest that during the periods when they occupied their respective sites that either achieved any material progress. But these scanty fragments of evidence for man in Middle Pleistocene China do provide information as to the nature of the climate, vegetation and wildlife that existed at the time. The moderate climate it appears was capable of supporting a rich and varied vegetation, certainly very much more extensive than at present, whilst buffalo, sheep, deer, boar and rhinoceros were among the animals with which Peking Man had to contend.

The vegetation and natural life of north China around half a million years ago may quite possibly not have been so different from that of the neolithic period, a mere 6,000 years ago; archaeology suggests that there have been dramatic changes caused by the gradual build-up of the loess soil during even the comparatively brief period of recorded history. But the connection between palaeolithic man, as represented by the Lan-t'ien and Choukoutien specimens, and neolithic man is tenuous indeed. Archaeological evidence and research have yet to account for the enormous gulf between embryonic man who lived in caves with his few roughly hewn stone tools, and the developed community-conscious cultures of neolithic China. In fact, many of the questions concerning proto-neolithic cultures in China have still to be answered. It is only since officially organized archaeological work commenced in 1949 that even a vague picture of the distribution and

development of neolithic cultures in China has become apparent. It is a complex tapestry of which only the framework is known at present.

Broadly speaking, neolithic cultures in China are identified and characterized by their pottery. In the early years of this century, Western, and particularly Swedish, engineers and archaeologists discovered a western neolithic culture centred on the Lanchou region of Kansu province which is characterized by its red pottery urns and vessels, known as the Pan-shan type, painted with broad and energetic spiral designs. For some considerable time this was the only known corpus of Chinese neolithic material, but it was clear that this undoubtedly sophisticated and developed material culture had its origins in another, possibly more central, tradition.

It now transpires that neolithic China may be divided into three broad cultural regions. In the central northern plain, with the Yellow River valley in Shensi and Honan provinces as its focal point, is the Yang-shao culture; in the east, in Shantung province, the Lung-shan culture; and in the far west, the aforementioned Pan-shan and associated cultures. Of these, the Yang-shao culture is the pivotal and critical representative, for not only did it originate and develop in the nuclear region, but it also shows the clearest stratigraphy and associated development pattern.

The origins of the critical Yang-shao culture remain obscure, but in its more developed stages the excavation of the representative site at Pan-p'o village on the outskirts of the modern city of Sian has proved to be something of a landmark. The pottery vessels painted with semi-abstracted fishes and human faces (*plate 29*), the bone needles, harpoons and arrowheads and other documentary evidence have provided much essential information for an assessment of the style and nature of early organized society in China. The value of the excavated material is greatly enhanced by the further evidence provided by the excavation of the village site itself; this includes the sizes, types and construction of houses and buildings, burial practice and elements of domestic, industrial and agricultural routine from which Chinese archaeologists and historians have been able to re-create the circumstances of neolithic life. Pan-p'o village is situated, like most neolithic communities, on raised ground close to a water source, in this case a river. By comparison with many such communities it was large, housing some 200–300 people who lived within the entrenched confines of the village (*plate 30*). The circular plan was divided into three general areas of activity: living, manufacture (such as pottery) and burial. Although hunting and fishing were important sources of food, it is evident that millet was cultivated as a staple crop, and that certain domestic animals, including the dog, goat and pig, were raised.

The distribution of this central Yang-shao tradition, or at least its influences, was more widespread than at first thought. It became evident in 1963, when the relics of a comparable or related culture were discovered in P'ei-hsien, in the easterly province of Kiangsu (*plate 31*). Outstanding among these finds was a range of pottery vessels painted with broad curvilinear designs within a geometric framework that bear an immediate resemblance to those of the Yang-shao ceramics. In fact, some vessels from the central Yang-shao at Miao-ti-kou in Honan parallel some of the Kiangsu finds in both form and decoration (*plate 32*). This site provides another new piece of evidence for the neolithic jigsaw, apparently representing an eastwards extension of the Yellow River Yang-shao tradition, for both the forms and styles of ornament of its painted pottery vessels represent a development of the later stages of the Honan-Shensi tradition. Related vessels of this so-called Ch'ing-lien-kang culture have been found as far south as the Shanghai region and thus provide further indications of the easterly movement of neolithic cultures in north China, for the origins of this painted pottery culture undoubtedly lie in the heart of the Yellow River basin.

The upper layers of the Yang-shao levels at a number of Honan sites, but not strangely enough at Pan-p'o, are overlaid with cultural remains which are more akin to those of the Lung-shan culture. This similarly distinctive pottery-based culture found its fullest expression in the eastern coastal province of Shantung and is characterized by its burnished, often eccentrically and emphatically non-ceramic shaped, thin-walled black pottery vessels (*plate 33*). Other paler, almost white, bodied vessels have also been found at Lung-shan sites, at Wei-fang in Shantung in particular, but although of different material they admirably illustrate that peculiar characteristic of eccentric form. The tripod jug, with its elaborate structure, studded appearance and imitation rope or wicker handle cannot conceivably have its origins in a ceramic tradition (*plate 34*). Such odd diversions are even less understandable when one considers that it was the Lung-shan potter who, it appears, introduced the fast wheel to the ceramic art of China. The use of this technique is clearly evident in many of the black pottery wares.

The fundamental differences in approach to ceramic design displayed in these two cultures makes it hard to believe that one developed out of the other. The Yang-shao culture produced a range of vessels which naturally adhere to the principles of ceramic form and which were, generally but not invariably, embellished with painted decoration. The Lung-shan culture produced vessels of peculiar form and structure which often bear no relation to the natural ceramic traditions, and furthermore its products were never embellished with painted ornamentation. And yet, in the central region of Honan, Lung-shan cultural remains are to be found wedged between earlier Yang-shao neolithic cultural deposits and those of the earliest stages of the subsequent Bronze Age. The resemblance of vessel forms between neolithic Lung-shan and the earliest phases of the Bronze Age leave no doubt that it was this neolithic culture which was the immediate predecessor of the Bronze Age in China.

The evidence of the somewhat sparse Lung-shan remains in central China and the advanced form from the relatively isolated Shantung sites (principally Ch'eng-tzu-yai and Wei-fang) is inconclusive. Two theories are currently propounded concerning probable

chronology and development, although there is no doubt that the Lung-shan generally post-dates the Yang-shao culture: firstly, that Lung-shan is the natural cultural successor to Yang-shao, and when the bronze culture emerged in the Yellow River valley in Honan, it moved eastwards to achieve its fullest development (in Shantung province); and, secondly, that it is an independent eastern tradition which filtered westwards to the nuclear region as those Yang-shao sites reached their later stages of development. Supporting evidence provided by the full excavation of village communities, such as that at Pan-p'o, have not yet been achieved in Lung-shan territory, but such may at some future date permit a more accurate assessment of its origins.

To complete the picture of neolithic China so far as it is currently known we must move to the far west, beyond Shensi province and into Kansu. In the distribution and development of neolithic China rivers undoubtedly played a vital role, and we have seen that the Yang-shao communities were generally maintained along water courses. The same may be said of both the Lung-shan and Ch'ien-lien-kang villages, they too normally occupying mounds to avoid possible flooding. Just as rivers were the arteries of neolithic civilization, so were they at times, like mountain ranges, natural barriers.

Midway between the modern cities of Loyang and Sian the Yellow River makes an abrupt deviation from its east-west course to a north-south axis, and at this point it is joined by the easterly flowing Wei River. The westernmost extension of the central Yang-shao tradition in all probability lay along the Wei River valley, beyond Sian. Although in the uppermost reaches of the Wei valley, between the low Tsinling and Liupan mountain ranges few neolithic cultural remains have been found. But beyond these hills, yet further to the west, in the Tao River valley another neolithic tradition developed. Certain aspects of this culture, termed Pan-shan, and predecessor to the later Ma Chang, Ma Chia Yao and Hsin Tien stages, lead one to believe it had associations with the nuclear region of the Yellow River valley. Once again this western extension is characterized by a red pottery ware, but distinctively painted with broad spiral designs which in general bear little resemblance in concept or execution to those of the Yang-shao pots (*plate 35*). The Kansu neolithic tradition has revealed a clear development pattern which suggests that, after its initial support and influence from elsewhere, it maintained its independence and momentum. The range of wide-bodied urns with comparatively narrow bases and necks, and painted in black and brown pigments with broad swirling and emphatically confident designs, often with cross-hatching for infilling and contrast, is synonymous with the Pan-shan tradition. A certain similarity in the flourish of the design on these vessels with those of some peripheral Yang-shao cultures, notably the Kiangsu tradition, may be detected, giving credence to the notion that they may have a common source. But once again we find ourselves confronted with a comparatively independent neolithic tradition, displaying a sophistication in design, concept and technique, which betrays an earlier phase of development, but once again we are at a loss to precisely identify those origins.

Although archaeology tends to characterize and identify the neolithic cultures of China by their pottery – possibly ascribing it too much significance within the culture – recent Chinese archaeological work has substantially increased our knowledge of these early civilized communities. In general, it would appear that they attained similar levels of cultural development, pursued life under comparable circumstances, adopted a fundamentally analogous social structure of village communities, and maintained either millet or rice as a staple crop supported by hunting and fishing. The stone axes, chisels and knives, the bone arrow-heads and needles, are as dissimilar as one would expect from cultures of the same family but at varying levels of development and occupying differing environments.

There is a semblance of consistency to the three broad divisions of the neolithic world in China and even though the precise relationships between them have still to be clarified, their cumulative effect is to provide a credible pattern of early civilization substantial enough to provide the foundations of the succeeding Bronze Age. The enigmatic member of the group is without doubt the Lung-shan culture, in which sophisticated, wheel-turned black pottery vessels display a technical, but not necessarily an artistic, superiority. They appear to be the illogical partner, and yet it is the Lung-shan tradition which, in its cultural deposits and pottery in particular, displays the closest affinity to the subsequent Bronze Age.

Bibliographical references
Andersson, J. G., *Children of the Yellow Earth: studies in prehistoric China*, London 1934.
Cheng Te-k'un, *Archaeology in China, Vol. 1, Prehistoric China*, Cambridge 1959.
New Light on Prehistoric China, Cambridge 1966.
Institute of Archaeology, *Hsi-an pan-p'o* (The site at Pan-p'o village near Sian), Peking 1963.
Miao-ti-kou yü san-li-ch'iao (The sites at Miao-ti-kou and San-li-ch'iao), Peking 1959.
Li Chi (and others), *Ch'eng-tzu-yai* (Report on the Lung-shan neolithic site at Ch'eng-tzu-yai in Shantung province), Nanking 1934. English translation by K. Starr, New Haven 1956.
Watson, William, *Early Civilization in China*, London 1966.
The Genius of China, London 1973.

29
Shallow red pottery basin with everted rim.
Painted in black with stylised human faces,
and a simple geometric pattern around the rim.
Excavated in 1954–7 from the neolithic
Yang-shao village site at Pan-p'o,
near Sian in Shensi.
5th–4th millennium B.C.
Diameter: 44.5 cms
China

30 (overleaf)
General view of the excavated area of the
neolithic village site at Pan-p'o, Shensi.
In addition to examples of excavated pottery
vessels, the outlines of the foundations of
typical circular, partially-sunk, houses may
also be seen.

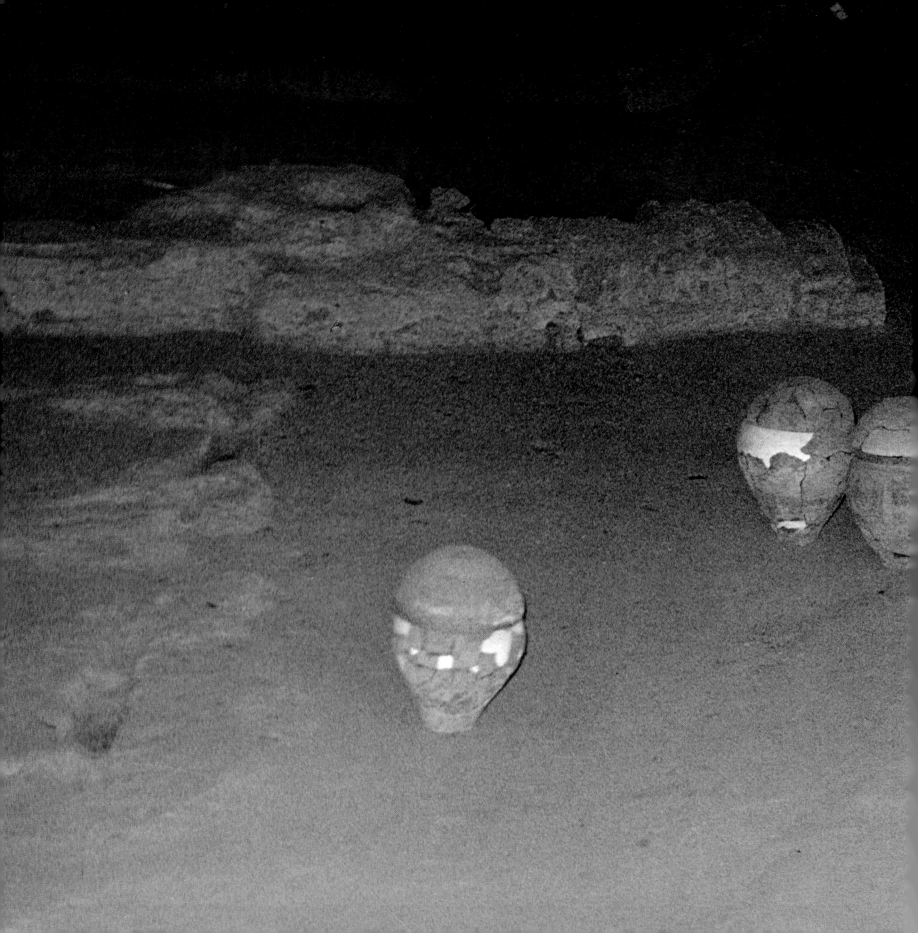

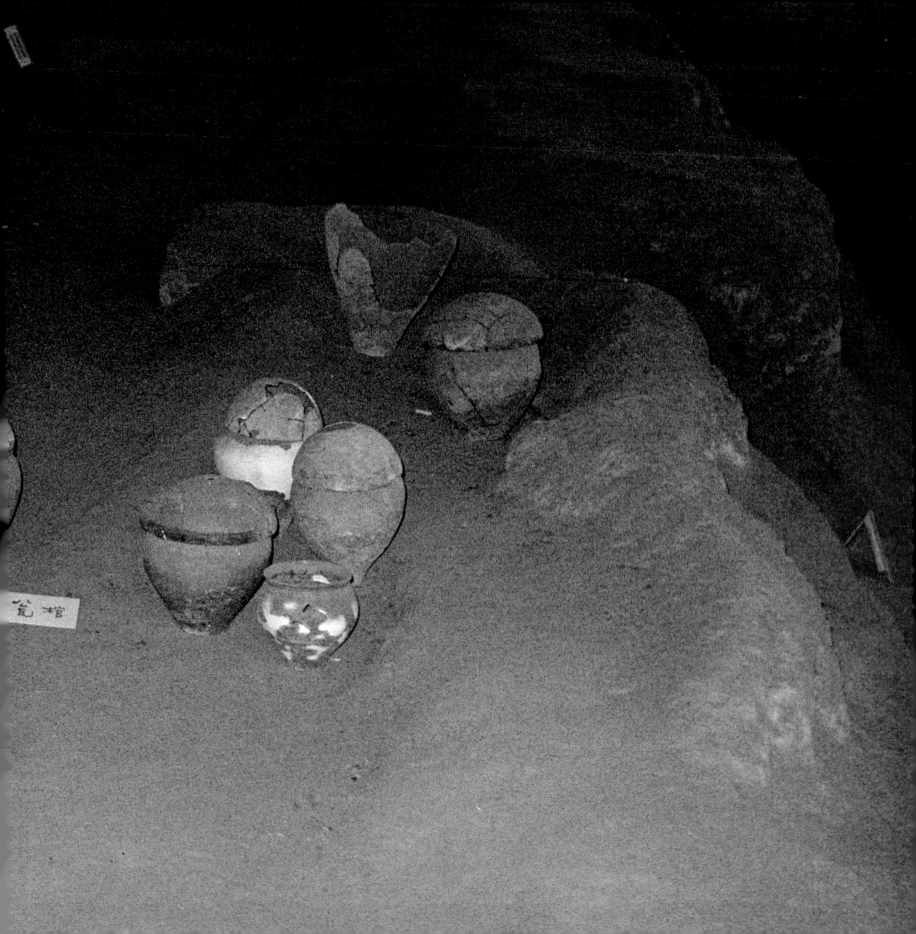

甕棺

31
*Neolithic pottery bowl painted with a design of
eight-pointed stars in white on a light red
ground. The shape of the vessel and the style of
its ornament suggest an association with the
central Yang-shao tradition.
Excavated in 1963 in P'ei-hsien, Kiangsu
province.*
4th–3rd millennium B.C.
Diameter: 33.8 cms
China

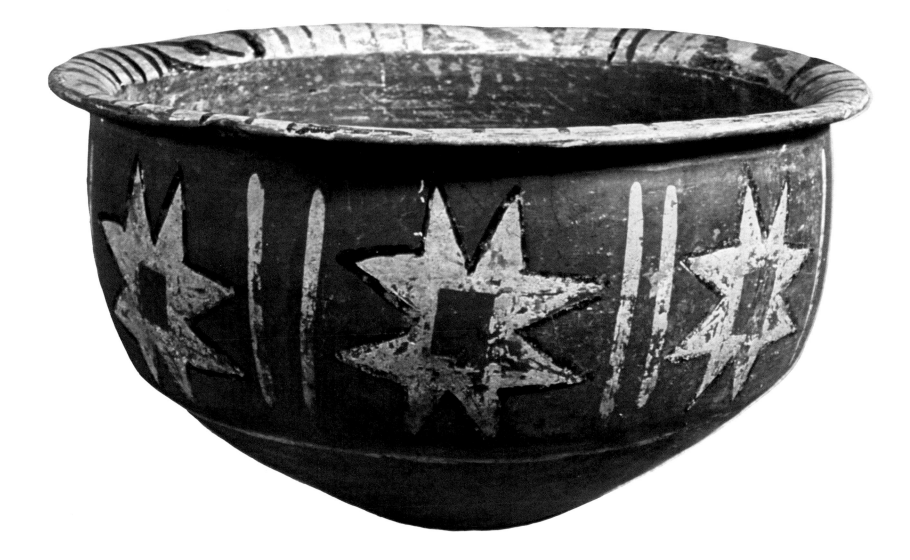

32
Neolithic painted pottery bowl from a central
Yang-shao site, but clearly illustrating a
relationship with the easterly Kiangsu tradition
(see plate 31).
Excavated in the late 1950's *at Miao-ti-kou,*
Honan province.
Circa 4th millennium B.C.
Height: 11.5 cms
China

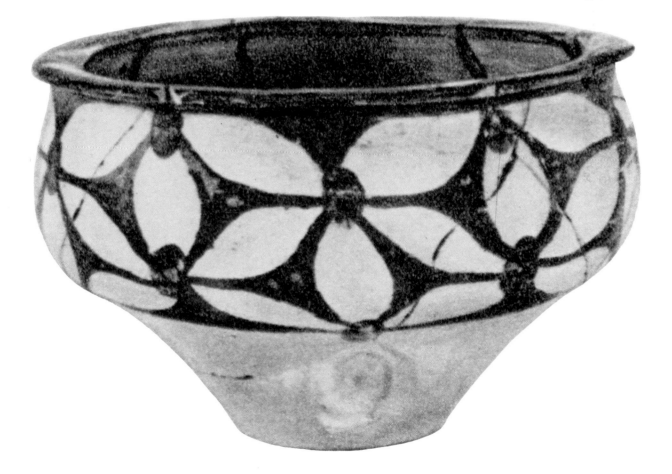

33
Burnished black pottery bowl,
with characteristically thin-walled,
wheel-turned body.
Neolithic Lung-shan culture
Circa 3rd millennium B.C.
Height: 11.0 cms
Museum of Far Eastern Antiquities, Stockholm.

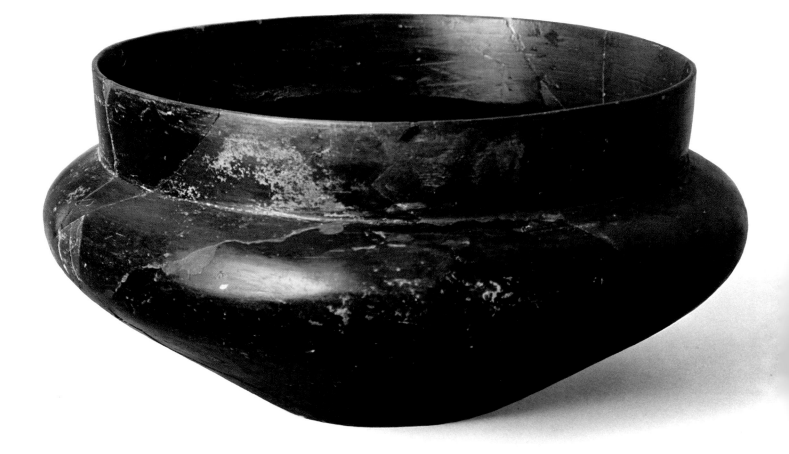

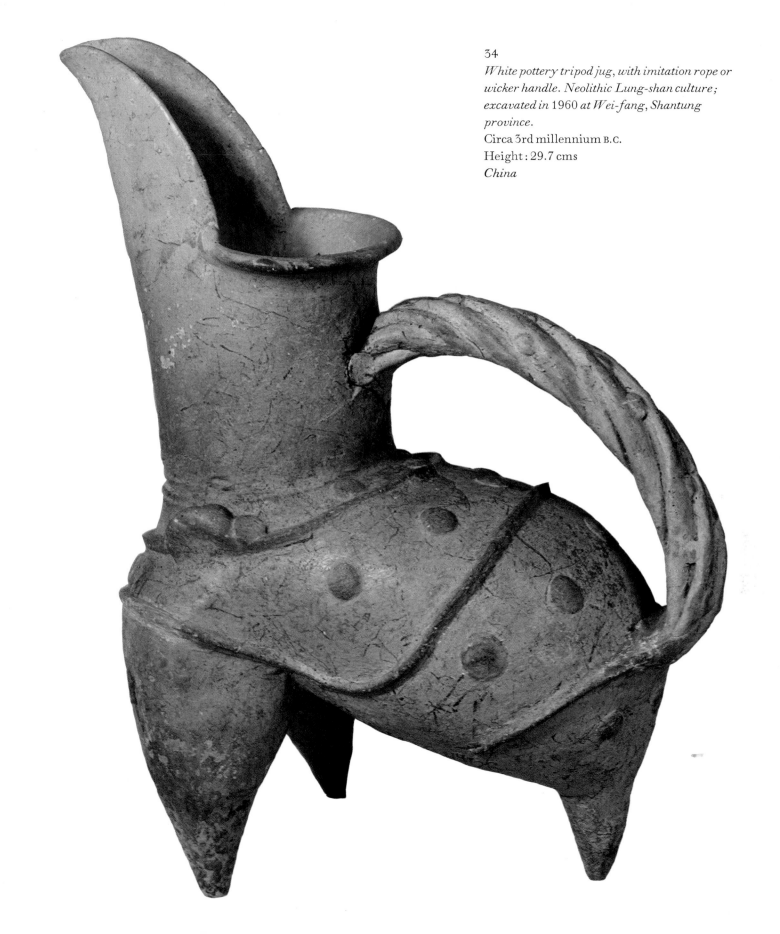

34
White pottery tripod jug, with imitation rope or wicker handle. Neolithic Lung-shan culture; excavated in 1960 at Wei-fang, Shantung province.
Circa 3rd millennium B.C.
Height: 29.7 cms
China

35
Red pottery urn painted in black with an exuberant swirling pattern typical of the western neolithic tradition.
Pan-shan type; from Ma-chia-yao, Kansu province.
Late 3rd–2nd millennium B.C.
Height: 15.5 cms
Museum of Far Eastern Antiquities, Stockholm

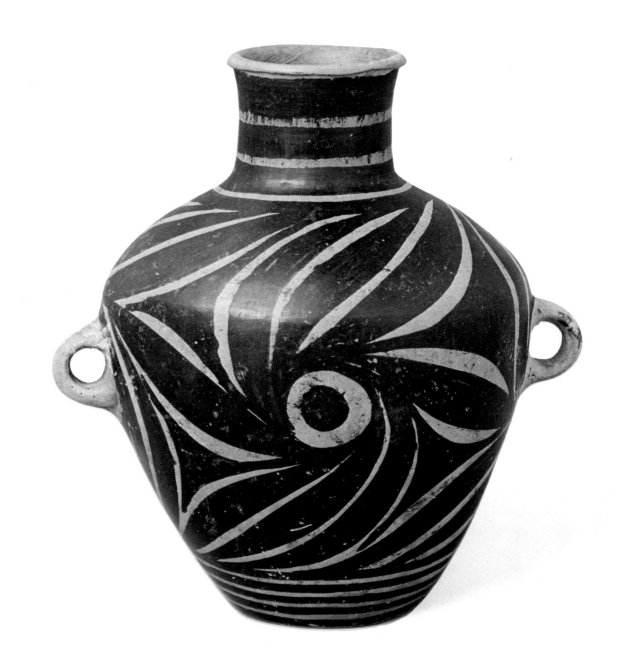

銅器時代

The Bronze Age (circa 1600 - 221 B.C.)

Introduction

The emergence of a metal-based culture in China occurred at sometime around the middle of the second millennium B.C. Although the earliest cultural deposits of Bronze Age China directly overlay those of the later stages of the Lung-shan pottery based culture – that is the final phase of the neolithic tradition – the origins of China's bronze culture are by no means clear. The mysteriously abrupt appearance of a comparatively developed bronze tradition in China happened shortly after the tribesmen of northern Europe had become acquainted with bronze under the influence of the more advanced Mediterranean countries. From this same source the tradition also spread to the East across Asia, and it has been suggested that it might thus have eventually arrived in China as a developed technology. Certainly such a thesis would account for the absence, in China, of a truly primitive bronze culture. However, the argument is contradicted by the connection, in vessel shapes, between the late neolithic Lung-shan pottery culture and the earliest known bronzes and related Bronze Age pottery vessels. It should also be remembered that China's bronze tradition, from its earliest known phase, maintained a stylistic and decorative independence betraying no associations with an alien culture.

From these relatively obscure beginnings, China embarked upon an age characterized by its bronze technology and lasting for some 1,500 years, until the founding of the Ch'in dynasty in 221 B.C. That technology found its finest expression in the production of bronze vessels in the service of ritual, and it is this tradition which both identifies and characterizes this most impressive era in the history of China, and of Chinese art in particular.

Simultaneous with the emergence of the Bronze Age in China was the re-organization of her political and social structure based on a central administration and authority. Neolithic society had no central administration and the village communities normally maintained total autonomy. A principal consequence of the establishment of such a hierarchy was the introduction of the dynastic system; that is, an hereditary succession of kings or rulers. When the independent neolithic villages and communities fell under the domination of the walled cities of the early Bronze Age rulers, they did so because they were unable to resist the superiority of a people equipped with bronze weapons, chariots and a determined organizational ability.

The complete domination of the ruling house in Bronze Age China, particularly in the earlier phases, is suggested in the wealth of ritual and material accessories attendant upon their burials. To a very large extent our knowledge of the period is based solely on archaeological evidence, and is currently limited to whatever may be derived from the vast and impressive burials of royal and aristocratic persons. It would seem that a system evolved whereby a small but overwhelmingly powerful minority wielded total control over a suppressed majority. As the Empire expanded from its heart in the central plains of the Yellow River valley in Honan province, it devised a system of maintaining effective control. This has been described as the 'city-state' plan, in which city and state were coeval, with the city as the dominant and organizing partner in the hierarchy. In this way, the ruling central authority established a bureaucracy of the elite such as one would expect in early civilized societies.

Thus the arrival of the Bronze Age in China, whether evolved or imported, wrought dramatic and apparently sudden changes to the hitherto dispersed agrarian communities of neolithic man. Suddenly and emphatically, a sophisticated and immensely powerful authority emerged and subdued the villages of the nuclear region. This authority established an elaborate system of centralized government, and similarly elaborate systems of religious activities and burial which required the services of ritualistic paraphernalia, and thus stimulated the concept of Imperial patronage, and control, of artistic endeavour.

The Shang Dynasty (circa 1600 to 1027 B.C.)

Archaeology has provided ample evidence for the existence of the Shang dynasty and, particularly in recent years, assisted in its physical definitions. It originated in the Yellow River valley of Honan province, most probably in the eastern regions of that province close to the borders with Shantung, and grew to embrace an area from the foot of the Shansi highlands in the north, central Shensi in the west, Shantung and parts of Kiangsu in the east, and included parts of Anhui in the south. Doubtless the strength and influence of the Shang had repercussions in other parts of China, particularly those bordering its undisputed territories. Archaeology has already provided some evidence that the impact of Shang culture was accepted in such areas.

Shang society was hieratic and aristocratic, and the archaeological evidence indicates conclusively that there was a convincing and emphatic gulf between the small but powerful ruling houses and the vast majority of common people. At the head of the state and his subjects stood the king who ruled by a divine right dependent upon his retaining the 'mandate of heaven'. Outlying regions and princi-

palities were probably governed by members of the Imperial household or by appointed officials, and thus the central authority at the capital attained a sense of unity and allegiance. It was almost certainly during the early years of the Shang dynasty, when China became aware of her political unity while totally ignorant of the great civilizations of the West, that the country came to be named *Chung-kuo* ('Middle Kingdom'), which remains to this day the name for China.

Although the spread of relevant cultural deposits has provided an indication of the extent of the Shang sphere of influence, it is not certain that the ruling house maintained effective control over quite so large an area. In any essentially city-state unit, particularly during its early stages of development, the precise boundaries are sure to be indistinct. At the hub of the Shang empire was the capital which, tradition has it, was moved several times during the dynasty, probably as a consequence of attempts to maintain government over a considerable and ever-increasing area. One of the earlier capitals was close by the modern city of Chengchou in Honan province, where the excavation of royal burial sites has provided abundant evidence for the artistic and cultural achievements of the bronze-smiths of ancient China. However, these burials are overshadowed by the magnificent royal tombs at the later capital, from *circa* 1400 B.C. to the end of the dynasty in 1027 B.C., at Hsiao T'un near Anyang, also in Honan province. And although the bronze ritual vessels from these great burials have come down to us as the principal material and artistic representatives of that society, they also provide much information concerning the nature and style of Shang society. When a king of the Shang people died, particularly during the later, or Anyang stages, he was buried in a vast cruciform pit approached by a sloping roadway down which the funeral cortege, including his horses and chariots, would have been driven. Recent finds of still manacled human skeletons suggest that the grim practice of human immolument, presumably practised on slaves but possibly on prisoners of war as well, was commonplace. In addition, servants, standard bearers, charioteers and animals were slain and buried with their deceased master. The curious custom of burying a dog, sometimes accompanied by a man, beneath the coffin of the dead king also became evident at the Anyang sites. In addition to the consequences of human and animal sacrifice, these Imperial tombs were furnished with a range of ritualistic and ceremonial paraphernalia, including the magnificent and familiar bronze vessels, bronze weapons and fittings, jades, stone carvings, carved bones and ivories, ceramics and probably offerings of food and wine.

Human and animal sacrifice was not apparently confined to occasions of burial. During the excavations at Hsiao T'un, within the Anyang complex, a group of building foundations was uncovered. These indicated the original structure to be of rectangular form, with a raised floor, some 30 metres in length, and the roof supported by a series of pillars which were set in concave bronze 'cushions' with stone foundations. Clearly an Imperial building, this imposing structure must

have been in some contrast to the small circular pit dwellings, based on the neolithic prototype as found at Pan-p'o, which constituted the typical housing of the common people. But perhaps more impressive than the building itself were the burials, both around the perimeter of the building and at the gateways, of victims evidently slaughtered during rites connected with the function or consecration of the building. The Shang rulers, by all accounts, were a ruthless and uncompromising people. Nevertheless, much of this seemingly needless slaughter was far from uncommon in the ancient world. Sacrifice, human or otherwise, was considered a most essential part of the ritual to appease the Gods and the Heavens. In a society so dependent upon agriculture and nature, sacrifices to, and worship of, the Sun, Clouds, Rain, Wind, Snow, Mountains and Rivers and the four directions was essential. The God of Heaven, Shang Ti, was also regularly worshipped, but probably the focus of religious activity in Shang China was the worship of ancestors. This is evidenced by the many enquiries on oracle bones concerning the possible beneficial or harmful influences of an ancestor upon his living descendants.

Towards the end of the 19th century, a large number of bones and tortoiseshells, with archaic inscriptions scratched into them, began to appear in the curio shops of Peking. Most of these, it appears, came from the village of Hsiao T'un, site of the impressive royal Shang burials outside Anyang, which had long been known as Yin Hsü – the Waste of Yin (the Shang dynasty was in its later years also known as the Yin). Subsequent excavations have produced further quantities of such oracle bones, which attracted the attention of scholars and historians since it appeared that the inscriptions mentioned names of the Shang kings. Some indeed do, but generally the inscriptions relate to the art of divination in which questions put to the ancestral spirits were incised into the bone. The bone was then scorched and the answer interpreted from the cracks produced (*plate 36*). Occasionally the answers deduced were subsequently inscribed in the same bone. The range of enquiries made on these oracle bones provides an indication as to the kind of matters which were of concern to the hierarchy. Matters relating to ancestors predominate, but strongly evident were enquiries as to the suitability of appointed days for offerings and sacrifices, and questions relating to natural phenomena such as crops and the harvest, the well-being of the Imperial family, and of course requests for advice as to the most propitious time for military expeditions.

Enquiries concerning military operations appear to dominate on bones which are attributed to the early Shang. The object of the question generally takes the form of two characters, the first a proper name and the second the character *fang*, meaning region or direction. Among the proper names a number recur and it may, therefore, be assumed that these were the more constant adversaries of the Shang people. It would also seem that the majority of these adversaries occupied regions to the north and north-west of the traditional Shang homelands, that is, those areas now designated as the modern provinces of Shansi and northern

Shensi. This tends to suggest that the Shang attempted to expand in these directions, a fact generally supported by the evidence of recent archaeological work.

The oracle bones regrettably provide little or no information concerning the material and spiritual lives of the peasant communities which constituted the vast majority of the population of Shang China. Imperial sacrifices, ritual pomp and the planning of military adventures were of no concern to them. It is clear that until the advent of iron some centuries later, probably in the 8th or 7th centuries B.C., metals simply were not available to them and they were obliged to rely on stone implements to till and hoe the ground, and use coarse pottery wares for domestic use; bronze was the preserve of the ruling hierarchy. Archaeology and the meagre literary records tend to preserve only the evidence of the rulers, and however unsatisfactory, or unjust even, that this may seem, it is inevitably the circumstances of the Kings and Imperial households which are the hallmarks of ancient societies and cultures, simply because they were the focus of activity and achievement.

The art of Shang China that has been preserved for later generations as buried treasure reflects only these aspects of Shang society: the extravagant ritual and ceremony which constantly attended kings and rulers (*plates 37, 38, 39, 40*) – magnificent bronze vessels of exotic form ornamented with the highly imaginative *t'ao-t'ieh* monster masks against exquisite *lei-wen* spiral pattern backgrounds, the jade tokens and symbolic burial accoutrements finely carved with similarly inspired decor, richly ornamented bronze ritual weapons and harness and bridle fittings, carved marble sections (*plate 41*) (presumably architectural fittings) and the rare white, pure kaolin, pottery vessels imitating their bronze counterparts. All echo the wealth and confidence of superiority and contrast with the humble material culture of the common people.

If one were to characterize Shang art in a single word, that word would be hieratic. For throughout the seemingly endless permutations of design and decorative motifs there is a determined formalism and in fact a limited range of ornamental – or symbolic – devices. These artistic characteristics mirror the concept of strict conventionalization which determined and governed the pattern of life and ceremony, however rich and extravagant it may now appear, of the rulers of Shang dynasty China.

Western Chou Dynasty (1027–771 B.C.)
Period of the Spring and Autumn Annals (770–475 B.C.)
Whereas the origins of the Shang dynasty still remain shrouded in mystery, the emergence of their Chou conquerors as the dominant peoples in Bronze Age China is better recorded in both archaeological and literary terms. The overthrow of the Shang was seen by the Confucian historians of the subsequent Warring States period as the most signal event in the history of China: a revolutionary upheaval.

Of course the displacement of one ruling house by another is always an upheaval of monumental proportions and, as viewed by the ancient historians, it must have appeared convincingly revolutionary. Today's historians, with a more profound and objective view of the transfer of power from the Shang to the Chou, see the events as somewhat less dramatic. But that should not impair recognition of the fact that certain fundamental changes in governmental structure, and subsequently of the social order itself, occurred; and these developments inevitably tended to influence the course of artistic style.

Shang oracle bones record that there was considerable military activity in the northern and western regions of their territory – that is, in modern Shansi and northern and western Shensi provinces – areas traditionally thought to be Chou domain. It is, therefore, entirely plausible that there was a limited overlap, or at least significant contact, between the Shang and the Chou before the conquest in 1027 B.C. Once again, archaeology has provided valuable evidence for the elucidation of historical fact. The bronze vessel tradition, so finely and maturely established by the Shang, continued to be the artistic hallmark of the Chou. However, there were undeniable stylistic distinctions which suggested that it was not, as had long been held, a question of the Chou conquering their neighbours and merely adopting their cultural and artistic heritage. Instead it now appears that an already established culture had taken over an associated, and in this case a perhaps artistically superior, contemporary and amalgamated the two traditions. The credibility of this theory has now been largely substantiated by recent archaeology in China. Most important are the bronze vessels which were excavated during the years 1960–3 at Fu-feng in western Shensi province, an area within the confines of traditional Chou territory (*plate 42*). These bronzes, therefore, help to support the claim that the Chou people maintained a bronze culture of related, but quite possibly inferior, form to that of the Shang. The bronzes from Fu-feng, although clearly belonging to the broad traditions of the early Chinese Bronze Age, nevertheless display an aggressive independence in their distinctive forms and exotic, often eccentric, decoration which is in some contrast to the quiet dignity of their Shang counterparts. The evidence of a pre-dynastic Chou bronze tradition is further substantiated by reference to a magnificent set of vessels reputedly excavated in 1901 at Pao-chi-hsien, some 30 miles to the west of Fu-feng (*plate 43*). These bronzes, now in the Metropolitan Museum of Art, New York, display similar tendencies towards extravagant ornamentation which characterizes the Fu-feng examples, and yet both groups of vessels betray a dependence upon the mainstream of Bronze Age art in their fundamental approach to form and decoration.

The archaeological evidence and the comparatively abrupt manner in which the Chou people appear to have superimposed their own artistic standards and notions upon the art of the Shang after the conquest strongly suggest, therefore, that an associated tradition coexisted with the Shang, but outside their territory. It has already been

noted that the oracle bones have provided some scant literary evidence of military conflict in the regions bordering Shang and Chou domains. Some inscriptions suggest that the Chou, in their original western Shensi homeland, accepted the suzerainty of their more illustrious neighbours, but it must have been an unsettled alliance – if indeed it ever existed. Towards the end of the Shang period, the late 12th and 11th centuries B.C., the Chou were evidently of sufficient power to pose a serious threat to the rulers of central China. That they were eventually capable of achieving such a victory, thereby gaining control of the vitally important 'nuclear' region of the Yellow River basin, is testimony to the supposition that the Chou were a powerful, well organized and materially substantial people who possessed bronze weapons and a military organization of some force. These factors tend to support the theory that the Chou people, even in Shang times, maintained a recognizable bronze-oriented culture. It is, however, probable that they had not developed quite the same sense of political unity as that shown by the centralized Shang state. The Chou were in all probability of disparate lineage; a loose affiliation of tribes, some of whom had Turkish and Tibetan origins, and the concept of autocratic centralization was thus unfamiliar to them. Certainly they imposed a new system of government in China when they came to power.

It was the Chou king, Wu Wang, who led the forces to the final conquest, and one of his immediate concerns was to establish control of his newly acquired lands. This he did by the simple expedient of setting members and relatives of the royal Chou household over the old Shang states: Sung and Wei (Honan), Yen (Hopei), Ch'i (Shansi) and Lu (Shantung). He thereby established feudal principles in the government of China. This was the Chou's greatest and most significant contribution since it set the pattern of governmental and social structure for the remainder of the Bronze Age.

The partitioning of the Empire into fiefs, which generally comprised a walled city and the surrounding countryside, caused the eventual downfall of the Chou; for although the kings and rulers of feudal possessions were obliged to supply troops, tribute and maintenance to the central authority, their inevitable tendency was to become increasingly independent. As the number of fiefs increased, so the kings were obliged to select their overlords from the periphery of the Imperial family, and the concept of allegiance was gradually eroded. In addition, the location of the Chou capital in their old homelands, south-western Shensi, perpetuated the disadvantage of physical separation of the seat of power from its most important territorial possessions, although a secondary capital was established in Honan province in order to maintain some kind of effective Imperial presence in the vital Central Plains region. The growing independence and autonomy of the feudal states led to an imbalance in the numbers and sizes of the vassal states. As one became weakened and fragmented, so a stronger neighbour swallowed it up. By the 8th century B.C., there was evidence of political aggregation into fewer and more powerful units.

At that time the number of such states within the Chou empire is estimated to have been 150 to 170. Clearly it was impossible for the Chou king to maintain strict control over, and thus maintain the allegiance of, so many and such widespread fiefs.

Effective centralized Chou power was more or less totally subdued by the end of the 8th century B.C. Apart from the difficulties of maintaining suzerainty over the feudal states, the Chou rulers had another primary concern: to keep constant surveillance on her western and northern borders lest the ever-present threat of invasion by 'barbarians' be fulfilled. In the end it was a combination of the two which defeated King Yu in 771 B.C. The 'barbarians' in alliance with a small number of rebel vassal states destroyed the Chou capital at Hao in Shensi. But the Chou line, nominally at least, maintained its position and the seat of government was removed to the hitherto 'secondary' capital near Loyang in Honan province. The first period of the Chou dynasty, that is from 1027–771 B.C., is known as the Western Chou because of the westerly (Shensi) location of its capital. With its removal to the east the dynasty thereafter became known as the Eastern Chou. In fact the Chou maintained its lineage until 256 B.C., but the Eastern Chou may more favourably be considered when sub-divided into the 'Spring and Autumn Annals' (771–475 B.C.) and the Warring States (475–221 B.C.) periods.

The appellation 'Spring and Autumn Annals' (Ch'un Ch'iu) stems from an historical work of that name which was the first accurate chronological history of China. It is a somewhat terse and entirely factual account of events in the state of Lu from 722 to 481 B.C. Since Lu was the home state of Confucius, the authorship has traditionally been ascribed to him, but there is no convincing evidence for this and it is now considered most unlikely. Chou feudalism was in essence maintained throughout the Ch'un Ch'iu period. The principal vassal states numbered just fifteen, with a large number of minor fiefs holding subsidiary or otherwise unclaimed territories. The traditional concept of Chung-kuo (Middle Kingdom, i.e. China) and the peripheral barbarians was constantly observed at that time, and even those fifteen principal states were divided between those which were recognized as truly Chinese, principally occupying the Central Plains, and those peripheral ones which were regarded as suspiciously 'barbarian'. The Chou kings maintained their capital near present-day Loyang in Honan, and the vassal states paid little more than lip-service to their supposed master. The autonomy of the principal feudal states was never seriously challenged.

Thus the usurpation of Imperial prerogative by the feudal kings and rulers became commonplace, and heralded a pattern of one state attaining the hegemony which was to become familiar to later Bronze Age China. As the principal contenders for absolute power vied with one another, so the hegemony passed from state to state. As the rivalry intensified, so the smaller fiefs were literally gobbled up by their avaricious and more powerful contemporaries. The pace of gradual

decline into total disorder quickened as the structure and constitution of the so-called feudal empire collapsed. The traditional end of the *Ch'un Ch'iu* period, in 475 B.C., heralded a period of perpetual strife and internecine warfare lasting some 250 years and aptly described as the Warring States period.

It has been noted that there were certain fundamental similarities between the Shang and pre-dynastic Chou cultures, especially as expressed in the bronze tradition. In principle, this broad cultural association continued into the Chou period, especially in the early Western Chou years when the influence of the Shang tradition was still to be strongly felt, and thus a certain continuity in style and tradition may be detected. The early Chou royal burials, for example, followed the same grandiose plan as those at Anyang. The ritual bronze vessels, although stylistically and to a certain extent iconographically distinctive, are clearly of the same broad tradition and an integral part of China's independent bronze culture. The ritual accoutrements such as jades, ceramics, fittings and weapons also display characteristics which betray an affiliation with the earlier Shang traditions.

Adopting the bronze vessel tradition as the artistic hallmark, however, is a useful and pertinent method of detecting and illustrating the changes and innovations which occurred when the cultures amalgamated. Firstly, the proximity of the Chou in their original homelands to the 'barbarian' lands of Mongolia and Central Asia, inhabited by tribes of disparate ethnic and cultural backgrounds is pertinent. The Chou peoples' constant contact with such alien cultures occasioned a less hieratic and more aggressively naturalistic approach to artistic style. This condition surely stemmed from such contacts, and thus their awareness of the material cultures of the wandering tribespeople of these regions. To such peoples, the animal and natural conditions were the primary inspirations for any kind of artistic endeavour, and not the demands of ritual and ceremony. The monster masks, *t'ao-t'ieh*, that fundamental element of decor on Chinese bronzes are, in the Chou style, more akin to real monster faces than the formalized and abstracted masks of the Shang. Certain vessel types, the *ku*, *chüeh* and *chia*, for example, were evidently not properly familiar to the Chou and soon after the conquest disappear from the repertoire altogether.

Secondly, the dissemination of central authority and the ensuing independence of the feudal states occasioned a comparable disintegration of the common artistic style that was characteristic of the Shang. As the Chou kingdom expanded so the use of bronze for ritual vessels and for weapons extended to areas that had hitherto been unfamiliar with the tradition. The incidence of 'provincial' styles is far greater, due to this and the independence of the feudal states, than was ever the case during the Shang.

The elaborate and complex religious and ritualistic obligations of the Shang were also adopted, but subsequently simplified by the more prosaic Chou people. Many of the great sacrificial ceremonies were discontinued, but the focus of religious activity remained on ancestor worship, and the two axes of the Universe, Earth in the person of Shang Ti, and Heaven.

The practice of divination as attested by the oracle bones appears to have ceased soon after the Chou conquest. To some extent this valuable source of literary evidence was supplemented by a custom that had appeared in embryonic form in the Shang, that of casting bronze vessels with lengthy inscriptions recording honours awarded in respect of some achievement, frequently in the sphere of military activities but not necessarily so. Such inscriptions can shed much interesting light upon historical facts concerning early Chou social, governmental and ceremonial practices, as well as mentioning names of feudal states and their leading figures. All of which greatly assists in the definition of Chou territory and its feudal holdings. A bronze *hu* from Fu-feng, for example, records in a relatively brief inscription that the vessel was made on behalf of a certain Chi Fu in pious commemoration of his having received certain gifts, among them slaves. The final acknowledgment in the inscription, "may his descendants treasure this vessel in use for a myriad years", is in typical dedicatory format. A somewhat larger inscription on the famous 'Hsing Hou' *kuei* in the British Museum records a gift of land together with inhabitants to a certain Marquis Hsing 'for his services' (*plate 44*).

After 771 B.C., such inscriptions no longer mentioned the Chou king and reflect the ever-increasing independence of the feudal states and the concurrent impotence of the Imperial household. Vessels bearing inscriptions naming feudal rulers are characteristic of the *Ch'un Ch'iu* period and may be considered as further testimony to their autonomy. It is this gradual disintegration of centralized authority and the emergence of powerful independent states that is the historical characteristic of the later Western Chou and *Ch'un Ch'iu* periods of China's Bronze Age. Archaeology has provided the evidence, in the form of a developing pattern of regional artistic styles, of the close relationship between political developments and the general direction of artistic endeavour. This was particularly true when the ruling house, or houses, determined the artistic hallmark of the period – in this case the bronze vessel tradition.

The Warring States

By the 5th century B.C. China had descended into the 'dark ages' of the Warring States, and lost all semblance of an organized confederacy of feudal states acknowledging suzerainty to an absolute Imperial authority. Paradoxically, these centuries of carefree violence and constant strife precipitated a tremendous impetus in the spheres of philosophy and art. Whilst the armies of the feudal warlords enjoined in bloody battle, heroes were made but thousands slain. Here, indeed, was the stuff from which legends are, and were, made.

Politically, the real power coalesced into the hands of two principal contenders, Ch'in in the north and Ch'u in the south. At the beginning of the 5th century the Ch'u had by far the largest territorial holdings of

all her contemporaries, with control over most of central and southern China between the Huai and Yangtze Rivers. The state of Ch'in, whose subsequent progress in the annals of Chinese history is of more than just passing interest and importance, originated in the Wei River valley of Shensi province, and remained confined to that region until the beginning of the 3rd century B.C., when first she toppled the mighty Chin state which had occupied most of Shansi and parts of Honan and Hopei. That success was but a preface to her subsequent achievements as the remaining northern states lost their defensive capacities and fell to the Ch'in.

The rapid expansion of this comparatively small state from its semi-concealed homelands in the west may, at first glance, appear odd and illogical. How could such a relatively insignificant state, very much on the periphery of the then Chinese cultural sphere, emerge from obscurity to rule firstly north, and, subsequently, the whole of the Middle Kingdom? It is tempting to ascribe great perception to the early Ch'in leaders for playing a 'waiting game' – of some two or more centuries! – while the remaining feudal states indulged in the irredeemable process of self-destruction, but such considered planning was certainly neither relevant nor likely. Nevertheless, the contentions of the major states in the north undoubtedly drained their resources and considerably weakened their military stature whilst Ch'in, until the 3rd century B.C., lurked menacingly in the far west largely unaffected by, and uninvolved in, the upheavals.

The political and social convulsions of the Warring States period were directly responsible for major developments in three broad areas of cultural interest. Firstly, it stimulated great debate, philosophical consideration and social and political re-assessment. As the structure of feudal society collapsed so the institutional notions and conventions which supported it were challenged, and such fundamental debate stirred men's imaginations to great achievements in thought and philosophy. Secondly, the Chinese cultural sphere of influence was greatly expanded, particularly in the south, as large sections of the population fled southwards, taking with them the cultural and artistic heritage of the cradle of Chinese civilization, the Yellow River basin. And thirdly, fresh artistic ideals, based on animal motifs, began to appear in the artistic and decorative repertoire. These were clearly inspired by the art of the nomadic peoples of the northern and western steppe and desert lands who made constant incursions into north China, thereby taking further advantage of the opportunities afforded by the discord and disruption in north China (*plate 45*).

The philosophic debate of the period became so diverse and widespread that the proliferation of teachings has been immortalized as the 'Hundred Schools'. Paramount among these was the familiar figure of Confucius, who formulated an ethical code that was to dominate in Chinese society for some 2,000 years. The Confucian code was constructed around the 'virtues' which, it was said, the *Chün-tzu* (literally 'ruler's son', but a term more generally applied to men of nobility)

should possess. From this basis, he formulated a rigid social hierarchy in which the educated ruling elite, well versed in the *Classics*, played a vital governing role, subject always to the absolute authority of the Emperor, the 'Son of Heaven'.

The emphatic gulf between the peasantry and the ruling classes, that had been characteristic of the very earliest phases of the Bronze Age, was very much a part of Confucian theory. This theory called for a rigid adherence to the social code in which ritual and ceremony, services in which all persons and artifacts have a set position or place, played an essential role. Confucius regarded the proper maintenance of ritual, as a popular reflection of the hierarchy, to be imperative.

Although Confucius was reputedly born of minor aristocratic parents, the ravages of warfare rapidly reduced them to poverty. In spite of his extraordinary reputation and influence, his life was apparently commonplace and undramatic. His teachings captured public attention as an expression of the desire for unity and order, qualities that were particularly absent in Chinese society at that time, and in doing so stimulated a movement towards a common purpose. After his death, his followers developed, expanded and continued to teach his work; of these the most important and influential figure was Mencius (*circa* 373–289 B.C.), who, if anything, democratized the Confucian ethic in his acknowledgment that all men were fundamentally good, thus withdrawing that basic distinction between peasant and aristocrat which had become so instituted into Chinese social life. Goodness was one of the basic prerequisites for entry to the *Chün-tzu* class and, Confucius considered, a prerogative of the nobility.

The second principal contender for honour in the great philosophical debate was the Legalist School. As their name implies, they believed that only rigid, authoritarian and uncompromising government could create the required order out of the chaos of the Warring States period. Indeed, it has been said that the Legalists' ideal state was one in which "an uneducated citizenry would blindly follow and obey an all-powerful hierarchy". The Legalists were very much a product of their time in their insistence that anarchic conditions could only be repaired by stringent law. The feudal system of dispersed political power was unacceptable to them, as they strongly advocated the absolute authority of a centralized government. They were both practical and realistic, spared no effort to promote intensive agriculture as the foundation industry of China, and cared little for the affairs and niceties of the scholar-official class and its devotion to Confucian ritual.

Next to Confucianism, Taoism has been the most important, enduring and influential of native Chinese doctrines. This 'nature-mystic' semi-religion also emerged from the philosophical debates of the Warring States. Many other schools of thought, social doctrines, systems of government and religious observances were propagated at the time, but it is significant, and a pertinent reflection of the profound anarchy which existed, that it was the realistic but strong-arm Legalist School which finally emerged triumphant. The Ch'in dynasty, which

reunified China in 221 B.C., adopted this authoritarian code as its basic creed.

The expansion of the Chinese cultural sphere at this time had a far-ranging, and rewarding, impact upon her art. It was noted that the comparative independence of the feudal states in early Chou times prompted a certain stylistic diversity in the bronze tradition. This process became even more emphatic in the later Chou, and is inextricably involved with the adoption of new styles, motifs and ideas indigenous to the peripheral regions. The expansion of the Chin state to the far north, and Ch'in in the west, brought them into contact with the people of the Ordos steppe lands whose art was basically inspired by the source of their livelihood, the animal (*plate 45*). Birds, deer, and even horses and tigers (*plate 46*) appear in the decorative schema which took on a new lease of life under the spell of naturalistic inspiration and representation. Even the mythical *t'ao-t'ieh* mask emerges from its abstraction to adopt a new animal naturalism. The same aspirations to naturalistic representation may be seen in the powerfully realistic bird's head on the *hu* ewer (*plate 47*). But it is important to note that whatever influence may be accepted, or given, the interpretation of these styles in the bronze tradition is totally harmonious with the enduring and continuing art of later Bronze Age China.

Concurrent with, but not necessarily a result of, the increasingly important bronze tradition in Ch'u territory south of the Huai river, was the evolvement of a banded or geometric ornamental style. The dragons were reduced to continuous stylized bands which virtually denied their origins (*plate 48*). The impetus of new gold and silver inlay techniques which were particularly well suited for geometric designs further stimulated the creation of complex interlacing patterns. This style flourished in the south but with the continual flow of peoples and artistic styles it soon became characteristic of the whole bronze tradition. The magnificent gold inlaid bovine head, reputedly excavated from Chin-ts'un in Honan province in the north, is testimony to the style's widespread acceptance (*plate 49*).

The extremely beautiful, but admittedly decorative, style of ornamentation on inlaid bronzes of the later Warring States period signals the end of the bronze tradition as the artistic hallmark of China. The demise of the tradition has often been attributed to the contending states' increasing demands on the metal for weapons. Henceforth, the practice of making pottery facsimiles, with bronze-style decoration subsequently painted on, became widely accepted and continued in the succeeding Ch'in and Han dynasties (*plate 50*). In the Shang and early Chou vessels decor was an integral part of the form. By contrast, the essentially surface-oriented ornamentation of the later inlaid bronzes developed in conjunction with their painted pottery counterparts.

These radical changes in artistic direction reflect the profound developments in Chinese social and political ideology which occurred during this extraordinarily rich period of cultural, and military, activity.

Bibliographical references

Academia Sinica: Institute of History and Philology, *An-yang fa-chüeh pao-kao* (Report on the excavations at Anyang), Peking 1929–33.

Ch'en Meng-chia, *Yin-hsü pu-ts'un tsung-shu* (Comprehensive account of oracle texts from Yin-hsü – the 'waste of Yin' at Hsiao-t'un, Anyang), Peking 1956. It was the scholar, Lo chen-yü (see *Study of the scripts of Shang oracle inscriptions*, Peking 1910), who first traced the bones to the vicinity of Hsiao-t'un. He was also among the first to decipher the inscriptions and work on the subject was subsequently done by him and Tsung Tso-pin.

Cheng Te-k'un, *Archaeology in China, Vol. III, Shang China*, Cambridge 1960.
Archaeology in China, Vol. IV, Chou China, Cambridge 1963.

Loehr, Max, *Ritual Vessels of Bronze Age China*, New York 1968. For a clear and concise account of the development of decorative style in Chinese bronze vessels.
Chinese Bronze Age Weapons, Michigan 1956. The most comprehensive account of this important aspect of early Chinese bronze age art and technology.

Washington, Freer Gallery of Art, *The Freer Chinese Bronzes*, 2 vols., by Pope, Gettens, Cahill and Barnard, Washington 1967–9. A thorough investigation into a fine and representative collection of Chinese bronzes; vol. II is devoted to technical studies and analysis.

Watson, William, *Ancient Chinese Bronzes*, London 1962. The best general book on the subject of vessels, mirrors and inscriptions.

Wheatley, P., *The Pivot of the Four Quarters*, Edinburgh 1971. A comprehensive discussion on the nature and structure of the ancient Chinese city and its role in government during the Shang dynasty.

Yetts, W. P., *Anyang: A Retrospect*, The China Society, London 1942. A summary of the history of the Anyang sites.

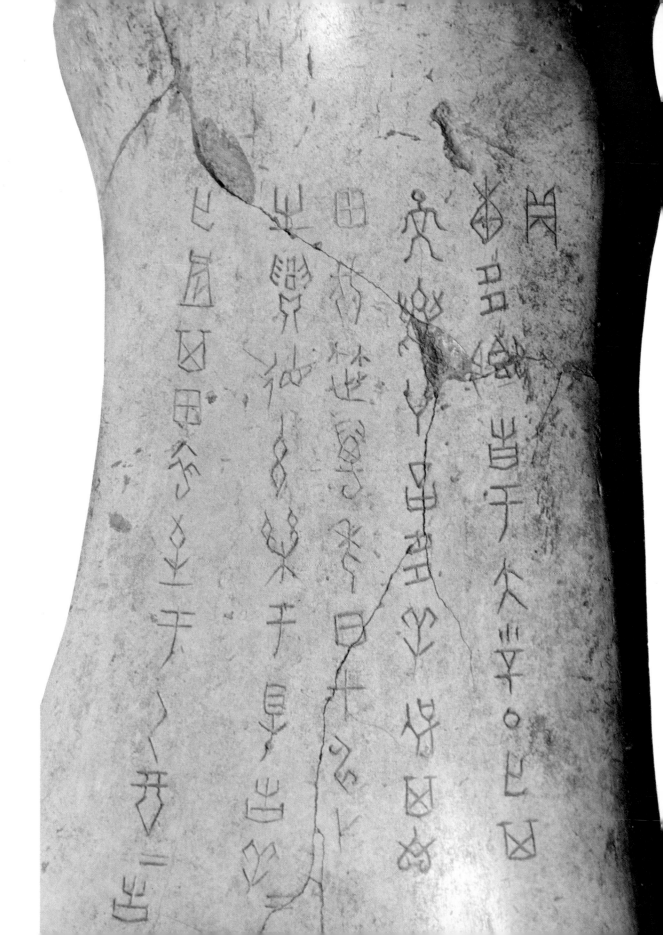

36
Inscribed oracle bone, probably the
scapula of an ox.
Shang dynasty
Musée Cernuschi, Paris

39
Bronze ritual wine vessel, tsun. *Excavated in
1957 at Fu-nan in Anhui province, and
illustrating a slightly variant style of a
peripheral Shang region.*
(*London etc. exhibition, cat. no. 80;
Australia exhibition, cat. no. 57*)
Shang dynasty: circa 12th century B.C.
Height: 47 cms
China

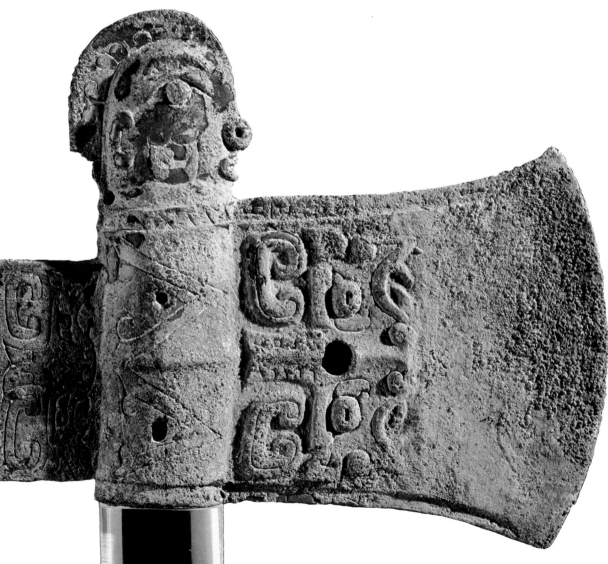

40
Ceremonial bronze axe-head
surmounted by a human face.
Shang dynasty : circa 12th century B.C.
Length : 16.5 cms
Victoria & Albert Museum

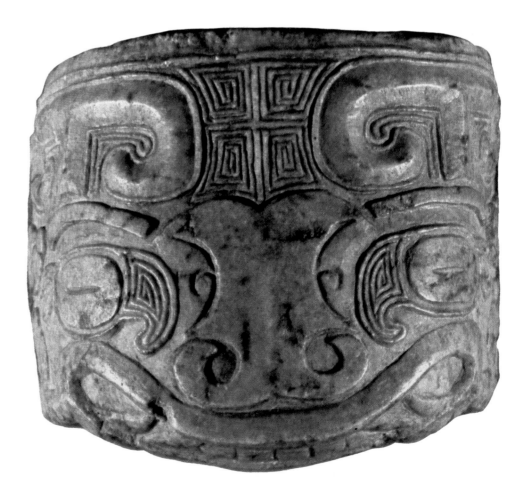

41
Marble architectural fitting, carved with a
t'ao-t'ieh *mask on a squared spiral ground.*
Shang dynasty: 13th–12th centuries B.C.
Width: 11.5 cms, height: 9.5 cms
Private collection, London

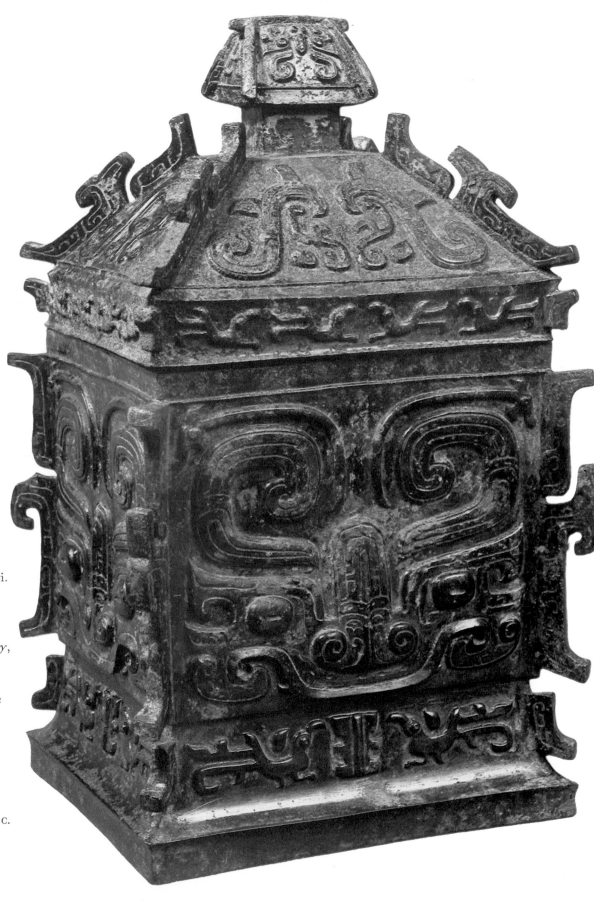

42

Rectangular bronze ritual vessel, fang-yi.
Excavated in 1963 at Fu-feng in Shensi
province, in traditional Chou territory.
An inscription inside the vessel reads:
'*for the august deceased Father Sixth Day,*
a precious ritual vessel to be placed in the
ancestral temple, to be treasured in
prominent use for a myriad years and in
perpetuity by sons and grandsons'.
The '*Sixth Day*' *refers to the offering*
day of the ancestor to whom the vessel
was dedicated.
(*London etc. exhibition, cat. no. 93;*
Australia exhibition, cat. no. 67).
Western Chou dynasty: 10th century B.C.
Height: 38.5 cms
China

43

An elaborate set of ritual vessels and altar table,
reputedly from Pao-chi hsien in Shensi province,
close to the old Chou capital. Shortly after its
excavation in 1901 *the set came into the*
possession of the noted collector, Viceroy
Tuan Fang.

Only the two handled yu *buckets, the* tsun *in the*
centre, the trumpet-shaped ku *and the* chih
vessel, share the same inscription. Differences in
style reinforce the suggestion that it is an
accumulated set rather than an homogenous one.
Late Shang dynasty, or Western Chou:
11th century B.C.
The altar table: length 91 cms, height 18.2 cms
Metropolitan Museum of Art, New York

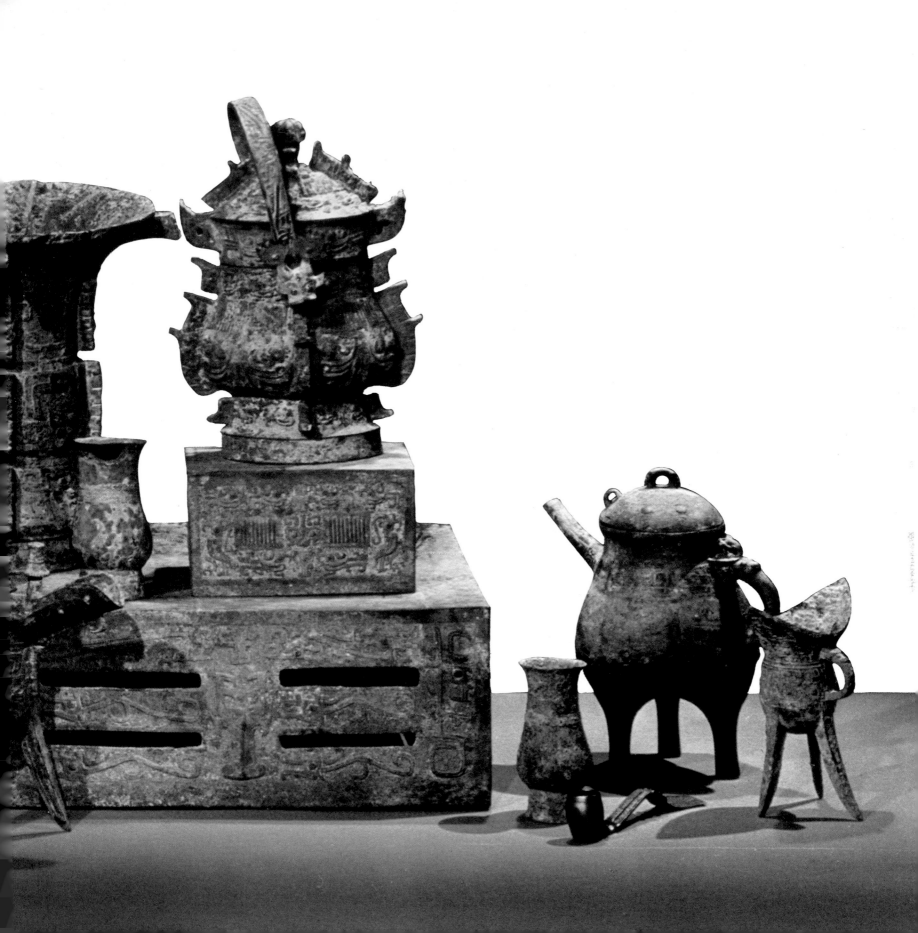

44

Bronze ritual vessel, kuei, *fitted with four*
instead of the more usual two handles.
In the bowl of the vessel is a long inscription
(see fig.) which records the award to a certain
Marquis of Hsing: 'In the third month the King
issued his command to Jung and the Inner
Minister, namely We bestow on the Marquis of
Hsing, for his services, subjects of three classes,
the men of Chou, the men of Chung, the men of
Yung. (The Marquis) saluted and bowed his
head to the ground, praising the Son of Heaven'.
The inscription continues with the Marquis's
reply: '... Ti will never withdraw the rule from
the house of Chou. Mindful of my ancestors,
I shall not be found wanting,' and ends,
'a record was made of the King's command and a
ritual vessel was made for the Duke of Chou.'
Early Western Chou dynasty: late 11th or early 10th century B.C.
Height: 19.2 cms
British Museum

維三月王命榮內史
曰蒼邢侯服賜臣三
品州人重人郭人臺
稽首魯天子廟厥瀕
福克奔走
于有周追考對不敢
墜昭朕福盟朕臣天子
用册上王命作周公彝

45
Bronze finial in the form of a stag; from the
Ordos regions.
4th to 3rd centuries B.C.
Height: 9.0 cms
Victoria & Albert Museum

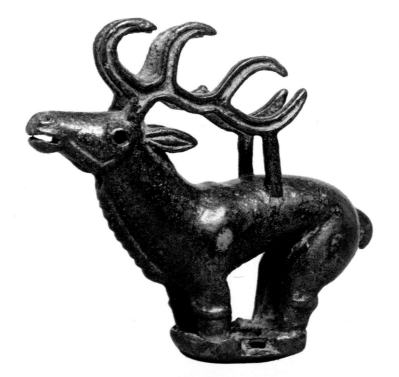

46

Bronze mount, or foot of a vessel, in the form of a
tiger, heralding the new realism of the late
Chou period.
Warring States period : 5th to 3rd centuries B.C.
Length : 16.5 cms
Ex-collection of Frederick M. Mayer (dec'd)

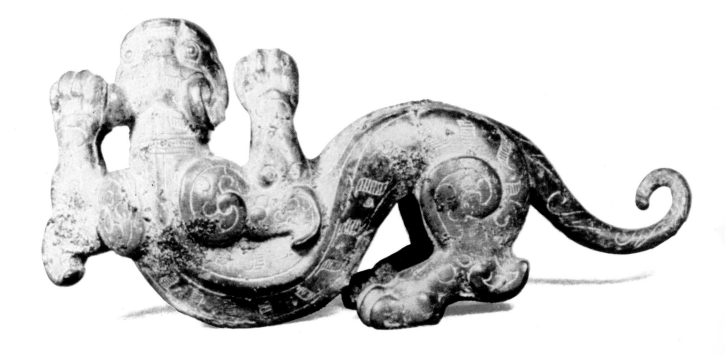

47
Bronze vessel, hu, with the lid in the form of an
impressively modelled bird of prey.
Another vessel of this type was excavated in 1970
at Chu-ch'eng in Shantung province and included
in the exhibition of Chinese Archaeological
Treasures.
(London etc. exhibition, cat. no. 124;
Australia exhibition, cat. no. 96).
Warring States period: 5th to 4th centuries B.C.
Height: 47.5 cms
Private collection, London

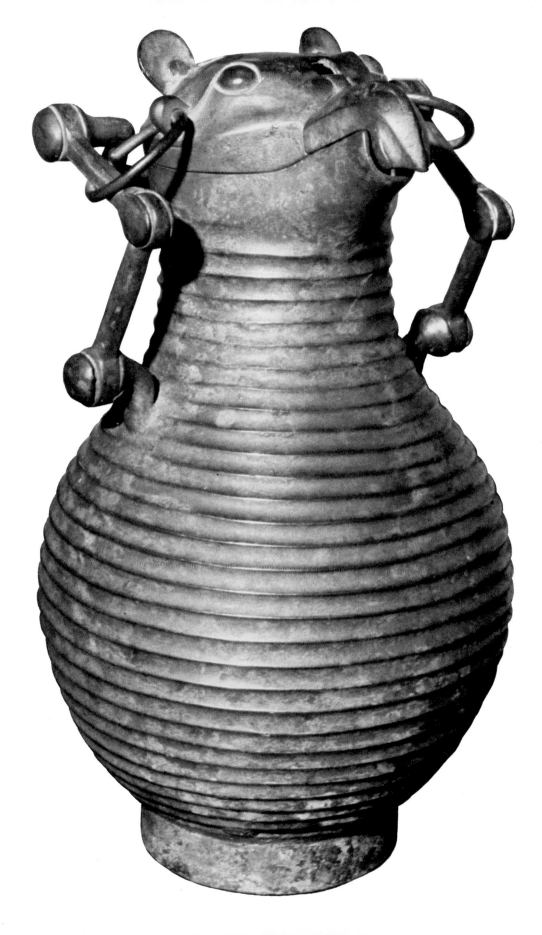

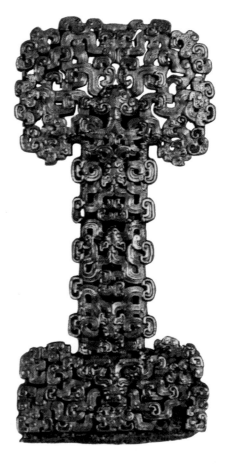

48
Openwork gold dagger handle of exceptional
workmanship, composed of interlaced dragons.
The complexity of the casting implies that it was
made by the 'cire-perdu', or lost wax, process.
Eastern Chou period : circa 5th century B.C.
Length : 11.2 cms
British Museum

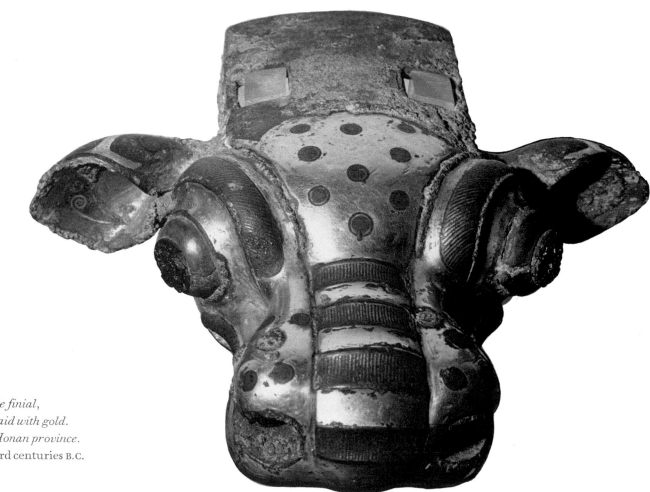

49
Chariot fitting, probably an axle finial,
in the form of a bovine head, inlaid with gold.
Reputedly from Chin-ts'un in Honan province.
Warring States period : 4th to 3rd centuries B.C.
Length : 16.5 cms
British Museum

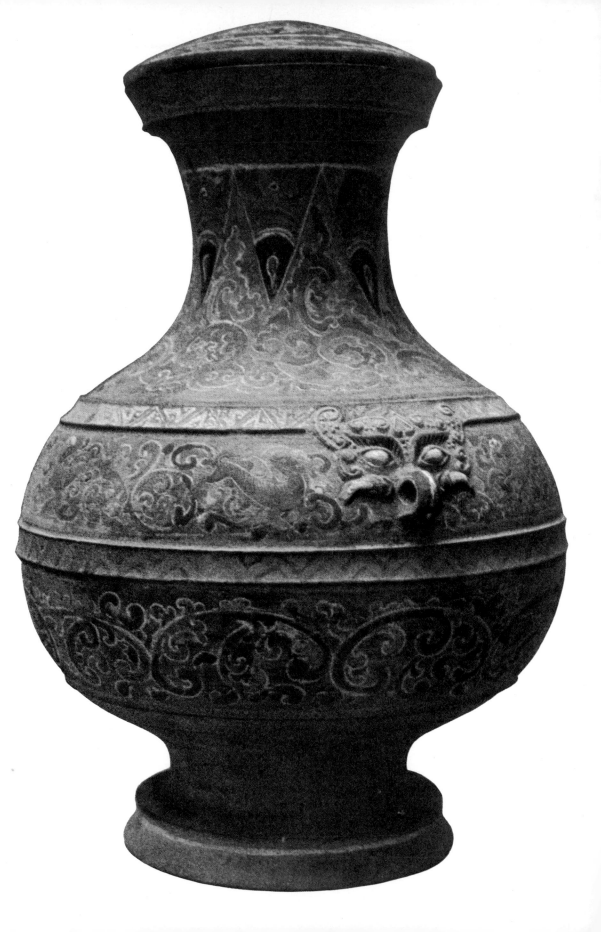

50
Pottery vessel based on the bronze hu *form,*
the painted decoration also derived from
earlier bronze counterparts.
Early Han dynasty : 2nd century B.C.
Height : 48 cms
British Museum

秦代

Ch'in Dynasty (221 - 206 B.C.)

The success of authoritarian Legalist principles, which underlie the establishment of the unifying Ch'in dynasty, is an acknowledgment that only supreme intransigence could overcome the anarchic conditions which had characterized China during the Warring States period. The overwhelming desire of the Chinese people at that time must surely have been for peace and stability, which only the combination of sheer physical strength and the purpose of an uncompromising ideology could achieve. The Confucian ingredients for the proper maintenance of government and society in ancient China, gentle debate, lordly suppression and observance of ritual, were subjugated to the practical requirements of a nation recovering from centuries of internal conflict.

The aggressively practical nature of Ch'in Legalist philosophy manifested itself in many, often peculiar, ways: among them the unification of weights and measures, the standardization of the axle length on wagons, and the infamous literary inquisition known as the 'Burning of the Books'.

Practical measures such as these reflect the concept of centralization or standardization, a basic tenet in the Legalist philosophy. When the King of Ch'in achieved final victory and established himself as 'Shih Huang-ti' (literally 'First Emperor'), he above all appreciated the need for invoking Legalist principles. But he faced the same problems that had confronted earlier rulers of China: vast distances, poor communications, difficult terrain, a demoralized population and the reactionary forces of vestigial feudal power and associated interests among the surviving aristocratic families.

In order to overcome these obstacles Shih Huang-ti adopted and developed the ideas of Shang Yang, a leading Ch'in statesman of the 4th century who was a principal exponent of Legalist ideology. It was Shang Yang who reformed the Ch'in system of government, introduced Legalist principles and brought their then territorial holdings, principally in Shensi province, under the direct control of central government. In addition, he is said to have instituted a strict system of reward and punishment, stimulated the concept of collective responsibility and organized labour into essential and productive work.

Interestingly, Shang Yang is an historical figure much admired in modern China because of his revolutionary social and political reforms (*plate 51*). The administrative reforms initiated by Shang Yang involved the division of the whole original Ch'in state into thirty-one prefectures, each of which was governed by an appointed officer of the central administration. In this way, allegiance to that authority and to the King was maintained whilst power and continuity were denied to feudal or hereditary holdings.

Shih Huang-ti accepted in principle the structure advocated and employed by his predecessor, but still his overwhelming problem was one of scale. The Ch'in state of Shang Yang's time bore scant resemblance in size to the vast Ch'in empire of the early 3rd century B.C. which stretched from the Great Wall in the north to Canton in the south, and from the eastern seaboard to Kansu and Szechwan provinces

in the west. Nevertheless, Shih Huang-ti adhered broadly to those traditional Legalist principles by dividing China into thirty-six (later increased to forty-two) commanderies, over each of which was placed a civil governor (*shou*) and a military governor (*chün-wei*). These substantial territories were then sub-divided into prefectures, again governed by an appointed official.

Ch'in Shih Huang-ti's principal motive in instituting such a rigid system, with appointed officials rather than hereditary aristocrats as rulers, was to extinguish the feudal hierarchy and notions of independence and autonomy within the Empire. The territories over which he had gained control had acknowledged nominal suzerainty to the Chou until their demise at the hands of the Ch'in in 256 B.C., and thereafter had maintained complete autonomy under war-lord or feudal rule. Notions of strictly enforced central government were, therefore, unfamiliar to most of Shih Huang-ti's newly acquired possessions and fiercely unacceptable to many of the traditional land-owning families, whose strength lay not only in their feudal hereditaments but also in their private armies. The Ch'in Emperor was, therefore, obliged to deprive these soldiers of their weapons and militarily invalidate them. At the same time he greatly reinforced his own armies and no doubt equipped them with the confiscated weapons. Such determined measures successfully removed, for the time being, any threat of real or concerted opposition to his establishment.

The severity of the administrative and military measures adopted by the Ch'in make it quite apparent that their Legalist background relieved them of any compunction against attempting to condition and regularize all aspects of life in China. The great flowering of thought and philosophy in the Warring States period had stimulated an intellectual licence which clearly might undermine authority. Thought and literature were inevitably to feel the effects of Shih Huang-ti's rule. Ancient books, such as the *Classic of Documents* and the *Classic of Songs*, the former a Chou historical compendium and the latter a volume of ceremonial and ritualistic poems and songs, had neither place nor function in such an intensely utilitarian ideology; in fact, they were considered subversive since they praised out-moded concepts and institutions. In 213 B.C., Li Ssu, leading statesman of the day, instituted the 'Burning of the Books' in which all such literature was destroyed. Books of practical value, such as those on divination, medicine, technology and agriculture were spared.

The extraordinary and uncompromising vigour with which the Ch'in sought to establish their dynasty into a universal and everlasting empire has left a permanent impression on the face of China. Under the Ch'in the map of China began to approximate its present appearance. Her armies penetrated as far south as present-day Vietnam, and the Canton coastal region became part of the empire. In the north the border was secured by further construction work to consolidate the Great Wall, truly a manifestation of the tremendous outburst of physical energy that was inspired by the Ch'in (*plate 52*). All these

monumental achievements were telescoped into a dynasty of just some fifteen years' duration.

The centralized structure which Shih Huang-ti had established to support an Empire which he declared would endure for "ten thousand generations" was to substantially contribute to its almost immediate demise. His situation exemplified what was to become a persistent affliction of the dynastic system in China. The founding Emperor was invariably a man of vision, determination and ability around whom the dynasty and its hierarchy were constructed, and from whom all inspiration and direction emanated. Ch'in Shih Huang-ti was such a man, but his son, who ostentatiously took the title Erh-shih Huang-ti (Second Emperor), was by comparison both inexperienced and incompetent.

The real power fell into the hands of Li Ssu and the chief eunuch, Chao Kao, who subsequently acquired total control. It was due to his machinations that the regime rapidly disintegrated, and by 206 B.C. Ch'in rule was finished. Shih Huang-ti's dynasty had outlived him by a mere four years. Although the majority of dynasties in Chinese history survived very much longer than fifteen years, the problem of a weak and ineffective succession to the throne was an ever-present threat to their continuity, which the fate of the Ch'in typifies.

Owing to the brevity of the dynasty, it is difficult to characterize Ch'in art or to draw any broad conclusions as to its nature and development. In addition, as we have seen, the energies and resources of the authorities were firmly directed towards the practical tasks of physical and material reconstruction and consolidation. In the Bronze Age, ritual and ceremony had been the principal arbiters of not only artistic style and content, but also the quality and variety of work produced. Now their absence further contributed to the apparent decline in artistic endeavour during the Ch'in. Nevertheless, in the retrospective view of Chinese art, developments which occurred at and around the early 3rd century B.C. played a crucial role in the change-over of fundamental artistic style from the hieratic nature of the bronze tradition to the underlying naturalism which characterizes the art of the succeeding Han dynasty.

Not surprisingly, the focus of artistic activity was the capital, and recent archaeological work in the region of the ancient Ch'in city of Hao, close by the modern city of Hsien-yang to the west of Sian in Shensi province, has produced much representative material which displays a very real concern for naturalistic representation.

But by far the most significant artistic relics of the Ch'in are without any doubt the staggering life-size pottery figures of soldiers, attendants and horses which were recovered in 1974 from vast burial pits close to the burial mound of Ch'in Shih Huang-ti (see *plates 26, 27*). These stunning figures are indeed as profound a testimony to the skill, craftsmanship and vision of early potter-sculptors in China, as they are to the overwhelming power and superiority of the autocratic Ch'in emperor (*plates 53, 54*). No less amazing than the size and quality of these revolutionary figures is their sheer quantity. It is still impossible to account precisely for the number of figures originally buried because of inevitable damage and disintegration, but it has been estimated that the pits originally contained several thousand such models. The serene figure of a kneeling woman, also recovered from the vicinity of the Ch'in emperor's mausoleum (*plate 55*), although smaller and less imposing, nevertheless displays these same mature sculptural qualities and realistic detail which vividly illustrate the important new artistic directions of the time.

Bibliographical references
de Bary, William T. (ed), *Sources of the Chinese Tradition*, New York 1960. Contains excerpts from works covering most aspects of the thought of the late Chou and Warring States eras, including Legalist philosophy and theory.
Duyvendak, J. J. L., *The Book of Lord Shang. A Classic of the Chinese School of Law*, London 1928. A translation of the work attributed to Wei Yang (Shang Yang).
The Archaeological Team for the Ch'in pottery figures, "Lin-t'ung-hsien ch'in-yung-k'eng shih-chüeh ti-i-hao chien-pao" (First report on the excavation of the Ch'in dynasty tomb figure pit at Lin-t'ung), *Wen Wu*, 1975 no. 11. This issue of *Wen Wu* (Cultural Relics) also contains other articles on the arrangement of the figures within the pit, and on their 'sculptural style'. *Kaogu* (Archaeology), 1975 no. 6 contains another article on this excavation. So far the most informative reports on these excavations have appeared only in Chinese archaeological journals.

51

'The State of Ch'in rises to power by adopting Legalism and opposing Feudalism.' A display in the Shensi Provincial Museum at Sian illustrating the revolutionary stand taken by the Ch'in and including a portrait of Shang Yang, a leading statesman of the Ch'in who died in 338 B.C.

In the foreground are pottery tomb figures, bronze weapons and a bronze ritual vessel.

52

The Great Wall of China; a section of the recently restored section of the wall near the Nanking gate. Originally constructed in the 4th to 3rd centuries B.C., the defensive wall was extended and consolidated by the first Ch'in Emperor, Shih Huang-ti.

The Great Wall extends to some 1500 miles as the crow flies, from southern Kansu province in the west to the coast east of Peking in the east, and in the Ch'in dynasty is estimated to have been at least 5000 kms. (over 3000 miles) in actual length. Although varying in both height and width, it averages 21 feet in height and the roadway on top approximately 18 feet in width; sufficient for five horses to ride abreast.

53
Life-size pottery figure of a guardian in full armour. Excavated in 1974 from the pits adjoining Ch'in Shih Huang-ti's burial at Lintung in Shensi province (see also plates 26 and 27).
Ch'in dynasty: 221–206 B.C.
Height: 184 cms
China

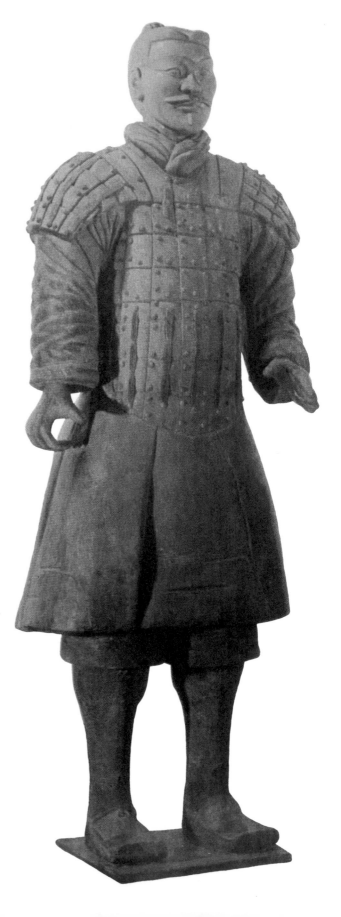

54
Life-size pottery model of a horse. Excavated in
1974 from the pits adjoining Ch'in Shih
Huang-ti's burial at Lintung in Shensi province
(*see also plates 26 and 27*).
Ch'in dynasty : 221–206 B.C.
Height : 170 cms, length : 220 cms
China

55
Pottery figure of a kneeling woman.
Excavated in 1974 at Lintung in Shensi
province, close to the burial of Ch'in Shih
Huang-ti
(*London etc. exhibition, cat. no.* 136;
Australia exhibition, cat. no. 108).
Ch'in dynasty: 221–206 B.C.
Height: 64.5 cms
China

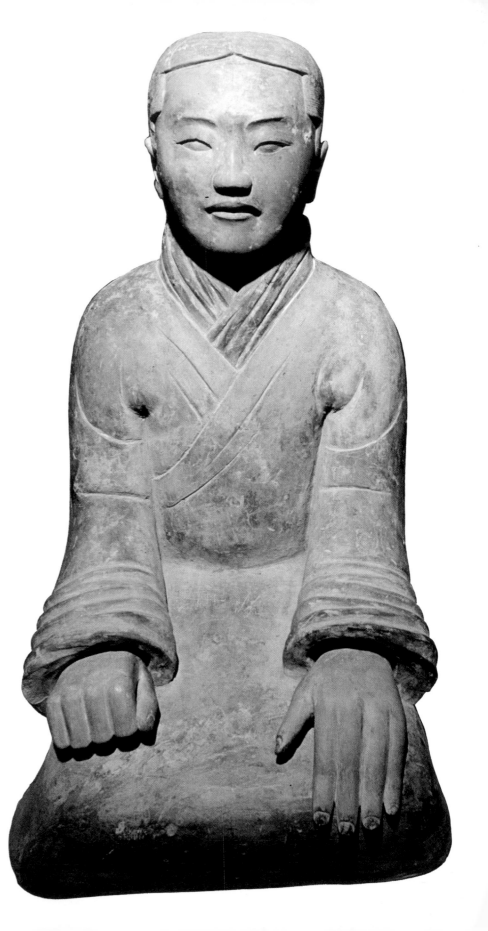

漢代

The Han Dynasty (206 B.C. to A.D. 220)

Former or Western Han (capital at Ch'ang-an, Shensi) 206 B.C. to A.D. 8.
Wang Mang interregnum A.D. 8–25.
Later or Eastern Han (capital at Loyang, Honan) A.D. 25–220.

The Ch'in dynasty is often regarded as a brief but emphatic preface to the Han dynasty; an entirely reasonable observation since the Han built on the unity forced by the Ch'in and established an era which is generally recognized as one of the greatest, most enduring and richest periods in the history of China. It is no mere coincidence that one of the largest and most exciting sections of the Chinese Archaeological Exhibition is that devoted to the arts of the Han.

The glories of the expansive Han dynasty, reflected in her art, literature and cosmopolitan exuberance, tend to obscure the humble origins of its founder, a rebel leader by the name of Liu Pang (*plate 56*). He was one of many such men, of peasant origins, who emerged to challenge the severity of Ch'in rule. A man of little education, certainly not well versed in the Classics or the Confucian ethic, he was in many ways the kind of person whose realistic and practical approach to life must have been admired by those whose downfall he sought, and achieved. That Liu Pang conquered the Ch'in, ascended the throne, and subsequently provided the foundations for the Han dynasty is testimony to his skill and vision in spite of his humble origins. During the period of his comparatively brief reign, from 206 to 195 B.C., his personal development from rebel peasant leader to sophisticated Emperor of China is reflected in the rapid emergence of the Han dynasty as an undoubted and unified force.

It is frequently asserted that the success of the Han in establishing a durable dynasty was due largely to Liu Pang's flexible and pragmatic approach to government. He was a self-made man who perhaps, and notwithstanding his position and his success, maintained a sympathy for the peasantry and thus subjected them to fewer demands for taxes, labour and the ever-present strictures of Ch'in autocracy. Under his adopted title Kao Tsu, first Emperor of the Han, Liu Pang pursued a policy that might be described as a 'new feudalism'. Although based on the Ch'in structure, the Han made a notable retreat from total centralization in permitting the partial re-instatement of vassal states, such as that ruled by Prince Liu Sheng and his consort Princess Tou Wan whose impressive burials and jade suits have been the focus of so much attention (see *plates 16, 17*). This was an entirely practical policy to adopt, in that it recognized the impossibility of effectively ruling the more distant regions of such a vast empire from the capital at Ch'ang-an. Communications once again became a primary consideration in the constitution and execution of government in ancient China. To achieve loyalty, Kao Tsu established the rule that only members of the Imperial clan should hold the rank of king, or ruler of a kingdom, but he was cautious not to provide any opportunities for them to gain significant power or autonomy, and their territories were considerably smaller than those of the great Chou warlords. In addition to these feudal kings,

a large number of lesser aristocrats and government officials ruled over a patchwork of minor states throughout the Empire. The Marquis of Tai, whose burial has recently been excavated along with those of his immediate family at Mawangtui near Ch'ang-sha in Hunan province (see *plate 24*), was such a ruler.

A most important feature of Han government was the re-emergence of the *Chün-tzu*, a figure who originally was the embodiment of the Confucian virtues. In the later Warring States period, the *Chün-tzu* was irrevocably associated with the reactionary ruling classes of hereditary nobles, but as the demands of the Han administration for governing officials increased so the *Chün-tzu* were re-instated as a large and vital force in Chinese society. Under the new regime they were not necessarily of noble birth, or distinguished by aristocratic lineage, but were identified by their education. In a sense, therefore, admission to the *Chün-tzu* was available to all.

The rise of a professional 'civil service' in the Han dynasty was synonymous with the gradual decline of aristocratic and feudal power. The feudal clanships and hereditaments instituted by the founding Emperor Kao Tsu were gradually eroded and their territories supervised by officers directly responsible to, and appointed by, the Emperor. Another ingenious method of reducing the size and influence of feudal territories was devised by the Emperor Hsiao Ching (157–141 B.C.). In a decree of 144 B.C. all sons of a feudal lord were made co-heirs of the hereditament, and the estates therefore divided between them. By such a process the fiefs became gradually smaller and smaller and, in the absence of heirs, made Imperial prefectures. Gradually, the administrative hierarchy became firmly established and the concept of the *Chün-tzu*, the educated professional official – literally, the forerunner of the mandarin – became an established fact of Chinese life. It was a pattern that was not just to survive, but dominate, in Chinese government and society until the end of the dynastic system in 1911.

Although the Han dynasty survived for some 400 years it was not a period of uninterrupted peace and prosperity. It had its great moments, such as the reigns of Emperors Wu (141–87 B.C.) and Ming (A.D. 57–75), and its darker moments, such as the Wang Mang interregnum (A.D. 8–25).

Emperor Wu, Wu Ti, was in the mould of his adventurous and illustrious predecessors, Ch'in Shih Huang-ti and Kao Tsu; a tough dynamic autocrat with considerable disregard for such cosy notions that the Emperor should leave the management of his Empire to the bureaucrats. Increasingly, he took over the mantle of chief administrator and his dynamism pervaded all aspects of life. His reign is characterized by expansion. Huge tracts of land in present-day Mongolia, southern Russia, Central Asia including the barren wastes of the Tarim basin and the Gobi desert, and lands as far distant as the borders of modern Afghanistan, all came under Chinese control. In the north, parts of Manchuria and northern Korea also became absorbed into the Han Empire. Wu Ti annexed these territories as part of his long-term

campaign to subdue the neighbouring 'barbarians', principally the Hsiung-nu, a Turkish-speaking people of Hunnish stock. At the same time he was undoubtedly inspired by territorial ambitions.

These campaigns often involved massive armies of 50,000 to 100,000 cavalry supported by infantry. The loss of life in the vast and isolated wastes of Central Asia was prodigious as Wu Ti hurled army after army against the barbarian nomads. And yet it was probably through the efforts of individuals, such as the adventurous ambassador Chang Ch'ien, that Han China consolidated and expanded her sphere of influence. He typifies the determined and imaginative attitude characteristic of the Han period.

Through captured Hsiung-nu tribesmen, the Emperor had learnt of the existence of a people known as the Yüeh-chih, who had earlier suffered defeat at the hands of the Hsiung-nu. In 138 B.C. Wu Ti, therefore, despatched Chang Ch'ien with 100 or so followers to seek out the Yüeh-chih and negotiate an alliance with them against their common adversary. The Han ambassador almost immediately fell into the hands of the barbarians, who held him captive for some 10 years. Undeterred, Chang eventually escaped and set off westwards on his original quest. He finally found the Yüeh-chih people living peacefully and quietly in the Kingdom of Bactria, in modern Afghanistan, which was then an eastern outpost of Hellenism. Unfortunately for Chang, the Yüeh-chih were not in the slightest interested in taking up the cudgels against their old enemies and he thus returned empty-handed after an absence from China of 12 years.

The significance of Chang's travels lies not in the failure of his mission, but in his having made contact with a Mediterranean culture. His report also provides invaluable evidence for the transmission of cultural and artistic concepts via the nomadic peoples of Central Asia. The Yüeh-chih were, after all, originally from Kansu province in west China and yet settled finally some 3,000 miles to the west, within the European sphere of cultural influence. These people would surely have taken with them certain cultural and artistic notions familiar to them in their original homelands, thus providing another vital cultural link between the peoples of East and West.

The wealth, power and confidence which accrued during the expansionist reigns of the early Han created internal problems. The population increased dramatically and so accordingly did the peoples' demands on the land. But with less land per peasant family or community to farm, their ability to provide taxes to both local and central government was diminished. Furthermore, certain aristocratic and feudal possessions were held free of tax; it is recorded that Prince Liu Sheng, for example, paid no taxes on his territories in Hopei province. Therefore, by the end of Wu Ti's dramatic but burdensome reign the state revenues were if anything declining, but not so the vast expenditures on military adventurism or the Imperial household. The ever-present threat of corruption became evident when these financial pressures began to exert themselves upon the Court.

Wu Ti's immediate successors were by comparison weak and incompetent, the hierarchy disintegrated and in A.D. 8, the 'Mandate of Heaven' was usurped by a certain Wang Mang, a former chief minister. More in the Legalist than the Confucian mould, his extremist rule soon prompted positive and effective reaction resulting in the restoration of the Han line in A.D. 25, under the leadership of Kuang Wu Ti.

The vigorous programme of reconstruction, consolidation and further expansion of the Han Empire by Kuang Wu was enthusiastically pursued by his successor, Emperor Ming, during whose reign China attained wealth, power and possessions which more than paralleled those of Wu Ti's time. Once again, the Han armies marched across the wastes of Central Asia to within sight of the Roman Empire, opening up new trade routes, acquiring new territories and broadening her artistic and cultural horizons. Such historical fact is substantiated and vividly illuminated by recent archaeological work in the far western regions of China, on the borders of Central Asia. The excavation of the tomb of a certain General Chang of the Later Han dynasty revealed a magnificent assortment of bronze figurines of soldiers, horses and chariots; dramatic and tangible evidence for the westward advance of the Han armies of nearly 2,000 years ago (*plate 57*). The reality of Han China's strength, territorial expansion and subsequent riches and confidence was a profound contributing factor to the tremendous wealth of artistic activity which occurred at the time.

The spirit of confidence and adventurism which so characterizes the Han dynasty is the underlying momentum of Han art. It was an age of stylistic innovation and technical accomplishment.

In attempting to define the particular qualities of Han art we can detect three broad areas of inspiration and interest. Firstly, subjects of a mythological or superstitious nature; secondly, realism and naturalistic representation; and thirdly, the continuing presence, or influence, of the formalism inherent in the hieratic art styles of the bronze tradition of the Shang and Chou periods.

The events leading to the demise of the Bronze Age had inspired a tremendous and sustained outburst of theoretical and philosophical debate and writing. This outburst suddenly was throttled by the effective, if short-lived, Ch'in. The intellectual release subsequently effected by the advent of a more liberal Han regime was manifest in a sudden burst of creative activity. The decree proscribing the teaching of the 'Hundred Schools' of thought and philosophy, and the accompanying literature, was finally repealed in 191 B.C. From this moment on, Han scholars laboured at the restoration of classical books, including the great canons of Confucianism which had been destroyed in the Ch'in. These events provided a further stimulus to the acceptance of the Confucian code which gradually permeated and became incorporated into the standards of the official class. On the other hand, popular and mythical beliefs, again having their roots in the intellectual turmoil of the Warring States period, also began to re-assert themselves and found a broad and receptive audience at all levels of Han society.

Fortunately, the greatest literary achievements of the Han were in the form of historical writings and much of the achievement of the period, particularly in the fields of science, technology and philosophy, is recorded in the *Historical Records (Shih Chi)* by Ssu-ma Ch'ien and Pan Ku's *History of the Former Han Dynasty (Han Shu)*. Significant sections of these volumes are devoted to ideas concerning the structure and nature of the universe; themes which found frequent expression in Han art. For example, the *po-shan-lu* censer (*plate 58*) represents a cosmic mountain around the base of which are featured three of the animals of the four quarters or directions: the green dragon of the east, the white tiger of the west, the red bird of the south and the black warrior of the north. The last is omitted on this bronze and is in fact often the most difficult to recognize, it generally adopting the form of a tortoise with a coiled serpent. The animals of the four quarters are amongst the most popular symbolical devices in Han art and appear with regularity on bronze mirrors which, by their very nature, became vehicles for the representation of all manner of astronomical and mythological ideas (*plate 59*).

Some of the most substantial examples of the dependence of Han art on mythological notions are to be found in the stone engravings of tomb entablatures. The mausoleum of the Wu family near Chia-hsiang in Shantung province dates from the Later Han dynasty (A.D. 2nd century) and is well known for such engravings. They reproduce a range of historical and mythological stories: legends such as that of the mythical archer Yi shooting nine of the ten suns, lest they should burn up the earth, but leaving one to light the universe. The essentially representational but nonetheless conventionalized, style is characteristic of much Han pictorial art. The individual elements betray a naturalistic approach, but the underlying formalism inherent in Chinese art is manifested in the organization of these elements into a rigid pattern. Notions concerning immortality were also of great concern and found widespread expression in the arts; the legend of Hsi Wang-mu, Queen Mother of the West, and her Paradise in the Western Mountains where she resided with the Immortals, is typical of such themes which were popularized and employed as decorative subjects. More specific is the story of the transmission of the spirit in the after-life which is vividly recounted on the silk banner from the Mawangtui tombs (see *plate 15*).

The concept of realism that is so apparent in Han artistic style developed out of the embryonic tradition detected in the later stages of the Bronze Age. It was suggested that constant contacts with Central Asian and southern Russian cultures and peoples were probably the principal contributing factors to these revitalizing developments. In the Han dynasty these contacts were amplified, and their effects consolidated. Han imperialism added further dimensions to the scope of artistic style through fresh cultural associations. The mountainous landscape and supporting human figure on the *po-shan* censer (see *plate 58*), the bronze lamp in the form of a ram also from the Man-ch'eng tombs, the serene and dignified gilt bronze figure of a kneeling attendant

holding a lamp (*plate 60*), the humorous bronze feet in the form of bears (*plate 61*), pottery tomb figures and models, and the impressive bronze horses and cavalry from the Kansu tomb, are all characteristic products of Han art in their obvious concern for naturalistic representation.

Not only was realism a new force in the sculptural sense, such as the models of horses and figures, but also in the pictorial sense. The sculptured reliefs from the Wu family shrines, for example, display a strong sense of pictorial continuity. Similar qualities may be seen in the painting of the figures on the lacquer box from Lolang (*plate 62*), the lively and individual wall paintings of guardians, officials and animals in a brick vaulted tomb at Wang-tu in Hopei province, and in the similarly vibrant paintings of processions of horses and carriages on the walls of the tomb of an unknown Han official at Holingol in Inner Mongolia.

Yet another vital new force in Han art was the landscape theme; another aspect of the then current concern for realism. Pottery bricks discovered in Szechwan province, ornamented with low relief designs of figures working a salt mine, others hunting and fishing in a landscape setting, suggest a new interest in defining man in relation to nature. Even painted, or moulded relief, pottery vessels were ornamented with embryonic landscape designs highlighted with animals and figures. Some of the pottery relief bricks from Szechwan, and indeed similar examples from Han tombs in other parts of China, depict acrobats, entertainers and feasting scenes. Here there is further evidence of the emphatic shift away from the hieratic conventionalization of the Bronze Age, for obvious attention was applied to the relationships between the figures. They are shown in some kind of mutual activity which demands individual expression.

The tremendous spread of the Han empire not only brought the cultures and arts of associated or even alien civilizations to within the Chinese sphere with some resounding consequences, but also brought the styles of metropolitan China to outlying and peripheral regions of the Empire. For example, Han art, albeit with a local flavour, has been found in north Korea (*plate 62*), in the far west and central Asia; Chinese silks have been discovered in Sinkiang at sites along the old 'Silk Route'; and in the southerly provinces the finds of lacquers and silks from Mawangtui (*plate 63*) still broadly reflect the characteristic features of Han metropolitan styles. Further south Han tomb ceramics, including models of houses, have been found in some quantities in the Canton and Hong Kong regions (*plate 64*), and still further south, into northern Vietnam, relics which may with certainty be defined as 'Han Chinese' in basic style have been found.

With the possible exception of the T'ang dynasty, no other period in Chinese history can provide us with so vivid a picture of daily life as that furnished by the pottery burial objects of the Han. Human figures predominate, and the serene models of courtly ladies demonstrate how succinctly the Han craftsmen could express essential sculptural qualities. In some contrast, but still displaying that basic understanding of simple volume and form, are the models of energetic acrobats, devilish shamans, soldiers, guardians and attendants. Naturally, horses feature strongly in the Han tomb figure tradition. These robustly modelled figures of the sturdy Central Asian horse which supported the Han armies in their military adventures to extend the Chinese Empire, have been discovered in tombs across China, often in impressive quantities. For example, the recently excavated tomb of a Western Han General near the city of Hsienyang in Shensi province revealed nearly 3,000 models of horses and attendants – material testimony to the enormous growth of the mortuary culture of China during the Han dynasty.

A most interesting aspect of Han tomb art concerns pottery models of buildings (see *plate 64*). Since most buildings in ancient China were constructed from timber virtually none have survived, and certainly none have done so from as early as the Han period. These models, which include courtyard houses, farms and farm buildings, defensive forts and, above all, multi-storied towers, provide a rare insight into the nature and style of Han architecture.

In the far south-west a semi-independent, but culturally and historically associated, kingdom emerged in the 4th century B.C. Adopting the name Tien, the kingdom was confined to remote Yünnan province until acknowledging Han suzerainty in 109 B.C. The excavation of the burials of Tien nobles, conducted in the years from 1955 to 1960, at Shih-chai-shan, revealed an excitingly vivid and imaginative culture which, although of an independent nature, was evidently related to that of its vast and more sophisticated contemporary.

The Yünnan bronzes exude a vibrant naturalism, such as that expressed in the plaque depicting two tigers attacking a boar (*plate 65*), and an almost naïve attention to detail (*plate 66*) which is evidently relieved of any restrictions imposed by an hieratic tradition. Nevertheless it is pertinent to acknowledge that, in spite of their independent character, these bronzes are instantly recognizable as Chinese, or from within the Chinese sphere of influence.

It has been noted that, however apparent and dynamic these infusions of new naturalistic concepts may have been, they were invariably subjected to the rigours of formalism, that enduring characteristic of Chinese art. The maintenance of the formalistic criteria of Bronze Age art is most evident during the Han dynasty in material which may claim direct descendancy from that bronze tradition. For example, a bronze *hu* vessel (*plate 67*) whose form, firstly, is based on the ancient Chou prototype and, secondly, whose decoration is inspired by the intricate convolutions of inlaid bronzes of the Warring States. Ultimately though, these elements of decoration, such as the dragon, may be traced back to Chou or earlier origins. But the conventionalized, often geometric, foundations of Han art are sometimes to be found in more obvious form. The woven silks from Sinkiang and Mawangtui (*plate 68*) describe this characteristic in more severe form, although the limitations of technique were inevitably a restricting feature. Similarly,

the painted lacquers (see *plate 63*) and painted pottery vessels (see *plate 50*) betray an underlying geometricism to the organization of the design, however fluent its execution may be.

This wealth of artistic enterprise and achievement was paralleled by advances in technology and the sciences. Mention has already been made of the interest in astronomy, and the Han scholars further concerned themselves with mechanics, mathematics, medicine and the natural sciences. Even the first known Chinese seismograph was invented during the Han dynasty (*plate 69*).

Technological advances, which included the introduction of a type of draw-loom for silk-weaving, and the development of high-fired stonewares with feldspathic glazes, were to have a profound effect upon subsequent artistic traditions (*plate 70*). The material and artistic achievements of the Han have for long been recognized as those of one of the great civilizations of China; achievements that were not to be matched until the T'ang empire restored comparable power and wealth to the Middle Kingdom some five centuries later.

Bibliographical references
Academy of Sciences: Institute of Archaeology, "Man-ch'eng han-mu fa-chüeh chi-yao", *Kaogu* (Archaeology) 1972, no. 1. For the fullest account of the excavation of the tombs of the jade-suited Prince Liu Sheng and Princess Tou Wan at Man-ch'eng.
Dubs, Homer H., *History of the Former Han Dynasty*, Baltimore and London 1938–55. A translation of the *Han Shu*, the history of the former Han dynasty by Pan Ku, which includes introductory statements to each reign and references to historical events & other topics.
Fairbank, Wilma, *Adventures in Retrieval*, Harvard 1972. An account of the Wu family tombs in Shantung province which includes a discussion on the pictorial and mythological scenes represented in the relief carvings.
Hunan Provincial Museum, *Ch'ang-sha ma-wang-tui i-hao han-mu* (The no. 1 Han tomb at Mawangtui, Ch'ang-sha), 2 vols, Peking 1973.
Kan Po-wen, "Kan-su wu-wei lei-t'ai tung-han-mu ch'ing-li chien-pao" (Report on the excavation of the Eastern Han tomb at Lei-t'ai in Wu-wei country, Kansu province), *Wen Wu* (Cultural relics) 1972, no. 2. A full report on the tomb from which the bronze models of horses, chariots and carriages were excavated. Another, equally comprehensive, report is published in *Kaogu Xuebao* (Journal of Chinese Archaeology) 1974, no. 2.
Loewe, Michael, *Everyday Life in Early Imperial China*, London 1968. An account of life, government and society in China during the Han dynasty.
Sullivan, Michael, *The Birth of Landscape Painting in China*, Berkeley and London 1962. For a discussion on the origins of the landscape theme, and realism in decorative style, in the Han dynasty.
Watson, Burton, *Records of the Grand Historian of China. Translated from the Shih Chi of Ssu-ma Ch'ien*, New York 1961. A translation of sections of the *Shih Chi* (Historical Records) which concerns significant periods of the Han dynasty.
Yunnan Provincial Museum, *Yün-nan chin-ning shih-chai-shan ku-mu-ch'ün fa-chüeh pao-kao*, Peking 1957. Full report on the tombs at Shih-chai-shan in Yunnan province.

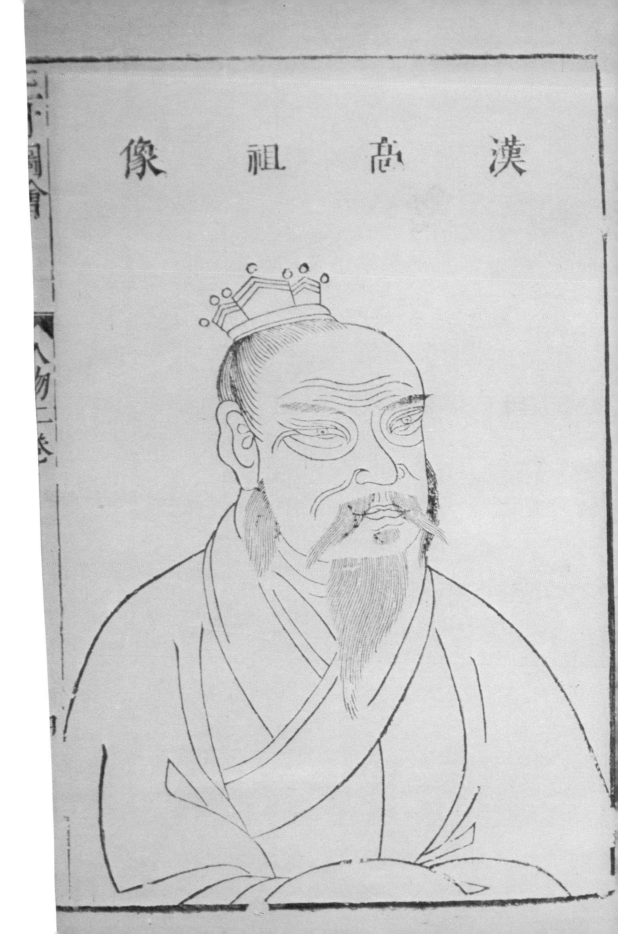

56
Portrait of the founder of the Han dynasty, Liu Pang; known as the Emperor Kao Tsu (*reigned* 206–195 B.C.).
From the San-ts'ai t'u-hui, 1609 *edition,* chüan 14, *biographies; portraits, section* 1.
British Library

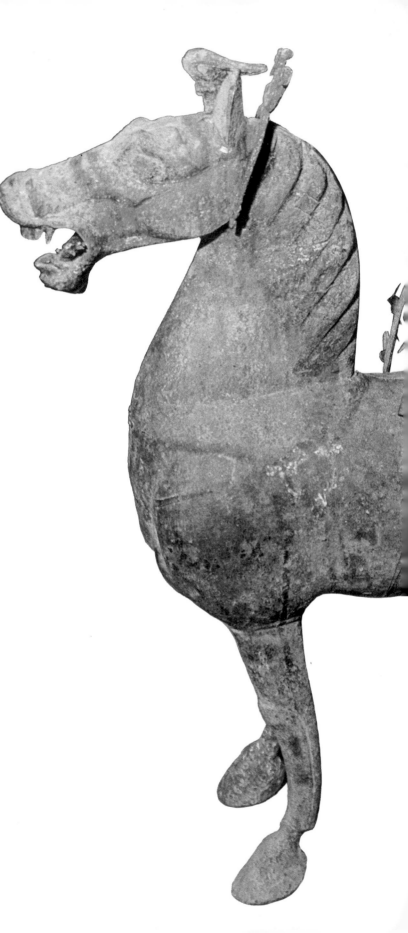

57
*Bronze models of horse and chariot, excavated
in* 1969 *at Wu-wei in Kansu province.*
(*London etc. exhibition, cat. nos.* 211–221;
Australia exhibition, cat. nos. 150–153).
Eastern Han dynasty: 2nd century A.D.
Height of horse: 40 cms
Height of chariot: 33 cms
China

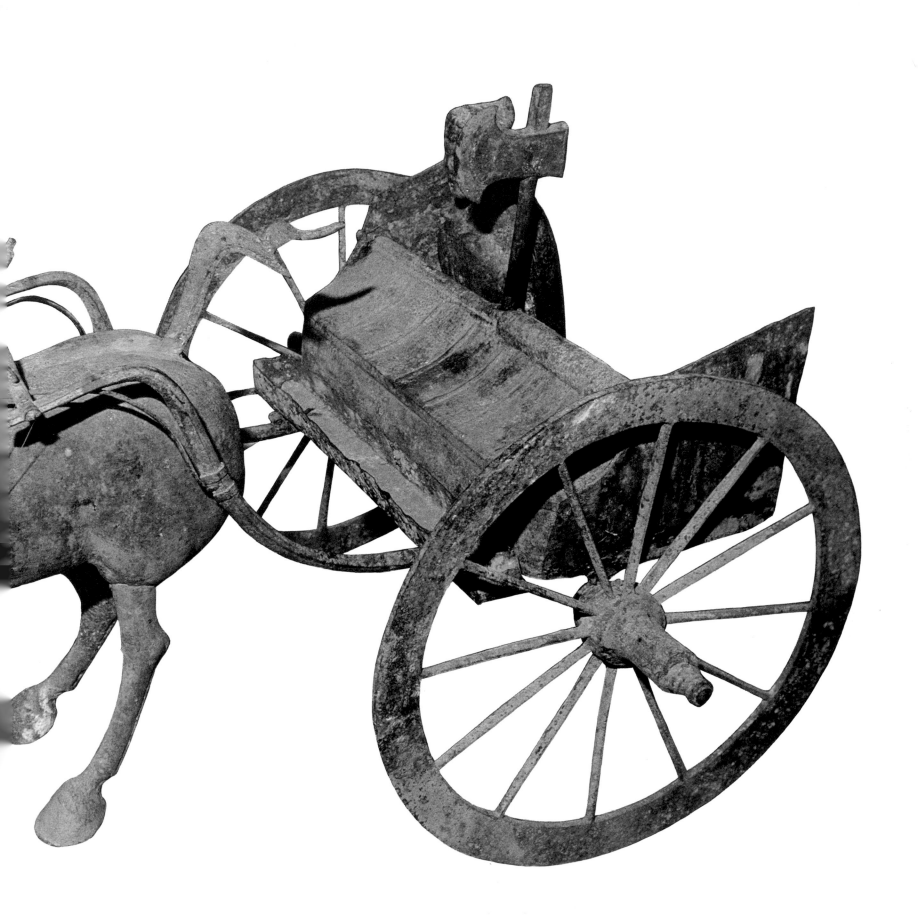

58

Bronze censer in the form of a cosmic mountain, po-shan-lu, *supported by a man seated on a monster. Excavated in 1968 from the tomb of Princess Tou Wan at Man-ch'eng in Hopei province. (London etc. exhibition, cat. no. 155; Australia exhibition, cat. no. 127).*

Height: 32.4 cms

Western Han dynasty: late 2nd century B.C.

China

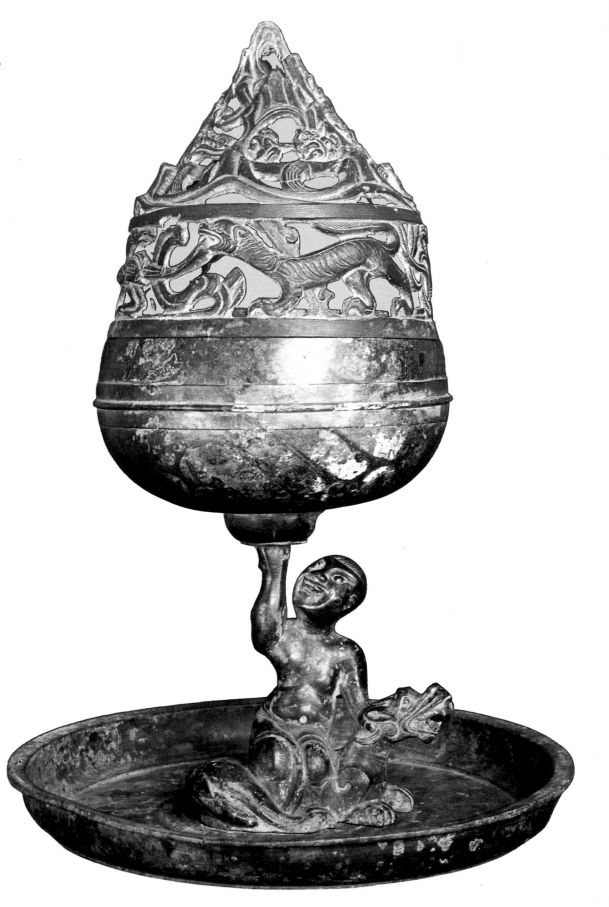

59

Bronze mirror with the TLV pattern.
An inscription, in the form of a poem, on the
inner border reads: 'This fine Shang-fang
mirror is truly excellent. Upon it are immortals
who know not of old age. When thirsty they drink
from jade springs; when hungry they feed on
fruits like gems. They float above the world and
roam among a myriad of peaks and gather
magic herbs. Under the protection of the heavens
may your longevity be like that of stone.'
Han dynasty: 1st century B.C. – 1st century A.D.
Diameter: 16 cms
British Museum

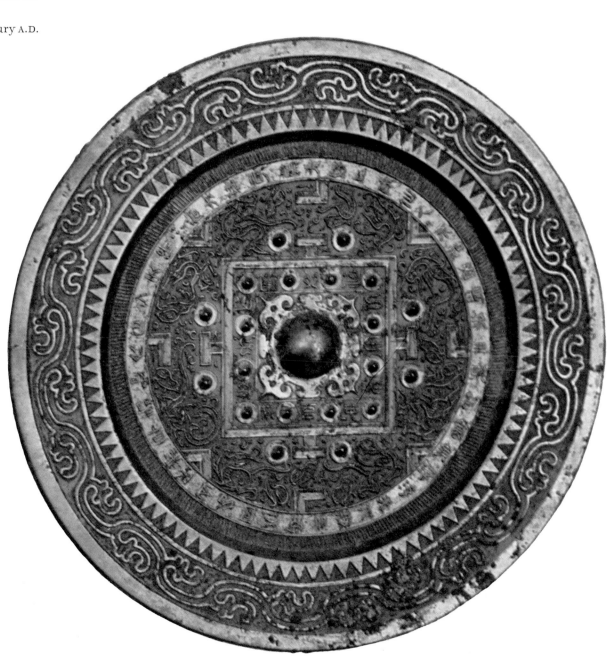

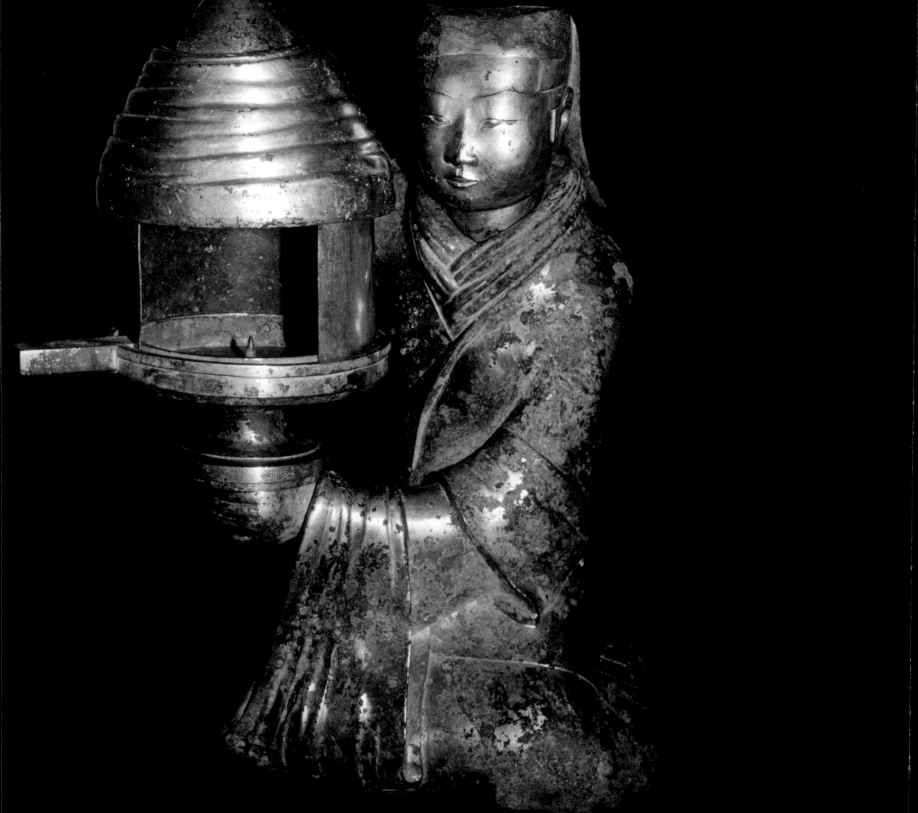

60

Gilt bronze figure of a kneeling girl holding a lamp inscribed chang-hsin (*eternal fidelity*) *palace. Excavated in 1968 from the tomb of Princess Tou Wan at Man-ch'eng in Hopei province.*
Western Han dynasty : late 2nd century B.C.
Height : 48 cms
China

61

Pair of feet from a bronze vessel in the form of bears standing on birds. In each example the right hand clasps an ear, and the left a knee. Excavated in 1968 from the tomb of Princess Tou Wan at Man-ch'eng in Hopei province. (*London etc. exhibition, cat. nos.* 152 *and* 153; *Australia exhibition, cat. nos.* 128 *and* 129).
Western Han dynasty : late 2nd century B.C.
Heights : 11.1 and 11.7 cms
China

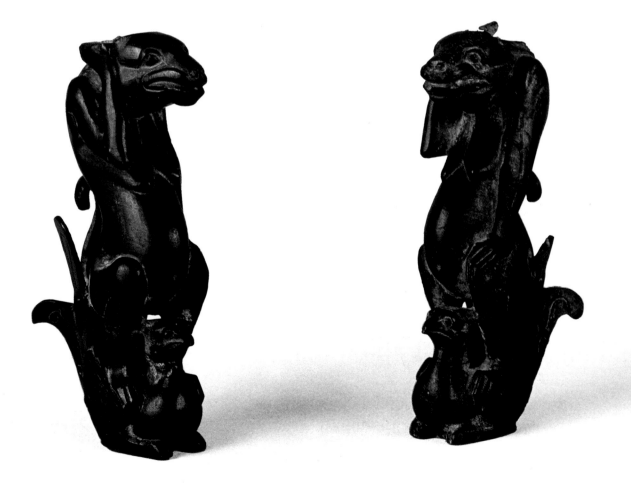

62
Painted lacquer basket excavated at Lolang in Korea. The style of painting is thoroughly Chinese, and the geometric bands correspond to those on inlaid bronzes.
Han dynasty: 206 B.C. – A.D. 221
Height: 22 cms, length: 39 cms, width: 18 cms
National Museum of Korea, Seoul

63

Painted lacquer vessel, hu, *in the form of its
bronze counterpart. The painted decoration is
based on that of the inlaid bronzes of the
Warring States, but freer in execution.
Excavated in 1972 from the no. 1 tomb at
Mawangtui near Ch'ang-sha in Hunan province
(see also plates 15, 24 and 68).*
Western Han dynasty : 2nd century B.C.
Height : 57 cms
China

A typical pottery model of a small courtyard farmhouse; excavated in the Canton region of southern China.
Eastern Han dynasty: 1st – 2nd centuries A.D.
Height: approximately 40 cms
Canton Museum

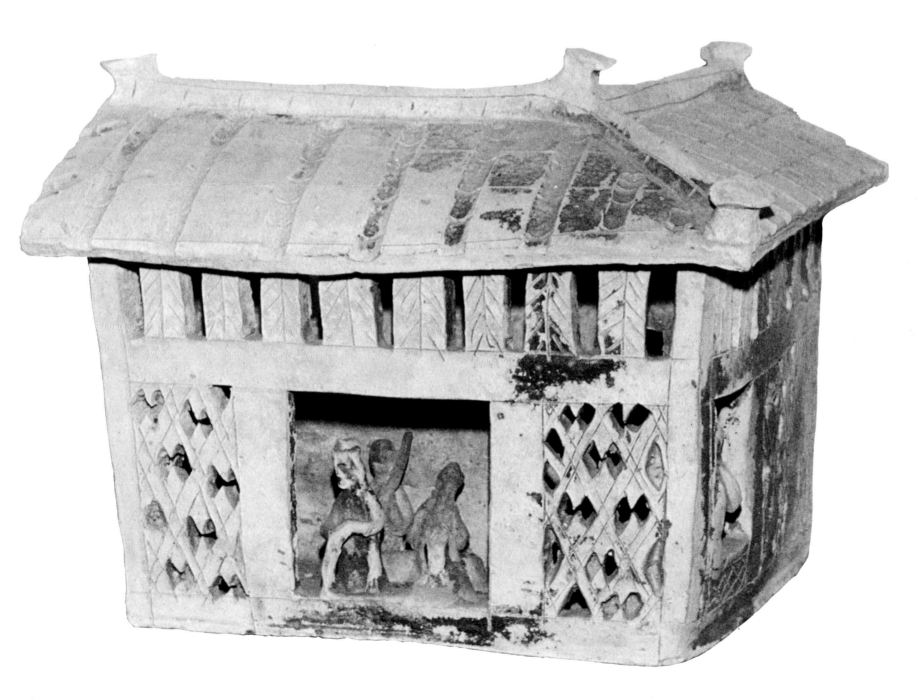

65

Bronze figure of two tigers in combat with a
boar. Excavated in 1955–60 from tomb no. 3 at
Shih-chai-shan in Yunnan province.
(*London etc. exhibition, cat. no. 205;*
Australia exhibition, cat. no. 137).
Western Han dynasty: 2nd – 1st centuries B.C.
Length: 17.1 cms
China

66

Bronze cowrie container; the base decorated with
peacocks, and the top with human figures
bearing trays with gifts and others seated whilst
weaving at looms. Cowries were used as a form of
currency. Excavated in 1955–60 from the
no. 1 tomb at Shih-chai-shan in Yunnan province.
(*London etc. exhibition, cat. no. 176;*
Australia exhibition, cat. no. 135).
Western Han dynasty: 2nd – 1st centuries B.C.
Total height: 27.5 cms
China

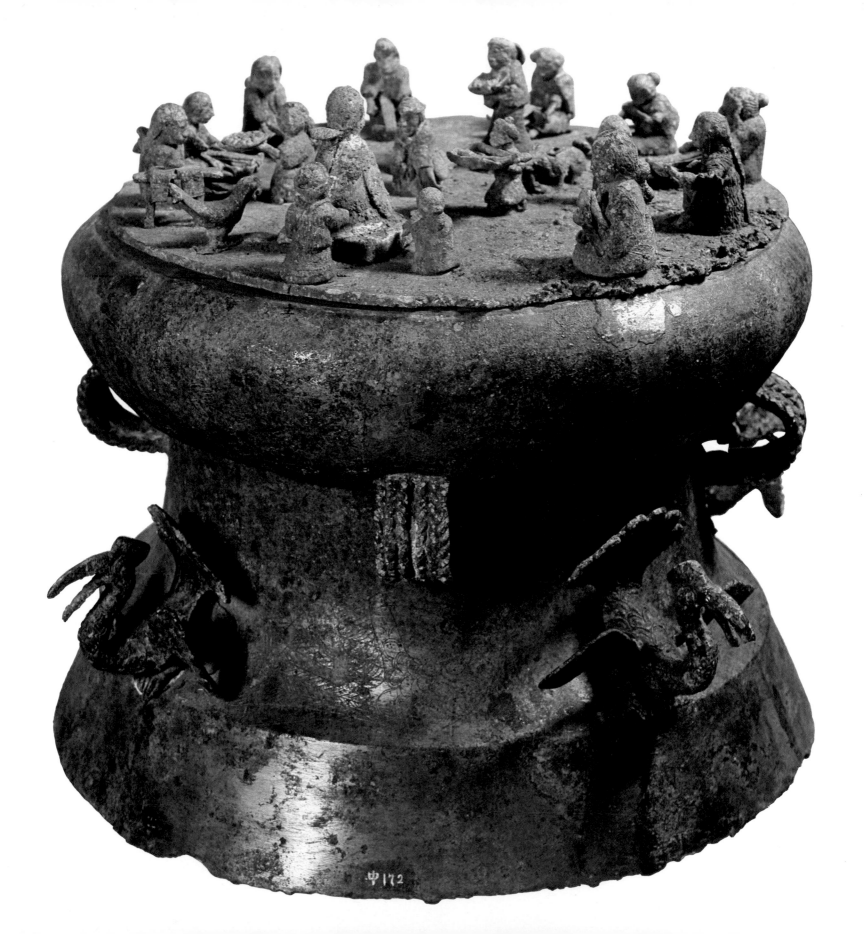

67

Bronze vessel, hu, *inlaid with gold and silver with scrolling designs in the so-called 'bird script'. Excavated in* 1968 *from the tomb of Prince Liu Sheng at Man-ch'eng in Hopei province.*
(*London etc. exhibition, cat. no.* 167; *Australia exhibition, cat. no.* 124).
Western Han dynasty: late 2nd century B.C.
Height (including lid): 40 cms
China

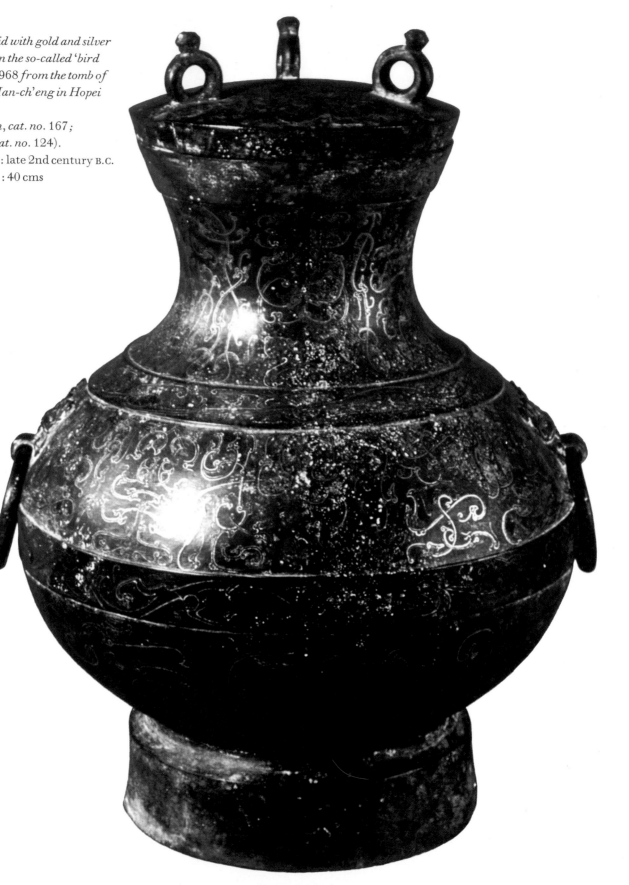

68

Woven silk damask with geometric lozenge pattern. Excavated in 1972 from the no. 1 tomb at Mawangtui near Ch'ang-sha in Hunan province (see also plate nos. 15, 24 and 63). Western Han dynasty : 2nd century B.C. Fragment measures 49.5 × 56 cms *China*

69

A reconstruction of a Han seismograph; when activated by an earth tremor, the jaws of the dragon open, releasing the bronze balls which fall into the gaping mouths of the toads. Honan Provincial Museum, Chengchou

70
Grey stoneware jar; the upper part of the body
covered with an olive-green glaze over incised
decoration composed of bird-headed scrolls.
Eastern Han dynasty : 1st – 2nd centuries A.D.
Height 32.5 cms
Victoria & Albert Museum

南北朝

Period of Division (A.D. 220 - 581)

The collapse of the mighty Han dynasty and its vast sprawling empire in the early 3rd century heralded another age of monumental upheaval and disruption: a great and protracted trough between strong and unified dynasties. Commonly termed the Six Dynasties, but perhaps more accurately identified as the 'Northern and Southern Dynasties', the history of these four centuries is so complex that it defies succinct characterization. States, kingdoms and their satellites came and went with extraordinary rapidity; brittle alliances were pledged but seldom honoured, and all the while foreign interventions further aggravated an already confused and turbulent situation. Indeed, the appellation 'Northern and Southern Dynasties' stems from the broad division of China at that time, with the Yangtze River generally accepted as the great divide. The north was overrun and governed by foreign 'barbarians', and in the south, the Chinese, including remnants of the old Han line, held sway.

The cumulative effect of these events tended to disrupt China's cultural life, yet the processes of artistic invention and experiment never ceased. This period of China's history has often been likened to the Dark Ages in Europe, but China escaped the social and cultural degeneration which accompanied the Western holocaust. Instead, the artistic achievements of these four centuries reflect a spirit of enterprise and experiment in an atmosphere of uncertainty and disunity. The fragmentation of power caused the decline of Imperial or metropolitan artistic styles and led to a pattern of local or provincial traditions. The dominance of the bronze tradition, fundamentally dependent upon centralized or Imperial patronage, was finally extinguished and varied and local ceramic traditions gained ascendancy.

The Han dynasty probably reached its apogee during the reign of Emperor Ming (A.D. 57–75); thereafter, a gradual, almost imperceptible decline of Imperial authority and security was, by the end of the 2nd century, gathering an irrepressible momentum. The root cause of the problem was a succession of inept and feeble Emperors who were unable to contain corruptive factions in the Court. Only the military was competent to quell the flickering flames of popular rebellion, and having done so, they enhanced their own power, authority and independence. Initially, a three-way division of power separated China into the Wei (in the north), Shu Han (in the south-west) and Wu (south) states, giving rise to a period known as the Three Kingdoms (A.D. 220–280). Afflicted by incessant conflict and the persistent advances by the barbarians on the northern and western frontiers, this fragile balance was short-lived. Ironically, the colourful personalities of some of the warlords captured the imaginations of Chinese writers and historians who immortalized many of them in a famous historical narrative, *The Romance of the Three Kingdoms (San-kuo-chih yen-i)*. Indeed one, Kuan Yü, even became canonized as Kuan Ti, the God of War, and was subsequently adopted as a popular theme for later decorative arts.

Under the banner of the Western Chin dynasty (A.D. 265–317) China was briefly re-united in the image of the Han. However, once

again the death of the founding Emperor precipitated dissension at the Court and the barbarian tribes, fully aware of the weaknesses and disruption at the Chin capital of Loyang, swept down in their hordes and literally overran north China. The scale of this monumental invasion of the very heart of China is difficult to imagine, as indeed is the destruction which it caused. A letter written by a Sodgian merchant to his master in far-off Samarkand in the early 4th century fleetingly captures the aura of desolation, "... the last emperor, so they say, fled from Loyang because of famine. And his fortified residence burned down and the city was destroyed. So Loyang is no more. If I wrote and told you all the detail of how China has fared it would be a story of debt and woe . . .". Little wonder, therefore, that artistic production was severely curtailed.

No less than sixteen petty states, all of foreign origin, ruled over various parts of north China in the century and a half following the collapse of the Western Chin. Upon one of them, the Northern Wei dynasty (A.D. 386–535), was to fall the mantle of principal political, cultural and artistic arbiter. The Northern Wei rulers were of T'o-pa or Turkish stock, but were emphatic in their acknowledgement of the traditions of Chinese civilization, government and culture. Quite possibly, it was the wisdom inherent in such an acknowledgement which provided them with a basis upon which to establish the most enduring and influential of the foreign northern dynasties.

Nevertheless, the constant presence of foreign peoples in north China during the 4th to 6th centuries created an unpredictable cultural atmosphere. Having invaded the homelands of one of the world's great civilizations, they were obliged to adopt its superior cultural heritage, although their own traditions permitted some freedom in the acceptance of alien, including their own, cultural and artistic traditions.

According to legend, the Buddhist faith first penetrated China during the 1st century A.D., no doubt transmitted by travellers and merchants along the ancient 'Silk Route'. But a foreign religion incorporating notions of strict spiritual conduct and *karma*, or rebirth, amidst a veritable pantheon of colourful gods and deities, made little impact upon the entrenched Confucian establishment of the Han. However, once that façade had collapsed and the less intractable hierarchies of the barbarian states were in power, the religion gradually gained recognition. Indeed the Chinese people themselves, searching for spiritual confidence in such social and cultural turmoil, turned to the Buddhist faith for comfort and inspiration. No alien cultural, philosophical or religious establishment could equal Buddhism in its profound and enduring influence on the Chinese people. After at least two centuries of almost total rejection, the faith was adopted by the Northern Wei rulers who subsequently produced an impressive tradition of monumental stone carvings. Not only was the religion new to China but so too was the artistic tradition.

With the exception of the monumental pottery figures of the Ch'in and some Han tomb figures, sculpture had been an unfamiliar concept in ancient China. Thus, the iconographical requirements of the Buddhist church introduced a totally new artistic tradition to the Middle Kingdom. Vast cave temples (as well as independent sculptures and small bronze icons) were carved into the living rock, and the cliff faces of northern China were transformed into imposing and enduring monuments to Buddhism. In the middle of the 5th century the first of these were carved into a sandstone cliff at Yün-kang, near the then Northern Wei capital of Ta-t'ung, in northern Shansi (*plate 71*). These sculptures betray an overwhelming dependence upon the sculptural styles of Central Asia and Gandhara, from whence the religion and its attendant iconography had travelled to China.

But by the end of the 5th century, Chinese taste and artistic discipline asserted themselves in the magnificent cave temples at Lungmen close to the second Northern Wei capital at Loyang (*plate 72*). Here, the emphasis was on formal, linear and geometric schemes which deny the human figure in favour of a conventionalized, often mysterious, façade. The evolution of early Buddhist sculptural style typifies and characterizes the processes by which imported artistic styles or ideas were adopted, before being adapted and reformed into a style entirely and recognizably Chinese (*plate 73*). Concepts of naturalistic representation in the late Bronze Age and in the Han dynasty had been similarly adapted by Chinese craftsmen, but by comparison with the wholesale adoption of a faith and its iconography, this was but a tentative preface. This process, sometimes but clumsily termed 'sinicization', was to be particularly evident in the artistic achievements of the succeeding T'ang dynasty.

The importance of Buddhism in the art of north China during the 4th to 6th centuries reflects the general tendency away from traditional concepts of Imperial patronage, and the hieratic styles which had so dominated during the Bronze Age and which were still present in the Han. Buddhist art apart, the energies of the artist craftsmen of the time were directed towards the making of mortuary furnishings. The bronze tradition having ceased, the development of pottery facsimiles, which can be traced back to the painted pottery vessels of the Warring States period, continued apace. The glorious and evocative range of pottery models of figures, horses and animals which were made in the Han was somewhat restricted during the lean years of the 3rd to 4th centuries. But the degree of security and continuity which the Northern Wei, and their neighbours the Northern Ch'i, managed to establish, stimulated a considerable regeneration of the tomb figure tradition.

It is pertinent to note, however, that the repertoire of subjects changed dramatically. Models of peaceful farmyards, serene attendants and lively entertainers were replaced by models of soldiers, cavalrymen, military horses and severe looking 'officials' (*plates 74, 75*). Such tomb furnishings and accoutrements may be considered appropriate and accurate reflections of the climate and concerns of the time.

By the 6th century, a degree of technical accomplishment and stylistic sophistication may be detected in some of the ceramic wares of north China. High-firing techniques and the application of feldspathic

glazes, which had developed in the south, were by this time filtering through to the north. Lead glazes, which had first appeared in the Han dynasty but subsequently fallen into comparative obscurity, also reappeared on the full-bodied jars typical of Honan province (*plate 76*). The use of foreign inspired decorative elements, such as the lotus petals and palmette scroll of Buddhist origin and exotic western Asian figurative themes to the pilgrim flasks (*plate 77*), are also characteristic features of the ceramic wares of north China in the 6th century. Most assuredly such themes would never have been employed in the decorative schemes of southern ceramics at that time.

The maintenance of native lineage in south China naturally produced a more cohesive and characteristically Chinese cultural and artistic tradition. The impact of the Buddhist church was far less noticeable south of the Yangtze although the faith enjoyed limited acceptance there. So dominant was the ceramic tradition that it is tempting to consider the southern Chinese states of the 3rd to 6th centuries as lacking in cultural and artistic vision and adventure. But, in retrospect, the contributions made to the development of ceramic technology are so vital that they cannot be underestimated.

Indeed, the whole range of new and purely ceramic inspired forms is testimony to the achievements of the southern craftsmen. And there is no lack of imagination, or technical virtuosity, in such early 4th century vases surmounted with a conglomeration of buildings and figures, which were characteristic of Chekiang province (*plate 78*).

After the fall of the short-lived Western Chin the south saw a succession of weak and insubstantial dynasties. But the Chinese people remained fiercely loyal to the traditional constitution and the role of the Emperor as mediator between man and Heaven. The destruction which the barbarian invaders inflicted on the north did not materially affect the south, and gradually a sense of unity and purpose emerged, though the governments came and went. These enduring traditions of Chinese civilization found their most fulfilling expression in the various fields of cultural endeavour (*plate 79*). The ancient capital of Chien-k'ang, the modern city of Nanking, soon became a flourishing centre for the arts as well as the seat of governments. Painting, calligraphy, music and poetry were especially favoured pursuits at the Courts of the southern dynasties, which appeared to adopt a deliberate policy of pursuing the more esoteric arts, perhaps to shield themselves from the reality of a China divided by the invader.

South of the capital at Nanking, in southern Kiangsu and northern Chekiang provinces, great strides were made in the development of ceramic technology. The Chinese concentrated their practical creative energies towards the development of high-fired wares, or stonewares, with feldspathic glazes of grey-green colour. These wares took the name Yüeh, after the name of the ancient Warring States kingdom which had controlled most of the eastern coastal provinces. Technological advances in the control of kiln conditions produced wares of a hard fine-grained body and permitted scope in the refinement of forms which owe no allegiance to any tradition, other than a purely ceramic one. Great efforts were made to attain purity in the glaze colour; originally the impurities caused the thin glaze to oxidize and discolour, but by the 4th and 5th centuries virtually clear, semi-translucent green and grey glazes were commonplace. The achievements of the ceramic industry of south China in the 3rd to 5th centuries inspired the regeneration of that tradition in the north in the 6th century, and indeed provided the foundations to a long history of green-glazed wares that was to become a significant feature of China's ceramic art.

Just as the political fragmentation of the period of division defies characterization, so does its culture and art. Developments in the south and the north followed different paths and neither events nor achievements in these two broad divisions necessarily coincided or related. Nevertheless, when forced to coalesce under the reunification of China at the end of the 6th century, they provided the foundations for the classic age of Chinese art and achievement.

Bibliographical references
Brewitt-Taylor, C. H., *San Kuo, or Romance of the Three Kingdoms*, 2 vols., Shanghai 1925. A translation of the famous novel.
Ch'en, Kenneth K. S., *Buddhism in China*, Princeton 1964. Describes the introduction and development of the Buddhist faith in China. For a fuller account see, E. Zürcher, *The Buddhist Conquest of China*, 2 vols., Leiden 1972 (reprint).
Gompertz, G. St.G. M., *Chinese Celadon Wares*, London 1958. For an introduction to the development of celadon wares of the period.
Mizuno, S. and Nagahiro, T., *Unko Sekkutsu: Yün Kang* (The Buddhist Cave Temples of Yün-kang), 16 vols., Kyoto 1951–6. A complete and detailed study of the Yün-kang cave temples.
Mizuno, S. and Nagahiro, T., *Ryumon Sekkutsu no Kenkyu* (A Study of the Buddhist Cave Temples at Lung-men), Tokyo 1941.
Nagahiro, T., *The Representational Arts of the Six Dynasties*, Japanese and English text, Tokyo 1969.
New York: China House Gallery, *Art of the Six Dynasties*, exhibition catalogue by Annette Juliano, New York 1975. With an introduction giving a brief historical background to the period and a discussion on the development and diversity of artistic style.
Sickman, L. and Soper, A., *The Art and Architecture of China*, Harmondsworth 1968 (paperback 1971). For a concise introduction to the Buddhist sculpture of China.
Soper, A., "South Chinese Influence on Buddhist Art of the Six Dynasties Period", *Bulletin of the Museum of Far Eastern Antiquities*, Stockholm, no. 36, 1960. An illuminating study on the possible origins of the 'Chinese' style of Buddhist sculpture which developed in the late 5th century in north China.

71

*The main seated Sakyamuni Buddha
in Cave 20 at the Yün-kang cave temples,
near Ta-t'ung in north Shansi province.
These earliest representatives of the
monumental figurative stone carving
tradition in China display an
overwhelming dependence upon the style
of the Buddhist sculpture of Gandhara.
Work on carving the temples at
Yün-kang, into the sandstone cliff-face,
began in* A.D. 460 *and largely ceased
in* A.D. 494 *when the Northern Wei
rulers removed their capital from
Ta-t'ung to Loyang in Honan province.*
Northern Wei dynasty : A.D. 460–470
Total height of principal seated
Buddha : approximately 45 feet
(approx. 13.8 m)

72
*Standing figure of Sakyamuni Buddha
in the Pin-yang (central) cave at the
Lung-men temples near Loyang
in Honan. Unlike the comparatively soft
sandstone at Yün-kang, the Lung-men
caves were carved into a hard grey
limestone cliff over-looking the I River,
a tributary of the Yellow River.
These carvings illustrate a mature
'Chinese' sculptural style in which
concepts of formalism over-ride the
naturalism of the original
Gandhara style.*
Northern Wei dynasty: circa A.D. 520
Height of Buddha figure:
approximately 10 to 12 feet.

73

*Sandstone Buddhist stele carved with scenes from
the* Vimalakirti sutra; *in the centre the
principal seated figure is Sakyamuni Buddha.
The rounded top is composed of dragons.
Stylistically related to the sculptures of the
Lung-men caves, the cascade of formalised
draperies and energetic, but regular, pleats and
folds represents the peak of the early 6th century
sculptural style.*
Northern Wei dynasty: dated by inscription to
A.D. 520
Height: 173.5 cms
Victoria & Albert Museum

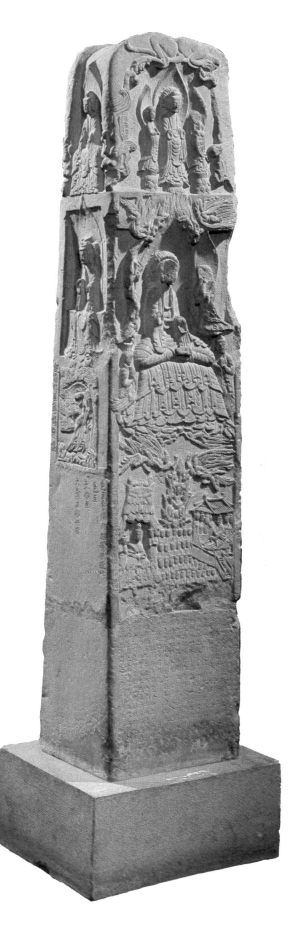

76

*Green and brown-glazed stoneware jar
decorated with petal-shaped lappets and
four handles. Excavated in 1958 at P'u-yang in
Honan province.*

*(London etc. exhibition, cat. no. 241;
Australia exhibition, cat. no. 168).*

Northern Ch'i dynasty: A.D. 549 to 577

Height: 23.5 cms

China

77

*Brown-glazed earthenware flask decorated with
relief-moulded figures in exotic Western Asiatic
style. This so-called pilgrim flask is modelled on
the leather bottle used by travellers across
Central Asia as water, or wine, containers.
Excavated in 1971 from the tomb of General
Fan Ts'ui at Anyang in Honan province.*

*(London etc. exhibition, cat. no. 242;
Australia exhibition, cat. no. 167).*

Northern Ch'i dynasty: from a tomb dated
A.D. 575

Height: 20.3 cms

China

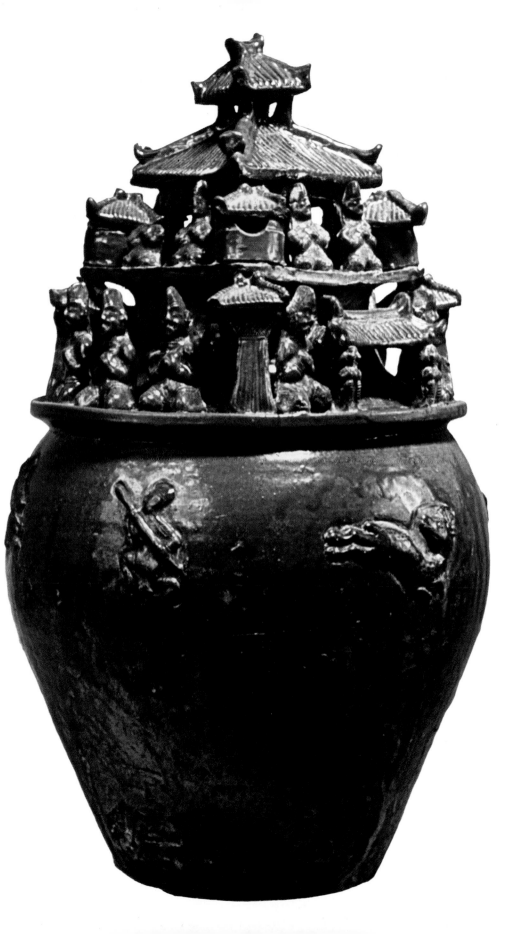

78
Green-glazed stoneware jar surmounted by a
conglomeration of buildings and figures.
Excavated in 1965 at Shao-hsing in
Chekiang province.
(*London etc. exhibition, cat. no.* 235;
Australia exhibition, cat. no. 163).
Western Chin dynasty : A.D. 265–316
Height : 46.6 cms
China

79

*Detail of a figurative and landscape engraving
on the side of a stone sarcophagus. The scenes
depicted are representative of filial piety.
These engravings particularly illustrate
the tendencies towards a figurative style and the
interest in developing the landscape theme.*
Length of sarcophagus : circa 200 cms
Maximum height : circa 63 cms
Northern Wei dynasty : early 6th century
*William Rockhill Nelson Gallery of Art,
Kansas City.*

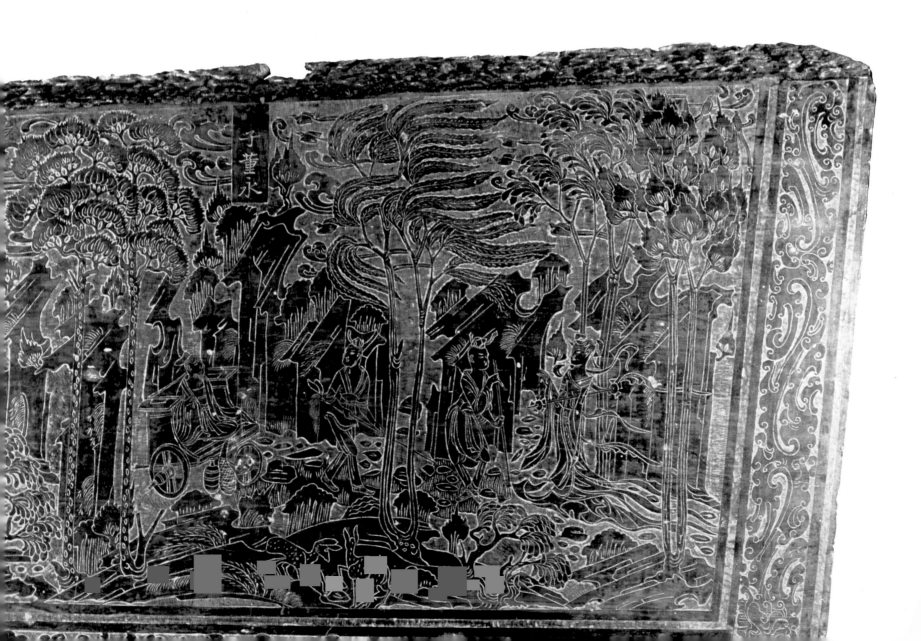

隋・唐

Sui and T'ang Dynasties (A.D. 581 - 906)

The founding of a second enduring and centralized dynasty heralded the classical age in Chinese history. No doubt inspired by the distant but not forgotten glories of the Han Empire, the T'ang established a civilization as vigorous, creative and productive as any the world has seen.

Seldom, if ever, has the ancient world experienced such wealth and inspiration as that engendered in the supremely confident and cosmopolitan capital of the T'ang Empire at Ch'ang-an. This city of nearly two million people was most emphatically the capital and heart of T'ang China: the focus of commercial, court and cultural activity. The ancient metropolis and its environs have yielded a seemingly inexhaustible flow of archaeological treasures. Amongst the endless stream of travellers, visitors, merchants, officials and tribute-bearers to Ch'ang-an from all parts of Central and Western Asia was the Arab Ibn Wahhāb who, upon his return home in the early 9th century, recorded this evocative account of the heart of the great T'ang Empire:

"The city was very large, and extensively populous; that it was divided into two great parts by a very long and broad street; that the Emperor, his chief ministers, the soldiery, the supreme Judge, the eunuchs, and all belonging to the Imperial Household, lived in that part of the city which is on the right hand eastward; that the people had no manner of communication with them and they were not admitted into the places watered by canals from different rivers, whose borders were planted with trees and adorned with magnificent dwellings. The part on the left hand westward, was inhabited by the people and the merchants, where were also great squares, and markets for all the necessaries of life. At break of day you see the Officers of the King's Household, with the inferior servants, the purveyors, and the domestics of the grandees of the Court, some on foot, others on horseback, who come into that division of the city where there are public markets, and the inhabitations of the merchants, where they buy whatever they want, and return not again to the same place till the next morning."

But Ch'ang-an was not the only city visited and inhabited by travellers and merchants; others too captured something of the kaleidoscope of colour and exoticism of Ch'ang-an. Loyang in Honan province, for example, was a busy commercial city endowed supposedly with a 'spiritual atmosphere' milder and more elegant than its westerly counterpart. Indeed Loyang was the 'Godly Metropolis' of the renowned Empress Wu. In the south, Canton was already an important commercial entrepôt, as well as something of a frontier post on the edge of the tropical wildernesses of South-east Asia, then populated by "savage peoples and wild beasts". Indian, Sinhalese, Persian, Arab and Malay traders congregated in the markets of Canton, bringing "aromatics, drugs and rare and precious things", and leaving with "cargoes heaped like hills" of silks, chinaware and even slaves.

The foundations of all this wealth, vigour and profound achievement were laid towards the end of the 6th century. A certain general, Yang Chien, usurped the throne of the decaying Northern Chou dynasty, which had extended its hold over most of north China by overrunning

its neighbours, the Northern Ch'i. With almost suspicious ease, Yang Chien established the Sui dynasty in 581, and by 589 he had conquered the last remaining southern state. China was once again united.

The role of the Sui dynasty in Chinese history has justifiably been likened to that of the Ch'in; the historical circumstances and consequences bear close comparison. Both followed upon a long period of desperate internecine conflict; both were founded in the Legalist concept by a man of uncompromising strength and considerable ability; both were intensely practical; both were exceedingly short-lived; and finally, both immediately preceded dynasties of such magnificence that they are virtually legendary.

Yang Chien, who adopted the name Wen Ti or 'Cultured' Emperor, vigorously worked to reconstruct the Empire. Like his successor, Yang Ti, he was probably overly ambitious, but his material achievements were nonetheless impressive and substantial. He created a strong centralized administration; ordered the reconstruction of the Great Wall at prodigious human cost, as well as the digging of long canals to link the Yangtze and Yellow Rivers, the establishment of communications systems and the creation of huge palaces. Above all, he reinstated the prestige of China. Territorial gains were relatively slight, but the reunification of China proper in so short a time was achievement enough, before the Sui collapsed after just 37 years' rule (*plate 80*).

By his relentless pursuit of material construction and reconstruction, Yang Ti also alienated himself from his people. Revolts broke out and much of his credibility was lost in a disastrous campaign against the Korean kingdom of Koguryō in northern Korea and southern Manchuria in A.D. 612. In A.D. 615, his armies were defeated by the Eastern Turks who had hitherto been his loyal subjects. He fled to the south and was subsequently assassinated in A.D. 618. His departure from the north left a vacuum which was filled by contending war-lords.

The man who emerged victorious was a one-time prominent Sui official named Li Yüan. Urged on by his extraordinarily ambitious son, Li Shih-min, and aided by Turkish allies, the old Li captured Ch'ang-an in A.D. 617. Li Yüan was proclaimed Emperor in the following year and the T'ang dynasty was founded. Under the constant eye of his watchful and eager son, Li (known to posterity as the Emperor Kao Tsu) set about the task of restoring peace and order to China. Within a decade this had been achieved.

Li Shih-min formally ascended the throne upon the death of his father in A.D. 627, and assumed the title T'ai Tsung. Though he died in A.D. 649 at the age of 59, T'ai Tsung's comparatively brief reign represents the first great period in the history of the T'ang dynasty. He was one of the two truly outstanding Emperors of the T'ang. He quelled the Turkish threat, extended Chinese suzerainty over the Tarim basin, then took over territories beyond the Pamir mountains to the Oxus valley and into modern Afghanistan. Tibet, which had been unified for the first time in A.D. 607, also came under the suzerainty of the T'ang. In the south, he created Annam (from 'an-nan' – 'pacify the south'), which is

today a part of Vietnam, whilst in the north Mongolia and southern Manchuria were quickly incorporated into the T'ang's irrepressible empire.

T'ai Tsung's only failure occurred in Korea, where his armies twice were repulsed by the Koguryō. It was his successor, Kao Tsung, who defeated the Koreans with the aid of the Silla from the southern regions of the peninsula. Thus, a unified Korea became a loyal state of the T'ang.

It is fitting that T'ai Tsung's most enduring memorial should depict the magnificent horses which played so vital a role in his exploits (*plate 81*). Consisting of carved stone reliefs from his sarcophagus, they now reside in the Shensi Provincial Museum at Sian (on the site of ancient Ch'ang-an), although two sections are located in the University Museum in Philadelphia.

Although T'ai Tsung is remembered for his military adventures and vast territorial acquisitions, he was evidently an able and conscientious administrator. Building on the achievements of the Sui, he instituted a rigid but democratic 'Equal Field' system of land tenure, and an accompanying tax structure which maintained the considerable Imperial expenses without draining the peasants and landlords of their livelihoods. The 'Equal Field' system, which had originated in the late 5th century under the Northern Wei, was based on the assigning of agricultural lands of specific dimensions to adult able-bodied peasants. Thus, it stemmed the flow of property into the great land-owning families without necessarily reducing their estates and, as employed in the Sui and the T'ang, greatly encouraged the opening up of new productive lands.

The role of the woman, or the woman behind the throne, is notorious in Chinese history. In fact, one of the more remarkable figures of the T'ang dynasty was a woman, the Empress Wu. In a sense, she characterizes the excitement of the T'ang by a unique achievement, unmatched even by the infamous Empress Dowager Tzu Hsi in the dying years of the Ch'ing dynasty. In A.D. 690 Empress Wu assumed the title of Emperor and ruled China for some 15 years. Wu Chao, as she was known, entered the Court at the tender age of 12, in A.D. 637 as a concubine to T'ai Tsung. After his death, Wu gained the favours of his successor, Kao Tsung, who although good-natured was not much given to devoting his energies to the affairs of state. Increasingly, Wu Chao, by that time his consort, took over the duties of government and upon the Emperor's death she assumed the throne.

It is difficult to assess the effect of a woman holding the 'Mandate of Heaven' on the people of China. The T'ang was at its height, controlling the Middle Kingdom, large sections of Central Asia and the peripheral regions, and her prosperity and well-being were without parallel. Certainly, there is no evidence to suggest her rule diminished the country's artistic and cultural pursuits in any way. The arts in all probability flourished under her aegis and certainly Buddhism and Buddhist art profited from her fervent support of the faith. She was the prime mover behind Kao Tsung's commissioning the construction of the massive Feng-hsien temple at the Lung-men caves near Loyang – that city she had termed as her "Godly Metropolis" (*plates 82, 83*).

Although the reign of Empress Wu was unparalleled in the history of China, and although the T'ang Empire sustained itself in might and wealth, the period of her rule was comparatively uneventful. Her immediate successor, Chung Tsung, posed a real danger to the T'ang hierarchy by his inadequacies. Fortunately the situation was recovered by a nephew of the Emperor, a certain Li Lung-chi, who assumed the throne as Emperor Hsüan Tsung, or Ming Huang, in A.D. 712. Far from descending into chaos and obscurity, the T'ang empire reached its apogee during Ming Huang's long reign, which endured until A.D. 756. His adopted title, Ming Huang meaning 'enlightened Emperor', was surely the most apt for any ruler of China.

He secured the Empire for another 40 years during which the arts flourished under his cultivated patronage. During his reign, some of the greatest Chinese poets and painters were inspired to their finest achievements. The concept of direct Imperial patronage in areas of academic and cultural interest, and the sheer pleasure which the Emperor obviously obtained from poetry and music, is best demonstrated in his founding of the famous Hanlin Academy. In later centuries, membership of this literary and cultural institution became one of the most highly prized of honours. At court the Emperor entertained famous poets, such as Li Po and Tu Fu, and painters of now legendary prowess. A flavour of the bracing intellectual atmosphere, tinged perhaps with a touch of decadence, is evident in this extract from Li Po's poem 'To His Old Friend Hsin':

> Long ago, among the bowers and willows,
> We sat drinking together at Ch'ang-an.
> The Five Barons and Seven Grandees were of our company
> But when some wild stroke was afoot
> It was we who led it, yet boisterous though we were
> In the arts and graces of life we could hold our own
> With any dandy in the town –
> In the days when there was youth in our cheeks
> And I was still not old.
> We galloped to the brothels, cracking our gilded whips
> We sent in our writings to the Palace of the Unicorn,
> Girls sang to us and danced hour by hour on tortoise-shell mats.
>
> (*from a translation by Arthur Waley*)

Virtually no works have survived which can with certainty be attributed to the great painters of the time, such as Wu tao-Tzu, Wang Wei and Han Kan. But the latter was renowned for his paintings of horses, animals of critical importance to the expansive T'ang in both commercial and military terms. Wu Tao-tzu and Wang Wei are regarded as the great inspirational forces in establishing the landscape theme, which would dominate later Chinese painting. Although

attracted to the mystics of Taoism, Ming Huang also explored the Buddhist faith and actively encouraged the construction of temples and the making of icons. His was indeed a reign of prodigious cultural activity and achievement.

All the while, trade and commerce were booming, the people prospering, and the T'ang Empire revered throughout Asia as the most commanding the Eastern world had ever known.

But the first signs of a reversal of fortunes occurred in 751, when Chinese armies were defeated by the Arabs in Central Asia. The battle took place in the Ferghana region to the west of the Tarim basin, the original source of the renowned Ferghana horse portrayed by the artists and craftsmen of the Han and T'ang dynasties. This was not an isolated event. Troubles accumulated for the Chinese leaders, particularly in the border regions. In the north-east the Khitan Mongols threatened, and in the south-west the Nan Chao, a Thai state in modern Yünnan province, defeated their Chinese overlords. But the critical confrontation was that in the wastes of Central Asia, for this presaged the loss of T'ang control over much of the trade route so vital to the Chinese economy.

At home, financial problems were gathering force; perhaps neither the Court nor the people were aware of it at that time, but the underlying wealth of China, essential to the maintenance of the Empire, was being threatened. But the attentions of the Court of the T'ang were then absorbed by a classic scandal which has become renowned in the history of China. A famous beauty, Yang Kuei-fei, once a wife of one of the Emperor's sons, was taken into his own household in A.D. 738 and immediately became his 'Precious Consort'. She encouraged the ageing ruler to indulge in every kind of gaiety and extravagance and was no mean spendthrift herself. Stories of her abound; it is, for example, recorded that no less than 700 weavers were devoted entirely to providing silks for her alone. It is little wonder that the very core of the mighty T'ang Empire was showing signs of corruption and decadence. Yang sought to assure her own future by gaining powerful positions in the administration for members of her family, quite irrespective of their ability.

The inevitable sequel to these events was rebellion. Ironically, it was led by a boisterous general of barbarian stock who, it was rumoured, had gained great power and influence through his associations with the insatiable Yang Kuei-fei. In 755, this man, An Lu-shan, unleashed his forces on Ch'ang-an and caused the Emperor to flee to Szechwan in the remote south-west; this flight has become immortalised in a magnificent painting in the so-called 'blue and green' style of landscape which flourished in the later T'ang (*plate 84*). In a fairy-tale landscape of winding valleys and ruptured peaks encircled by wispy clouds, the Emperor and his small caravan seem entirely at peace, in spite of their desperate circumstances.

Although peace and order were restored to the Middle Kingdom in A.D. 766, the magic spell of the T'ang had been broken. From the time of

the An Lu-shan rebellion, the dynasty followed a path of gradual but irreversible decline. The Empire shrank under the persistent pressures of the Turks, Mongolians and Tibetans who eroded not only the territory of the T'ang, but also their wealth and confidence.

The golden age of Chinese art, so inspired and supported by the wealth and excesses of a powerful and extroverted Court hierarchy, was also at an end. The tremendous patronage afforded the arts had been reflected in the quality, quantity and diversity of artistic endeavour, in Buddhist sculpture and painting, in ceramics, metalwork and Court painting. Suddenly it diminished almost to the point of extinction. The Court and the administration directed their concerns and resources to maintaining their positions, and so the vast entourage of artists and craftsmen receded into comparative obscurity. The painters, in particular, retired to the dramatic but serene mountainous landscapes for solace and inspiration, thereby providing the foundations for the great tradition of monumental landscape painting which was to follow in the succeeding Sung and Yüan dynasties.

There is a colour and vivacity to T'ang art which transcends the traditional qualities of reserve and formalism, without ever denying them, or the great traditions of earlier Chinese art.

In no sphere of activity is this exciting freedom from hierarchical constraints better illustrated than in the tomb figure tradition. The enormous and widespread wealth of the T'ang caused a fantastic proliferation of mortuary art, and tomb figures in particular. Building upon the visions of naturalism and three-dimensional sculptural concepts, which can be traced back to the monumental pottery figures of the Ch'in Shih Huang-ti burial, the tradition produced an extraordinary range of models of unrestrained colour, expression and beauty, under the T'ang. They are not just works of art, but also valuable historical documents.

The crucial importance of the horse in the social, Imperial, military and commercial life of the T'ang is demonstrated in the sheer quantity of models made; well over 250 such figures were, for example, recently recovered from just one tomb, that of the T'ang Prince I Te dated to A.D. 701 (see plate 85). Figures of the magnificent and sturdy Central Asian horse vary in size from the massive (plate 86) to the comparatively handy. Like all tomb figures, they were either glazed, in rich tones of cream, green, tan or blue, or left unglazed but painted with rich detail in an even greater range of colours often embellished with luxuriant gilding. Many recently excavated examples, such as those from the Yung T'ai and I Te tombs, have enormously enhanced our knowledge and appreciation of the variety of such techniques (plate 87). Models of horses and riders provide a tantalizing glimpse into the multitude of roles which the horse fulfilled in T'ang China: cavalrymen, polo players, hunters, often with leopards or cheetahs in attendance, musicians and court ladies are all depicted in the saddle (plate 88).

The camel evidently was second to the horse as a beast of burden in T'ang society. The two-humped Bactrian camel laboured endlessly across the long trade routes carrying loads of rich silks to the markets of Central and Western Asia. From there, it returned with cargoes of gold, silver and glass for the markets of Ch'ang-an (plate 89). Camels were maintained in vast government herds, like horses. Although no accurate figures have been preserved, it is recorded that in A.D. 754 there were 279,900 cattle, sheep and camels in the Imperial herds. It is also pertinent to note the dictum of the famed T'ang poet Tu Fu that, "Western boys have power over camels", for both tomb figures (see plate 89) and literary references agree that only foreigners were employed as herdsmen, trainers and cameleers.

The representations of ferocious-looking guardians to fend off sickness and evil were essential to the maintenance of a proper spirit and atmosphere in the tomb (plate 90). Noble and dignified models of attendants and advisers were also placed in the tomb, along with musicians, plump-faced ladies of the Court, servants, dancers from South-east Asia (plate 91) and grooms from Central Asia (plate 92) – in fact, models of all those who served or attended in the household. On the walls of the tomb, colourful paintings reflect the pottery figures of Court ladies dressed in long, flowing and characteristically high-waisted robes (plates 93, 94), and pictures of hunting scenes and ranks of officials (plate 96). Fine engravings in the coffin or sarcophagus similarly reflect the grace and beauty of the T'ang figurative style (plate 95). T'ang tombs were further embellished by less emphatically mortuary works of art. Ceramics maintained their numerical supremacy, including richly san-ts'ai (three-coloured) lead glazed earthenware bowls, vases and dishes (plate 97) and early porcelains (plate 98), while in the south examples of a continuing Yüeh ware tradition have been found (plate 99).

A major influence throughout T'ang art was the constant influx of new ideas from Western Asiatic sources. In purely artistic terms, these notions found their fulfilment in the Chinese tradition through the limited but rewarding field of T'ang gold and silver work – for example, a recently excavated octagonal cup ornamented with human figures which closely resembles its Iranian counterpart. Other examples show that the Chinese craftsmen quickly imposed their own ideas of formalism, such as the gold bowl with a well-ordered and balanced design of lotus petals in repoussé (plate 100). Totally Chinese in character and tradition are the bronze mirrors, although even these sometimes display elements of Western design, such as the grape-vine pattern (plate 101).

T'ang art is dominated by the excitement of works produced at the hub of a vast and cosmopolitan Empire, accepting influence and concepts from afar, but never to the detriment of its essentially Chinese character. Without doubt, Ch'ang-an was the focus of cultural activity, and the majority of cultural and historical relics of the period have been recovered in the vicinity of the site of the T'ang capital. Loyang, clearly the second city of the T'ang, maintained a significant role and, of course, predominated in the field of Buddhist sculpture, particularly with the considerable extensions to the Lung-men cave temples. Here again, the

essential quality of naturalism permeated even the conventionalized schema of Buddhist iconography, and by the early 8th century sculptural art was displaying a real concern for the expression of the volumes and relative proportions of the figure (*plate 102*).

Due to the constant emphasis upon activities in the north, the southern regions of China tend to become neglected in any consideration of T'ang art. However, the Yüeh ware ceramic tradition continued to develop in Chekiang province and was to flourish in the succeeding Sung period; and new ceramic traditions were emerging in the Ch'ang-sha area of Hunan. But in the final analysis it is to the north that one must turn to savour the tremendous vitality and creative genius which was expressed in the art of the T'ang dynasty.

Bibliographical references

Gyllensvard, B., "T'ang Gold and Silver", *Bulletin of the Museum of Far Eastern Antiquities*, Stockholm, no. 29, 1957.

Los Angeles County Museum, *The Arts of the T'ang Dynasty*, Los Angeles 1957. Catalogue of a major exhibition on the arts of the T'ang dynasty written by Henry Trubner.

Mahler, Jane G., *The Westerners Among the Figurines of the T'ang Dynasty of China*, Rome 1959. A study of the foreigners represented in T'ang mortuary art.

Mizuno, S. and Nagahiro, T., *Ryumon Sekkutsu no Kenkyu* (A study of the Buddhist Cave Temples at Lung-men), Tokyo 1941.

Pulleybank, E. G., *The Background of the Rebellion of An Lu-shan*, London, New York and Toronto 1955.

Reischauer, E. O., *Ennin's Travels in T'ang China*, New York 1955. Records of a Japanese diarist who stayed in China between AD 838 and 847.

Reischauer, E. O. and Fairbank, J. K., *East Asia: The Great Tradition*, Boston 1958 and 1960. An historical survey of China which gives an account of the "Equal Field" system.

Schafer, Edward H., *The Golden Peaches of Samarkand: A Study of T'ang Exotics*, Berkeley and Los Angeles 1963. An evocative and lively account of the "fairylands of commerce" and of the fascinating world of the T'ang dynasty.

Shensi Cultural Committee, "T'ang yung-t'ai kung-chu mu fa-chüeh chien-pao" (Report on the excavation of the tomb of the T'ang Princess Yung T'ai), *Wen Wu*, 1964, no. 1.

Shensi Provincial Museum, "T'ang i-te t'ai-tzu mu fa-chüeh chien-pao" (Report on the excavation of the tomb of the T'ang Prince I Te), *Wen Wu*, 1972, no. 7.

Watson, William (ed.), *Pottery and Metalwork in T'ang China*, London (Percival David Foundation) 1970. Proceedings of a colloquy held at the University of London on T'ang pottery and metalwork with special reference to Western Asiatic influences.

80

Pottery figure of a tomb guardian; stoneware
with creamy white and dark brown glazes.
Excavated in 1959 from the tomb of General
Chang Sheng at Anyang in Honan province.
(London etc. exhibition, cat. no. 262;
Australia exhibition, cat. no. 172).
Sui dynasty: from a tomb dated A.D. 595
Height: 71 cms
China

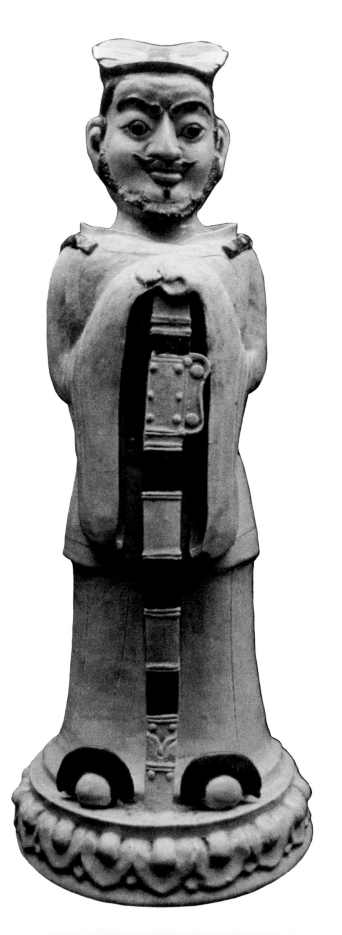

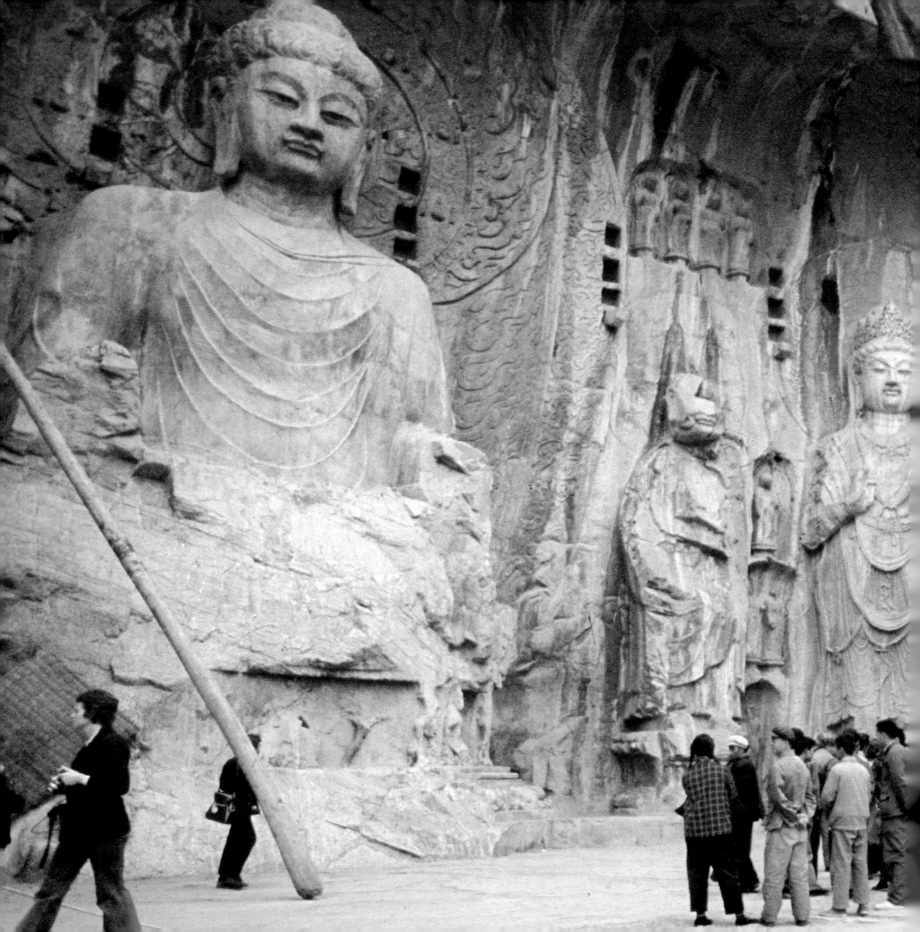

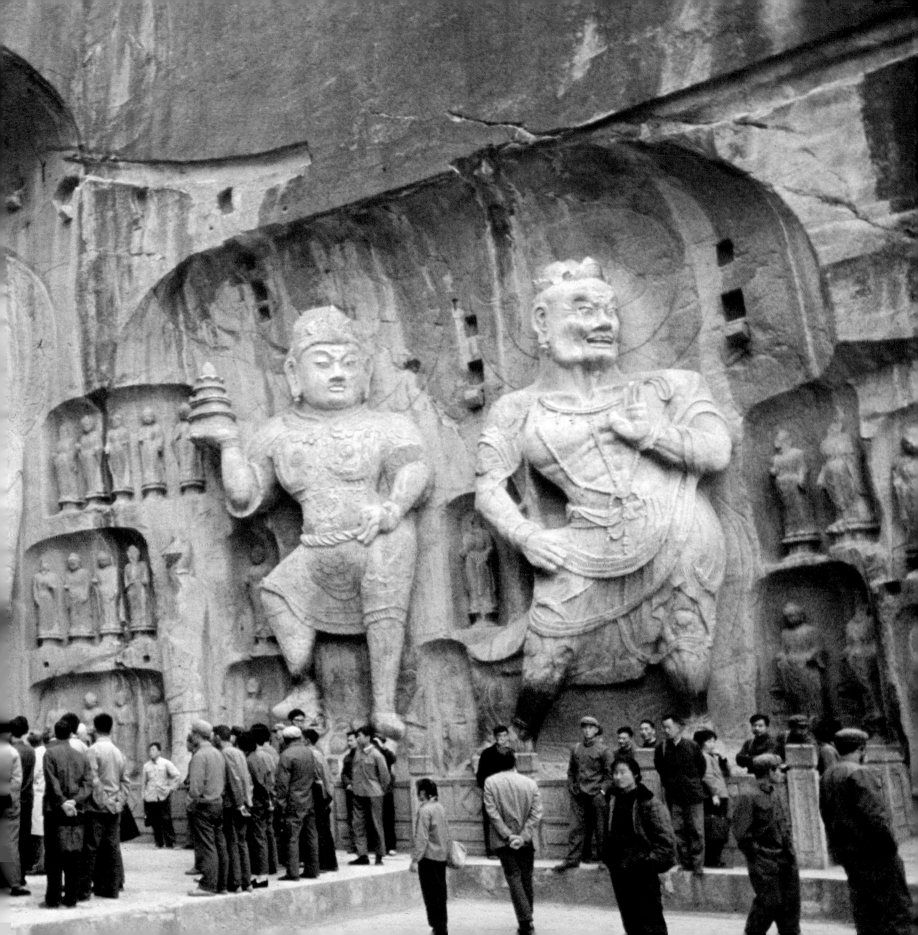

81 (*overleaf*)
A close-up of the sculpture of the Feng-hsien temple at Lung-men. The realism characteristic of the T'ang is amply illustrated in these monumental carvings; particularly in the lively representations of the heavenly kings and dvārapālas flanking the main seated figure of Vairocana Buddha. The standing figures of Bodhisattvas, however, retain earlier features in their stiff pose and more conventionalised drapery folds and patterns.
T'ang dynasty: work on the central figure commenced in A.D. 672 and was completed in A.D. 675
Height of central seated Buddha, including base: circa 50 feet (15.25 m.)

82
General view of the Buddhist cave temples at Lung-men, near Loyang, in Honan province, showing the vast carvings of the Feng-hsien ssu. The carving of this massive temple was commissioned by the Emperor Kao Tsung (reigned A.D. 650–683).
A wooden structure originally protected the temple and its sculptures, but this has long since disappeared.

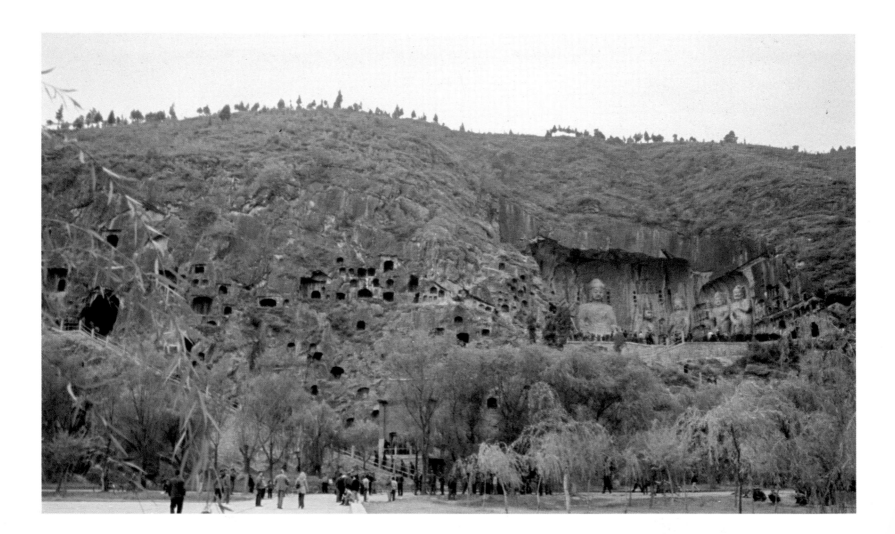

83

One of six stone slabs from the sarcophagus of the T'ang Emperor,
T'ai Tsung; carved in relief from a grey limestone these horses exude the
strength and power which so endeared them to the T'ang Emperor.
T'ang dynasty: the tomb was constructed circa A.D. 637
Height: circa 5 feet 6 inches (168 cms)
Shensi Provincial Museum, Sian

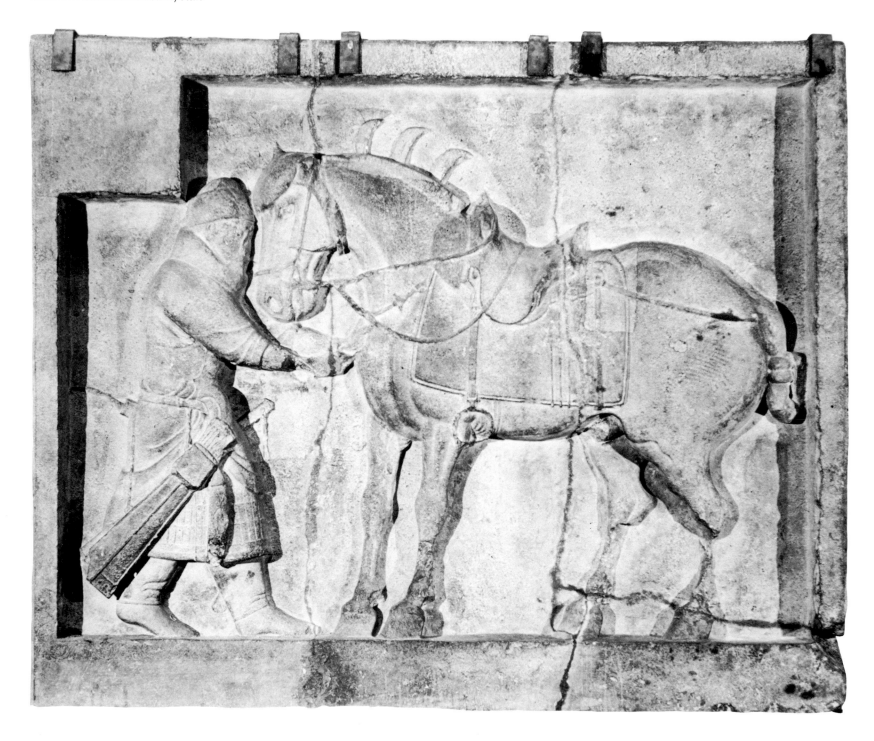

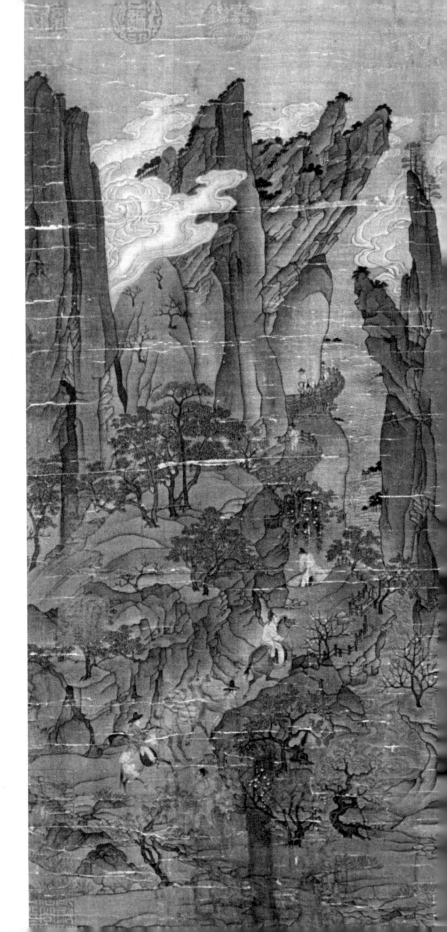

84
Painting in the T'ang 'blue and green' style of
Emperor Ming Huang's flight to Shu
(Szechwan).
Anonymous; colours and ink on silk.
Possibly T'ang dynasty; 8th century
55.9 × 81 cms
National Palace Museum, Taiwan

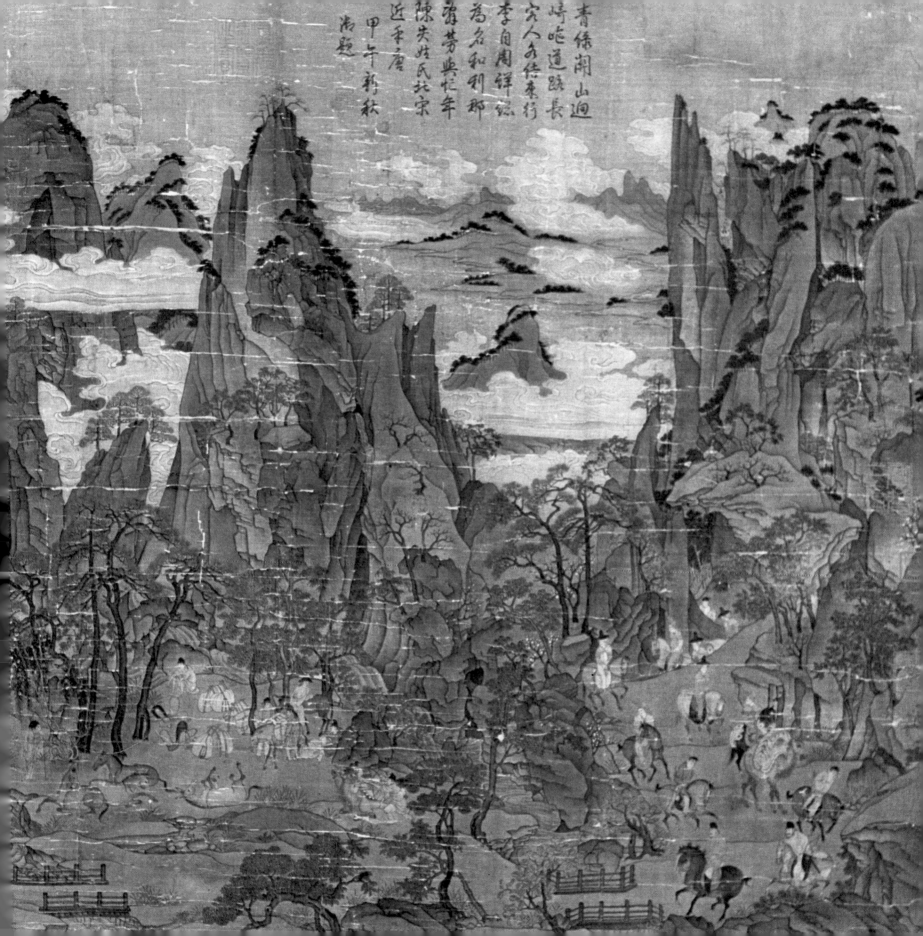

青綠湖山迥
嶒峙道路長
宋人多倚東行
李自周詳錄
為名和利耶
聲芳與忙年
陳失姓氏玄宗
近乎唐
甲午新秋
溥題

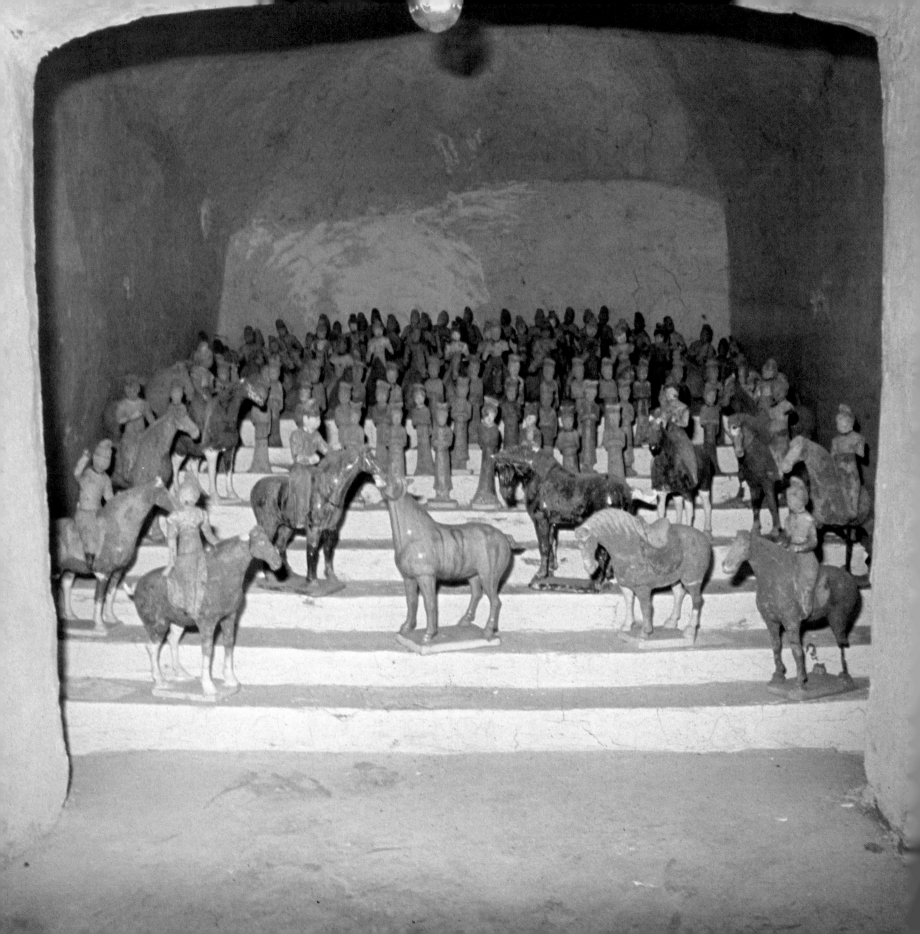

86
Large pottery model of horse with coloured lead glazes.
T'ang dynasty : early 8th century
Length : 80.5 cms, height : 75 cms
Victoria & Albert Museum

85
A niche filled with tomb figures in the tomb of Princess Yung T'ai at Ch'ien-hsien, to the west of Sian in Shensi province. A number of such niches were built into the walls of the passage to the tomb chamber, and all were filled with such tomb figures of horses, guardians, grooms, soldiers, etc., other ceramics, silver works and mortuary furniture.
T'ang dynasty : A.D. 706

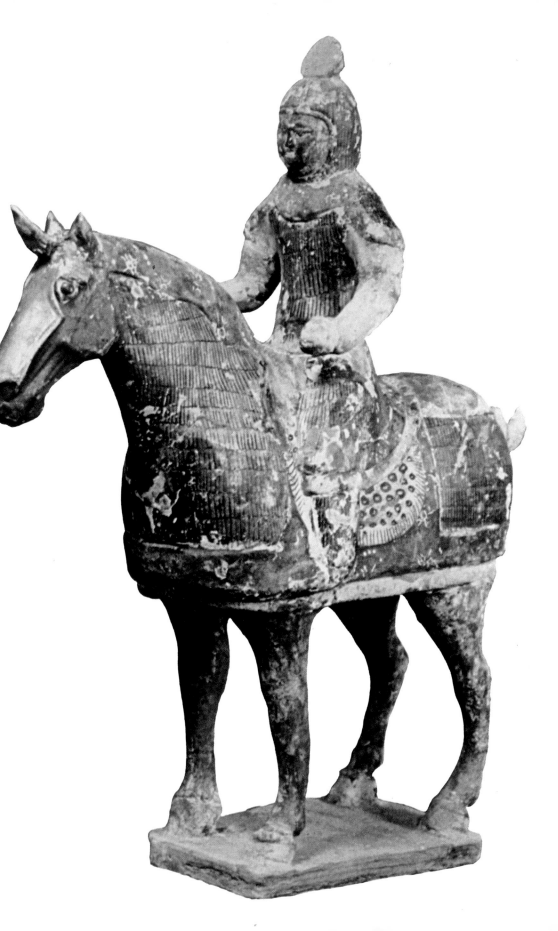

87
Pottery model of a horse and rider ; unglazed and
with painted details, the nosepiece of the horse
gilded. Excavated in 1972 *from the tomb of*
Prince I Te at Ch'ien-hsien near Sian.
T'ang dynasty : A.D. 701
Height : 35 cms
China

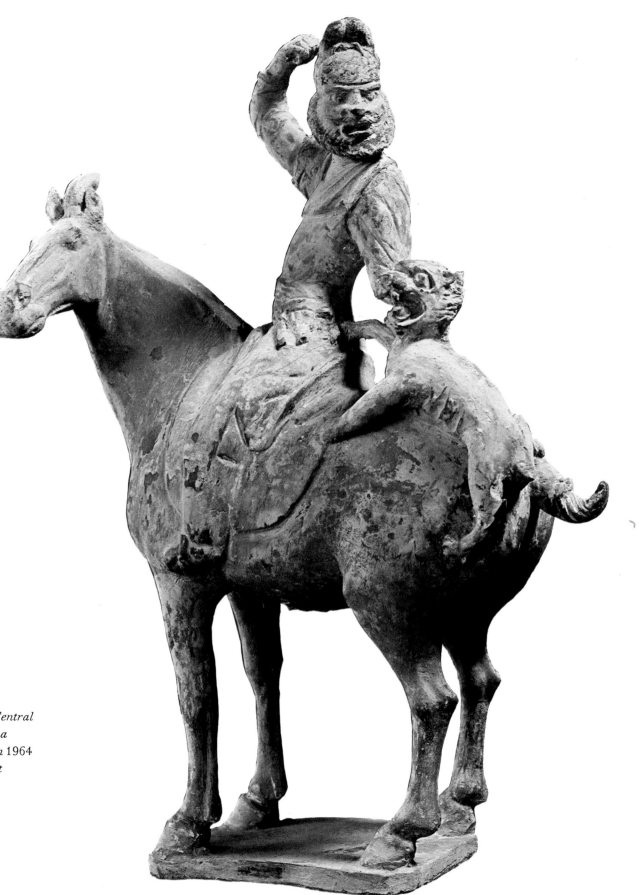

88
*Painted pottery model of a horse and Central
Asian rider. On the back of the horse is a
cheetah, used for hunting. Excavated in* 1964
*from the tomb of Princess Yung T'ai at
Ch'ien-hsien near Sian.*
(*London etc. exhibition, cat. no.* 275)
T'ang dynasty: A.D. 706
Height: 31.5 cms
China

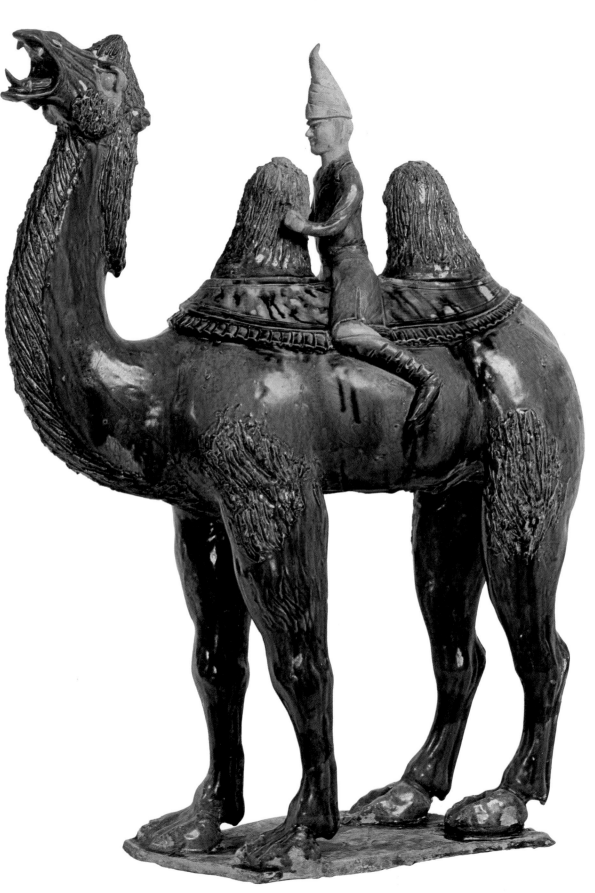

89
Large pottery model of a camel with a
Central Asian groom wearing a pointed hat.
Brown, green and cream lead glazes.
T'ang dynasty : early 8th century
Height : 73 cms
Victoria & Albert Museum

90
Glazed pottery figure of an exotic tomb
guardian, or ch'i-t'ou, *to protect the deceased*
from evil spirits.
Excavated in 1959 *from a tomb at Ch'ung-p'u,*
near Sian.
(*London etc. exhibition, cat. no.* 297)
T'ang dynasty: early 8th century
Height: 65.5 cms
China

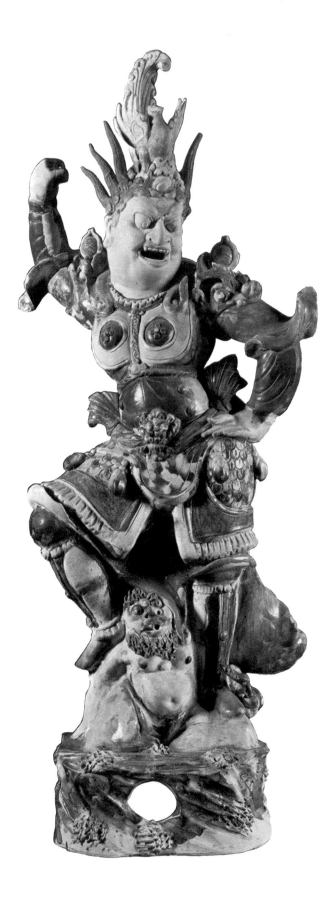

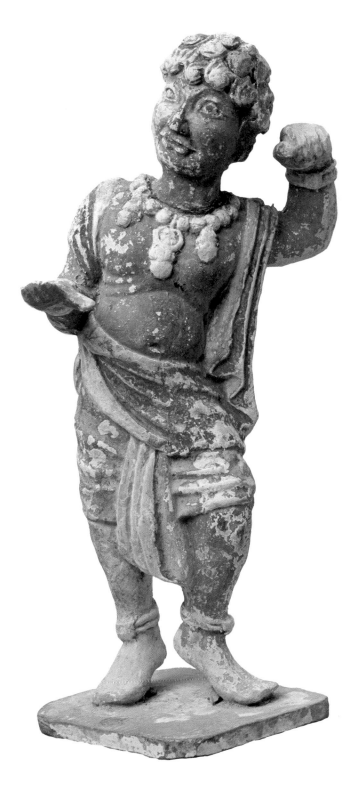

91
Pottery figure of a youthful South-East Asian
dancer, of the type imported by the T'ang rulers
to entertain them in their palaces at Ch'ang-an.
Unglazed and with painted details, and some
traces of gilding on the necklace.
T'ang dynasty: late 7th or early 8th century
Height: 25.8 cms
Victoria & Albert Museum

92
Glazed pottery figure of a Central Asian
camel groom. Excavated in 1959 from a tomb
at Ch'ung-p'u near Sian.
(London etc. exhibition, cat. no. 294;
Australia exhibition, cat. no. 199)
T'ang dynasty: early 8th century
Height: 29.7 cms
China

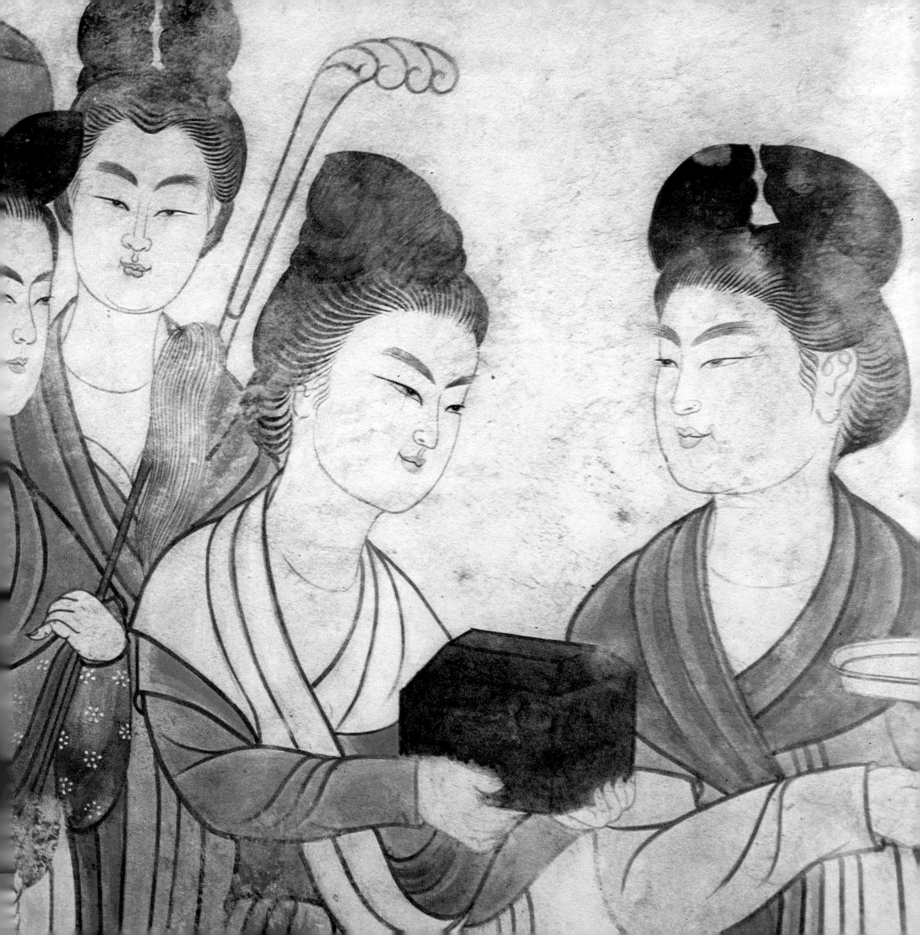

93 (*overleaf*)
*Wall painting of courtly ladies and attendants
holding fans, caskets and gifts, in the tomb of
Princess Yung T'ai at Ch'ien-hsien, near Sian.
The style of such painted figures corresponds to
that of the 3-dimensional pottery models.*
T'ang dynasty: A.D. 706
Photographed in situ

94
*Glazed pottery figure of a courtly lady in the
long flowing robes and a stole or shawl.
Note also the exotic hair style with single
prominent topknot. Excavated in 1959 from a
tomb at Ch'ung-p'u near Sian.
(London etc. exhibition, cat. no. 300;
Australia exhibition, cat. no. 201)*
T'ang dynasty: early 8th century
Height: 45 cms
China

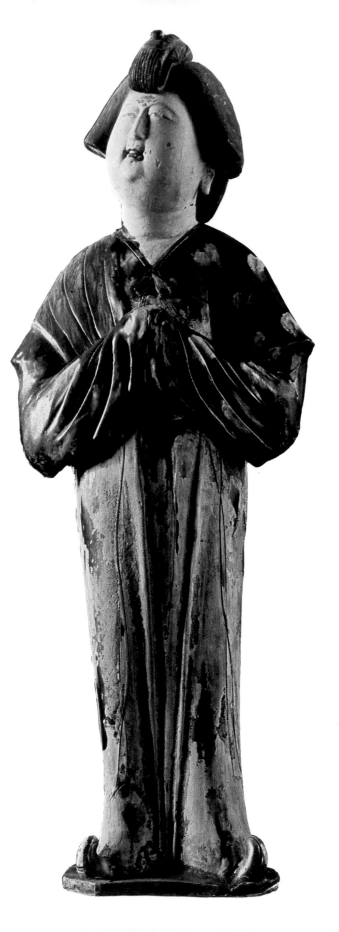

95

Interior of the tomb chamber of Princess Yung T'ai. On the right is the stone sarcophagus, very finely engraved with figures of court ladies and attendants, and naturalistic elements and floral decorative motifs.

T'ang dynasty: A.D. 706

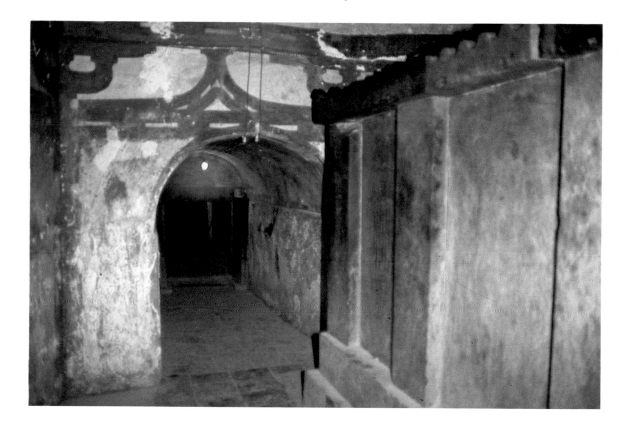

96

Copy of a wall painting in the tomb of Prince Chang Huai (Li Hsien) at Ch'ien-hsien, near Sian. The riders on horseback are holding clubs and probably represented as playing polo; quite possibly the laden camels are carrying the picnic.

T'ang dynasty: late 7th century

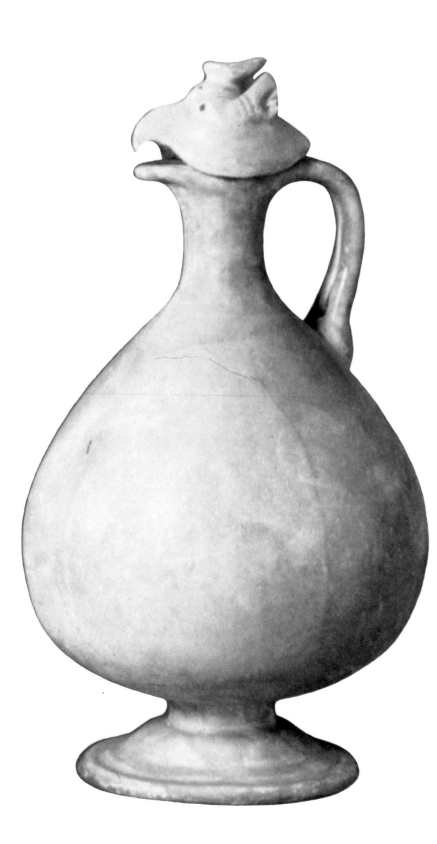

97
Pottery dish with typical impressed design and 3-colour glazes.
T'ang dynasty: late 7th or early 8th century
Diameter: 38.1 cms
Victoria & Albert Museum

98
White porcelain phoenix-headed ewer, based on a Near Eastern metalwork shape.
T'ang dynasty: late 7th or 8th century
Height: 28.5 cms
Tokyo National Museum

99
Lobed stoneware stem-cup covered with a pale greyish-green glaze. Yüeh ware.
Late T'ang dynasty or early Five Dynasties: 9th or 10th century
Height: 7.4 cms
Victoria & Albert Museum

100
Gold pedestal bowl with repoussé petals and
traced decoration of deer, birds and flowers.
Although the form is of Iranian inspiration, the
decoration is in the Chinese idiom.
Excavated in 1970 at Ho-chia village, near Sian.
(London etc. exhibition, cat. no. 305;
Australia exhibition, catalogue no. 185)
T'ang dynasty : 8th century
Diameter : 13.5 cms
China

101
*Bronze mirror overlaid with silver; the design
comprising a western Asiatic inspired grape
vine pattern.*
T'ang dynasty : 8th century
Diameter : 19.0 cms
Victoria & Albert Museum

102

The Bodhisattva Avalokitesvera (Kuan-yin); carved into the limestone cliff at the entrance to the Wan-fo (thousand Buddha) cave at Lung-men. The realistic proportions, finely carved detail and jewellery and tribhanga *pose are characteristic features of 'high T'ang' Buddhist sculptures.*
T'ang dynasty: early 8th century
Height of figure: approximately 1.2 m

五代
宋代

Five Dynasties and Sung Dynasty
(A.D. 906 - 1279)

Although there is an inescapable continuity to Chinese history and culture, there is no doubt that the demise of the T'ang dynasty at the beginning of the 10th century precipitated a fundamental change in the direction of Chinese art. Viewed in retrospect, the T'ang period may be seen as the end of the 'archaeological road' in China, when the artistic character of a period was largely determined by the requirements of burial and its accoutrements.

The concept of works of art being produced for a service other than ritual or sacrifice had gained increasing recognition during the T'ang, and was further encouraged by the interests of the Court in painting and poetry. In the immediate post-T'ang period, we move entirely into the realm of the 'living' arts. The era has often been described as the great age of Chinese painting, dominated by the towering landscapes of the Northern Sung masters. Synonymous with the interest in the landscape theme, and in man's relationship with nature, was a kind of poetical contemplation which drew upon the mysticism of Taoism and the quietude of the Buddhist faith to achieve and express harmony with nature.

The second principal area of artistic endeavour was in ceramics. Here, the subtle severity of form and expressive but restrained ornament again illustrates the studious serenity which characterizes the art and intellectual climate of the 10th to 13th centuries. These attitudes and interests stemmed from an introspection that distinguishes the character of the Sung dynasty from the vibrant and extrovert T'ang.

The immediate consequence of the fall of the T'ang dynasty was a brief period of confusion and anarchy known as the Five Dynasties, so called because of the ephemeral military dictatorships which controlled north China. In the south the various states which had gradually attained autonomy in the dying years of the T'ang maintained a semblance of order, preserved something of T'ang culture and literature, and generally avoided any contact with the sparring war-lords of the north. Predictably, the task of re-uniting China fell to a military commander, Chao K'uang-yin. A leading general of Chinese origin, he was despatched in A.D. 960 to arrest a Khitan invasion in the far north, but usurped the throne instead. Unlike his immediate predecessors, Chao, known as the Emperor T'ai Tsu, managed to establish a stable government in the north largely through placing civil officials in important government posts and pensioning off his military commanders. The re-conquest of the south followed without great resistance and, by the time of T'ai Tsu's death in A.D. 976, all but a few isolated regions had been re-instated.

Unlike the Han and the T'ang dynasties, this reunion of the Middle Kingdom was achieved more by policy than by military exploit, which undoubtedly contributed to the calm conservatism of the period. The Sung had no territorial ambitions outside China proper, and their only contacts with non-Chinese peoples involved the repelling of barbarian invasions – principally the Liao in the north and the Hsi Hsia in the north-west. The Chinese were fully aware of their cultural identity;

they had no concern for the affairs of civilizations or peoples beyond the confines of the Middle Kingdom, and devoted their energies to the reconstitution of a peaceful society in the Confucian tradition.

However, the relative weakness of the Sung in military terms was a constant threat to their very existence. T'ai T'su's deliberate policy of undermining the provincial military organizations, and subjugating the military to the civil administration, had drastically reduced China's military strength. Perhaps even more importantly, the social and ideological attitudes of the people had fundamentally changed, and military adventurism was quite simply abhorrent to the Sung Court. Thus, when the Khitan Liao people severely threatened to overrun north China, the Sung acknowledged Tartar superiority in a treaty dated A.D. 1004, accepted the loss of small parts of northern China including Peking, and agreed to pay an annual tribute to the Liao in order to keep the peace. The Sung acquiesced in a similar manner to the Hsi Hsia, Tangut tribes of Tibetan peoples who had threatened from the north-west, in another treaty of A.D.1044. The Sung, therefore, literally bought their peace with a substantial tribute.

Disaster struck the Sung during the reign of one of China's greatest Imperial patrons of the arts, the Emperor Hui Tsung (reigned 1100–25). He was himself a talented painter, in the delicate Sung Academy style, and particularly noted for his bird and flower paintings (*plate 104*). He established an academy of painting and presided over a Court of cultural brilliance but, regrettably, political impotence. The Court's incessant drain on the resources of the Empire, and its disinterest in the social and economic problems of the community, prompted the inevitable peasant rebellions.

But the real blow came from outside. Beyond the territory held by the Liao people a new barbarian tribe known as the Ju-chen tartars, a Tungusic people then inhabiting northern Manchuria, threw off the yoke of their Liao overlords, conquered their territory and quickly occupied north China under the banner of the Chin dynasty. In 1126, the Chin captured Kaifeng, the Sung capital, and no less a person than the Emperor Hui Tsung himself. Only dissensions in their own ranks prevented the Chin from occupying all China, and they accepted the northern watershed of the Yangtze River as their southerly frontier.

Once again China was divided, with the north in the hands of the Tartars. The remnants of the Sung Court fled to the south and the dynasty continued under the name Southern Sung, with their capital at Hangchou.

The advent of a Tartar dynasty did not substantially alter cultural, economic or social patterns. Certainly the principal fields of artistic endeavour, painting and ceramics, maintained their momentum and development without any appreciable break in continuity.

Similarly, the removal of the Sung Court to the south apparently did little to deter them from their esoteric pursuits. Under this admittedly elitist and cultured regime, the south expanded rapidly and soon established beyond doubt its economic, cultural and intellectual leader-ship of the whole of China. Vast sums were spent on enlarging and elaborating the capital city of Hangchou until it far exceeded in grandeur the early Sung capital at Kaifeng in the north. Even after its capture by the Mongols over a century later, it still struck Marco Polo as being, "beyond doubt the finest and noblest" city in the world.

No nomad people has ever attained such renown, and infamy, as the Mongols. It was none other than the Great Khan himself, Genghis Khan, who was to set in motion the sequence of events which led to the fall of the Sung. First he subjugated the Hsi Hsia, between 1205 and 1209, and then by 1234 his armies had extinguished the Chin in north China, after a somewhat laborious campaign which was in some contrast to their rapid sweeps across Asia. The southern Sung finally capitulated in 1279 after another lengthy campaign in which the art and cunning of the Chinese, and their use of gunpowder in explosive bombs, very nearly turned the tide on the advancing Mongol hordes.

A surge of neo-Confucianism swept Sung China and dominated the attitudes and approaches of the Court. In the arts it manifested itself in the study of the ancient Bronze Age culture and in the making of facsimiles (*see plate 14*). Greatly assisted by significant developments in printing, the Sung scholars began compiling mammoth encyclopaedias of ancient art forms including not only bronzes, but jades and other artifacts (*plate 106*). These circulated among the Imperial workshops and stimulated a significant but limited resurgence of the bronze industry.

The Sung dependence upon the Confucian ethic by no means eclipsed the continuing traditions of Buddhism and Taoism. In the south particularly, a new strain of the Buddhist faith gained wide recognition, that of the Ch'an or Meditative School, whose theories and terminology were often equated with Taoist notions. The cumulative effect of these varied currents in philosophical thought was to further stimulate the interest in nature, the landscape and the relationship between man and his environment. Such themes were adopted and explored by the great landscape painters of the Northern Sung, whose awe-inspiring monu-mental landscapes were dominated by ruptured peaks which rose far into the cloud-flecked heavens and entirely dwarfed the figure of man. The senses of solitude and contemplation were perfectly captured in the majestic compositions of the great Northern Sung masters, Li Ch'eng, Fan K'uan and Kuo Hsi, where the human representation was so dwarfed and insignificant as to be virtually invisible (*plate 103*). These paintings were a poignant comment on the humble situation of man in the vast and timeless environment of nature.

The Emperor Hui Tsung and his southern academy initiated a new school and style of painting. In place of the enormity of the northern landscapes they concentrated their energies and emotions on small, delicate and intimate paintings of birds and flowers. The Emperor's passion was for the literal renderings of the real appearances of things, and he castigated his protégés for lapses into fulsome expressionism. An edict issued by the academy ran: "Painters are not to imitate their

predecessors, but are to depict objects as they exist, true to form and colour."

Slightly less stringent rules were applied to the landscape painters of the Southern Sung Academy. Here again the theme was man in nature, but the scale reduced from the monumental to the intimacy of the south. Paintings by the recognized masters of this school, Ma Yüan and Hsia Kuei, are characterized by detail in the foreground contrasting with a misty void beyond; the compositions reflect the contemplative mood of the human presence (*plate 105*).

The very specific and literal rules to which the painters of the Sung adhered were no less explicit in the field of ceramics. The Sung potters achieved a purity of form which displays the severity of their intellectual application as much as it does their grasp of technique (*plate 107*). During the Northern Sung period, ceramic development in the north focused on wares made to Imperial order. Of these the products of the Ting kilns, a white porcellaneous ware, were by far the most numerous. Sensitively potted bowls, jars and dishes were embellished with incised, carved or moulded decoration composed of naturalistic elements which fused with and enhanced the shape of the vessel (*plate 108*). More robustly potted were the Chün wares with their distinctive lavender colour glaze, and a range of brown glazed types. Most prized of all were the *kuan* (official) (*see plate 107*) and *ju* wares, the latter of exceptional rarity; always undecorated, their reputation rests entirely upon the perfection of form and glaze.

In some contrast to these profoundly sophisticated Imperial ceramic wares were those of the Tz'u-chou region of Hopei province. These stonewares are characterized by their ornament, applied in a variety of techniques of which painting was the most common (*plate 109*), and display a robust exuberance which contravenes the accepted standards of Imperial Sung conservatism.

The term celadon is applied to a wide range of grey to green glazed ceramic wares, although it is no more than a loose descriptive designation of colour. The term is derived from the name Céladon, the shepherd in Honoré D'Urfé's pastoral romance *L'Astrée*, who wore ribbons of a soft grey-green colour that evidently bore a close resemblance to the glaze colour on certain Chinese ceramics.

A Northern Celadon ware was widely produced during the early Sung period in the north and is characterized by a darker, glassier, green glaze generally applied over incised or carved decoration in the style of the related Ting types (*plate 110*). Although production of the most exclusive ceramic wares, in particular the *kuan* and *ju* types, ceased after the consolidation of Chin rule, the northern kilns maintained the ceramic tradition and continuity in the Ting, Tz'u-chou and to a lesser extent the Northern Celadon wares.

But the production of celadon wares proliferated in the south, principally in Chekiang province where the Yüeh tradition had flourished since the early post-Han era. Indeed, some of the finest examples in the celadon tradition were undoubtedly made under the Southern Sung regime, and the active and stimulating patronage of the Court at Hangchou. The principal centre was the Lung-ch'üan region, which subsequently lent its name to a range of ceramic wares with a distinctive pale-green glaze produced during the Sung and succeeding dynasties. Great advances in ceramic technology, particularly in the attainment of fine and beautifully textured glazes such as those on the *ju*, *kuan* and Southern Celadon wares, nevertheless failed to stem the tide of conservatism, indeed archaism, which permeated the tradition. Lung-ch'üan celadons in particular looked to ancient bronzes for inspiration in shapes and forms (*plate 111*), and even in the more adventurous north old familiar shapes tended to re-appear (*plate 112*).

The application of ancient bronze vessel forms to the new and sophisticated ceramic technology of the Sung illustrates an attitude which provided much of the inspiration for the regeneration of cultural activity after the fall of the T'ang and the anarchy of the Five Dynasties. The Sung were, above all, thoroughly Chinese and denied any foreign intervention into their supremely independent cultural and intellectual world. Buddhism apart, this world relied entirely upon native standards and philosophies for social, administrative and cultural order. Although harassed by the barbarian Tartars and Mongols, and fully aware of the pressures from within which have constantly afflicted Imperial hierarchies, the Sung proved that the Chinese had lost none of their creative genius and artistic brilliance.

Bibliographical references

de Bary, W. Theodore, "A Reappraisal of Neo-Confucianism", in *Studies in Chinese Thought*, edited by Arthur F. Wright, Chicago 1953 (reprinted 1967). A study of the Confucian revival in the Sung dynasty.

Cahill, James, *Chinese Painting*, Geneva 1960. A general introduction to Chinese painting with a chapter on developments during the Sung period.

Cahill, James, *The Art of Southern Sung China*, New York 1962. Catalogue of an exhibition at the Asia House Gallery.

Ch'en, Kenneth K. S., *Buddhism in China*, Princeton 1964. Contains a section on Ch'an Buddhism and its development during the Sung dynasty.

London, Oriental Ceramic Society, *The Arts of the Sung Dynasty*, London 1960. Catalogue of an exhibition held in conjunction with the Arts Council of Great Britain.

Palmgren, N., *Sung Sherds*, Stockholm 1963.

Wirgin, Jan, *Sung Ceramic Designs*, Stockholm 1970. A comprehensive survey of the designs found on all major types of Sung ceramic wares.

103
'*Travelling Among Mountains and Streams.*'
Hanging scroll, ink on silk. A majestic landscape
painting of the Northern Sung period in which
the human prescence is characteristically
insignificant.
By Fan K'uan; circa A.D. 990 to 1030
Northern Sung period
206.3 × 103.3 cms
National Palace Museum, Taiwan.

飛鳴似憐毛羽貴徘徊如飽稻梁心
緗膺紺趾誠端雅為賦新篇安武吟

御製

并書

104
'*The Five-coloured Parakeet.*' *Painting in*
colour on silk by the Emperor Hui Tsung
(*reigned* A.D. 1101 to 1125).
Sung dynasty : early 12th century
53 × 125 cms
Museum of Fine Arts, Boston

105
'On a Mountain Path in Spring.' Album leaf
painting, ink and colour on silk.
By Ma Yüan; circa A.D. 1190 to 1224
Southern Sung period
27.4 × 43.1 cms
National Palace Museum, Taiwan

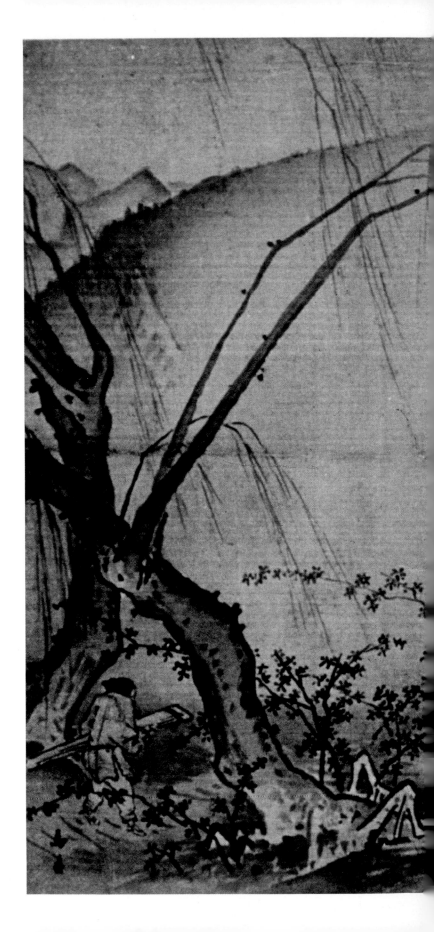

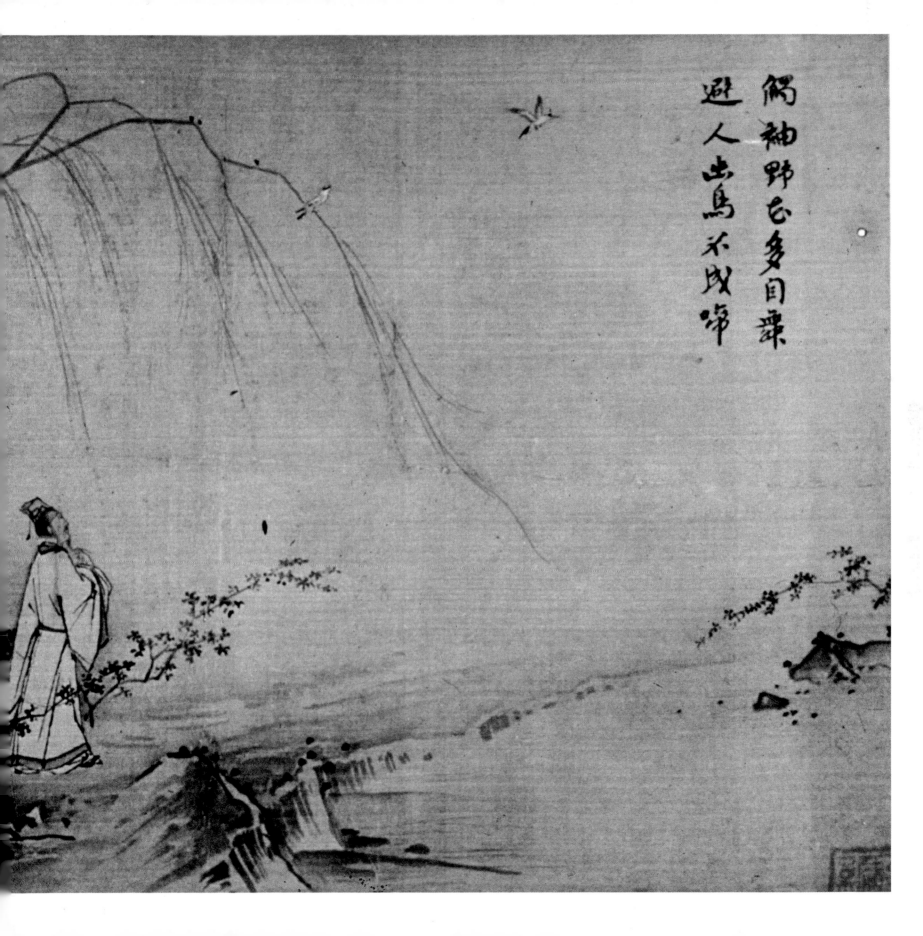

106

Archaistic two-handled cup in imitation of an
Early Western Chou, 10th century B.C.,
bronze ritual vessel, kuei. *Carved from*
greenish-grey jade.
Late Sung or early Ming dynasties:
13th to 15th centuries
Width: 16.8 cms
The Barlow Collection, University of Sussex

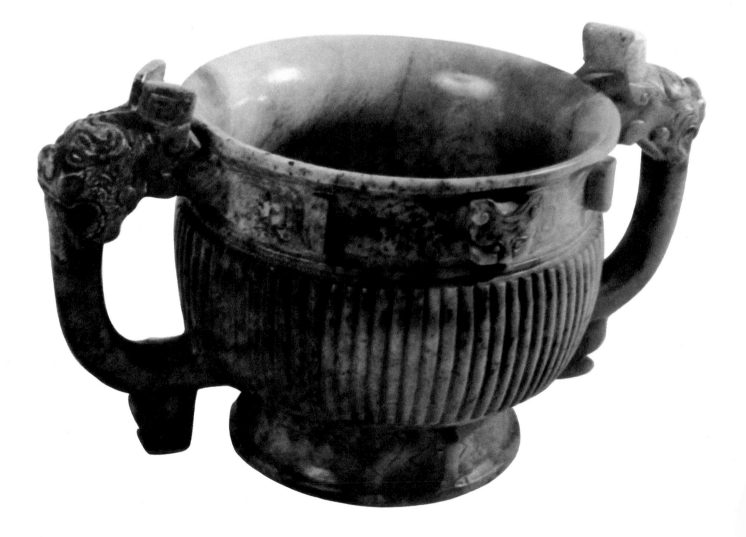

107
*Stoneware bottle with bluish-green glaze;
illustrating the perfection of simple form and
rich glaze achieved by the Imperial kilns of the
Northern Sung.* Kuan (*official*) *ware.*
Northern Sung period: 11th or early 12th
century
Height: 13.7 cms
Victoria & Albert Museum

108

Porcellaneous stoneware dish with incised
floral decoration. Ting *ware; from Hopei*
province.
Sung dynasty: 12th century
Diameter: 16.5 cms
Percival David Foundation of Chinese Art,
London

109

Stoneware pillow painted with a picture of a boy fishing on the top, and broad floral scrolls on the sides. Tz'u-chou *ware.*
Excavated in 1955 at Hsing-t'ai in Hopei province.
(*London etc. exhibition, cat. no. 338;*
Australia exhibition, cat. no. 222).
Sung dynasty : 12th century
Length : 28.8 cms
China

110
Stoneware bottle with incised floral decoration
under an olive-green coloured glaze.
Northern Celadon ware.
Northern Sung period : 11th to early 12th
century
Height : 23.9 cms
Victoria & Albert Museum

111
Stoneware tripod vessel, in imitation of the
ancient bronze ting, *covered with a celadon*
glaze. Lung-ch'üan type.
Excavated in 1954 *at Jui-an in Chekiang*
province.
(*London etc. exhibition, cat. no.* 336;
Australia exhibition, cat. no. 219).
Sung dynasty : 12th to 13th century
Height : 12.4 cms
China

112 (*overleaf*)
Stoneware tripod vessel, in imitation of the
ancient bronze ting, *with handles and relief*
ornament also derived from the early bronze
tradition. Covered with a celadon glaze;
Yao-chou ware.
Excavated in 1960 *at Lan-t'ien in Shansi*
province.
(*London etc. exhibition, cat. no.* 337;
Australia exhibition, cat. no. 221).
Sung dynasty : 12th century
Height : 27 cms
China

元代

Yüan Dynasty (A.D. 1279 - 1368)

Foreign rule in China has always been a deterrent to full and proper appreciation by Chinese historians since the fact of invasion was, naturally enough, repugnant to them. Inevitably, such circumstances were a hindrance to the continuity of social and cultural traditions, but to what extent foreign intervention changed the course of history is debatable, particularly in the case of the Mongol invasion. In many ways the period of Mongol rule in China under the Yüan dynasty was merely an interruption, for it lasted just 90 years, unlike the great and enduring dynasties, in particular the Han, T'ang and Sung, all of which lasted 300 years or more. As a result there was no opportunity for innovative concepts to be absorbed or individual traditions to develop. The Yüan was a dynasty which lacked consistency and thus identity.

The absence of concerted Imperial patronage tended to fragment the cultural and artistic unity which had been so characteristic of the Sung. The rich flowering of artistic enterprise under the auspices of a profoundly sympathetic Sung Court was dissipated by the advancing Mongols, and yet there is an undeniable continuity in various branches of the arts. Clearly the Mongols did not stimulate fresh cultural directions, neither did they significantly impose their own crude standards upon such an indelible native tradition. It was far too substantial a civilization to be absorbed into any alien culture. Since few Chinese ever agreed to actively serve the Yüan government, its administration fell largely to the Tartars. Possibly this stimulated a certain nationalistic pride in the maintenance of Sung cultural and artistic standards. But if it did so, at the same time it removed that sparkle of invention and genius. By comparison with the Han, T'ang and Sung dynasties the cultural tempo of the Yüan was slow, with the exception of painting.

The Southern Sung had offered surprisingly tenacious resistance to the Mongol advance, and the end was sealed in dramatic fashion as the commander of the remnants of the Sung forces flung both himself and the boy Emperor into the sea. Such an act illustrates the sheer desperation which must have overtaken the mild and cultured Sung as they faced the inevitable onslaught of the Mongol war machine.

The Mongol invasion of Sung China had begun in 1235, after they had conquered the Chin in the north, but was not completed until the capitulation of the boy Emperor in 1279. The invincible momentum of the Mongol advance carried them on through south China into Burma and South-east Asia. China was only a part of a vast Mongol Empire which the redoubtable and brutal Genghis Khan and his successors had established; by the end of the 13th century, it stretched from Hungary in the west to Manchuria in the east, and from Siberia in the north to Burma in the south. Genghis Khan himself initiated and witnessed the beginnings of the Mongol takeover of China before his death in 1227. In 1263, Kubilai Khan (*plate 113*), the grandson of Genghis, took over the mantle of Great Khan and removed the Mongol capital from Karakorum in Mongolia to Peking; a surprising move, for it relaxed the cohesion of the Empire and further alienated the westernmost extensions. The conversion of the western Khans to the Islamic faith in 1295 lent

further emphasis to this rift and marks the end of a unified Mongol Empire.

Kubilai was at best slightly less brutal than his grandfather had been, although he evidently devoted some energies to establishing a workable administration in China. His preparedness and interest were inherent in the decision to move the capital to Peking. Although the cultural abyss between the Chinese and their Mongol overlords was enormous and beyond breaching, Kubilai himself possibly attained a measure of understanding of the concepts of Confucian rule; he adopted the Chinese system in establishing his Yüan (or 'First') dynasty and, in principle, the T'ang administrative structure which had been maintained by the Sung. But there is no denying that the Mongols as a whole preserved their identity through their unwillingness and inability to identify with the conquered. Constantly re-inforced by contacts with other parts of the massive Empire, their non-Chinese traits were always in evidence. The habits and customs of a people with emphatic nomadic traditions, including modes of dress, moral codes, food and their passion for excessive drinking, merely strengthened Chinese suspicion of the invaders. Later Chinese chronicles are unanimous in their condemnation of the Mongols as primitive savages capable only of orgiastic excesses, destruction, brutal conduct and heavy drinking. In the south, where the Sung had for so long clung to their regime, such feelings were strongly evident and quite probably it was the Mongols' obnoxious personal habits that the Han people found most repellent; one Chinese account of the Mongols in their homeland records with undisguised relish that, "they smell so heavily that one cannot approach them. They wash themselves in urine".

Co-operation in the administration of the Chinese Mongol Empire was, therefore, only offered by the Chinese with great reluctance, or under duress. In the face of such hostility the Mongols were obliged to employ foreigners, particularly Moslems from Central and Western Asia, to fill the vital government posts. The introduction of the Moslem faith into China made little impact, in sharp contrast to that of Buddhism some centuries before, not only because of the manner of its introduction but also because Buddhism had become so entrenched and absorbed into Chinese thought and philosophy that there was simply no requirement for an additional faith. The religious convictions of the imported administrators, therefore, accentuated the cultural divisions and amplified mutual dislike and suspicion. As Marco Polo recorded: "All the Cathaians detested the Great Khan's rule because he set over them governors who were Tartars, or still more frequently Saracens, and these they could not endure, for they were treated by them just like slaves. You see the Great Khan had not succeeded to the dominion of Cathay by hereditary right, but held it by conquest, and thus, having no confidence in the natives he put all authority into the hands of the Tartars, Saracens or Christians, who were attached to his household and devoted to his service, but were foreigners in Cathay".

In their faint-hearted adoption of Confucian principles in govern-ment, the Mongols attempted to placate and temper such hostile attitudes, although such a move must also be considered as reluctant recognition of their inability to impose a workable administration. They were, after all, totally inexperienced in the management of such a large and well-defined unit. Similarly, the Great Khan acknowledged the Buddhist faith and made expressions of support, although they were made with little conviction.

Imperial patronage was certainly not forthcoming, but the more flexible attitude did permit a continuity of the religion and its attendant iconography. Since the mid-T'ang period, Buddhism had failed to attract massive Imperial patronage, and thus the carving of monumental cave-temples had more or less ceased. Attendant upon this was a move towards the less demanding, and certainly less monumental, wood-carving tradition which had flourished in north China during the Five Dynasties and Sung periods (*plate 114*). The icons of the day tended to reflect a changing pattern of religious attention in their flamboyant, exotic and overly 'fleshy' style.

Buddhism in China had reached its peak in the mid-T'ang and was, therefore, only able to maintain its momentum in diversions, such as the Ch'an (later Zen) sects which grew up in the Southern Sung, and, on the other hand, the vivid and colourful imagery of the Paradise themes which had obvious popular appeal. Thus, during the years of foreign domination in the north, sculptural style deviated from the discipline of a religious icon. The wood sculptures of the Chin, Liao and Yüan periods are conspicuously lacking in religious conviction and solemnity, but exude an atmosphere of almost decorous frivolity. Yüan Buddhist sculpture is florid and enjoyable, but clearly in the service of a faith in decline.

The intellectual and spiritual attentions of the Chinese scholars, which were at one time greatly attracted to Buddhism, were in the post-T'ang increasingly occupied with nature and the landscape. Alienating themselves from society and most emphatically avoiding any identification with their Mongol rulers, small groups of painters dedicated themselves to the solitude of nature. From this developed the *wen-jen*, or literary man's, style in which paintings took on a new and disturbingly different appearance. Chao Meng-fu (1254–1322), who was in the vanguard of this new movement, wrote on a scroll known only through copies and literary references that, "I dare not claim that my paintings are comparable to those of the ancients; contrasted with those of recent times, I dare say they are a bit different".

The Yüan painters were free from the restrictions of a Court hierarchy or responsibility to ancient styles, and rejected the sentimental and conventionalized concepts of the Southern Sung Academy. Thus, they were able to experiment with expressive brushwork and textural qualities. These became the accepted tenets for later traditions of landscape painting in the Ming and Ch'ing dynasties, and the works of the Four Great Masters of the late Yüan period became the cornerstones upon which much later Chinese painting was built. The land-

scapes of Huang Kung-wang and Ni Tsan, for example, exemplify the ideal scholarly temperament which sought to achieve in painting an appearance of cool understatement, but one imbued with a spiritual resonance (*plate 115*). As another of the Four Masters, Wu Chen, put it, "flavour with blandness".

The second major artistic development of the Yüan period, that of blue and white porcelain, coincided with the emergence of the enduring and influential *wen-jen* painting tradition. Precisely when the technique of underglaze painting in cobalt blue was introduced into China is simply not known, and the subject of much debate, but there can be no doubt that it was a signal event. The technique was copied from the Persian painters and potters of Kashan and could be considered a tangible and beneficial consequence of Mongol involvement. The Chinese potters perfected the technique to an extent that permitted exceptionally fine and expressive brush-work in high-firing conditions. This was the beginning of a tradition that was to dominate in the production of later ceramic wares which became synonymous with China when exported on a massive scale to the Near East, Europe and South-east Asia (*plate 116*). Less successful, although technically similar, was the development of under-glaze painting in copper red which probably originated in China since it was unknown in Near Eastern ceramics.

The technique of underglaze painting permitted a new exoticism which sometimes found its expression in the more familiar ceramic types in extravagant form. In the north, the distinctive Chün and Tz'u-chou traditions flourished under Tartar rule. Chün wares became characterized by stronger purple flushes in the glaze and by occasional extraordinary forms (*plate 117*). The range of Tz'u-chou decorative schemes continued, but on larger, generally more heavily potted vessels (*plate 118*). The use of overglaze enamel painting, which had made a tentative appearance in the Sung, became more widespread.

In the south the Celadon tradition became increasingly decorative. Possibly as a consequence of Mongol intervention there was a general tendency to develop an exuberant, space-filling, decorative concept; the purity of Sung form gradually became subverted to the Yüan penchant for ornament. The other principal ceramic traditions were fine porcelains of the *ch'ing-pai* or *ying-ch'ing* (literally bluish-white or shadow blue respectively) types, again a continuing Sung tradition, and the *shu-fu* wares, another white porcelain which was restricted to Yüan Imperial use.

It would be wrong to say that the Yüan was the last innovative age in Chinese art, and yet it must be recognized that the art of Ming and Ch'ing China is essentially derived from traditions which existed in the Yüan. Many of these traditions have far deeper roots, but two outstanding contributions, that of painting in the *wen-jen* style and underglaze painting of blue and white porcelain, are undoubtedly original achievements of China under Mongol rule. But the most fitting memorial to the artists and craftsmen of the Yüan is not neces-sarily in the acknowledgement of their innovative achievements, but in the recognition of the continuity of China's cultural and artistic traditions in the face of such a massive and diversive upheaval as the Mongol invasion.

When the Ming re-established Chinese rule over the Middle Kingdom in 1368 there was an immediate and understandable tendency towards retrenchment. The familiar and established Confucian ideals, which had been the hallmark of Sung China, re-asserted themselves as the Ming rulers strove to unify the Middle Kingdom and obliterate the memories of Mongol domination. The country soon began to enjoy the peace and prosperity occasioned by stability in government and social order. But therein lay the seeds of stagnation. Antiquarianism became something of a fetish and the Chinese once again severed connections with the rest of the world. She developed a sense of cultural superiority which, as we have noted, was to cause such problems when the inevitable confrontation with the Western mercantile nations occurred.

These tendencies are reflected in the arts of the Ming period in which certain traditions betray a strong dependence upon the past. And yet, in the ceramic tradition, which dominated the artistic achievements of both the Ming and Ch'ing dynasties, technical accomplishment and high artistic standards in form and decoration produced a tradition of immense renown.

Developing upon concepts introduced in the Yüan, during which time there was an undoubted move towards an emphasis upon ornament, the arts of the Ming and Ch'ing periods explored a vast range of decorative possibilities. The so-called minor arts, textiles, cloisonné enamels and lacquers in particular, became the vehicles for the expression of these designs. In retrospect, therefore, the Yüan may be seen as a critical period in the history of Chinese art. A period when a new emphasis was placed upon decorative elements, which contrasts with the earlier concentration upon form and ritualistic ornament.

Bibliographical references

Cahill, James, *Chinese Painting*, Geneva 1960

Chang-ning, "Chi-yüan ta-tu ch'u-t'u wen-wu" (Cultural relics from the site of the ancient Yüan capital of Tatu near Peking), *Kaogu*, 1972, no. 6. A report on an excavation at the site of the Yüan capital which produced many outstanding examples of porcelains and other ceramic wares.

Garner, Sir Harry, *Oriental Blue and White*, London 1954 (2nd and 3rd eds. 1964 and 1970). Describes the introduction of underglaze painting in blue during the Yüan dynasty.

Lee, Sherman and Ho, Wai-kam, *Chinese Art under the Mongols: The Yüan Dynasty (1279–1368)*, Cleveland 1968. Catalogue of the most comprehensive exhibition yet held on the arts of the Yüan, with lengthy introductions to each section.

Medley, Margaret, *Yüan Porcelain and Stoneware*, London 1975.

Pope, J. A., *Fourteenth Century Blue and White in the Topkapu Serayi Muzesi, Istanbul*, Washington 1952 and 1970.

Sickman, L., "Chinese Silver of the Yüan Dynasty", *Archives of the Chinese Art Society of America*, vol. 9, 1957.

像祖世元

113
Portrait of Kubilai Khan, known as
T'ai Tsu, first Emperor of the Mongol
Yüan dynasty.
From the San-ts'ai t'u-hui, 1609
edition. chuan 14, *biographies;*
portraits, section 3.
British Library

114
Carved wood seated figure of the
Bodhisattva, Kuan-yin.
Sung dynasty : 13th century
Height : 43.5 cms
Victoria & Albert Museum

115
'*Small Pavilion in a Grove of Pines.*'
Hanging scroll, ink on paper. By Ni Tsan;
A.D. 1301 *to* 1374
Yüan dynasty
National Palace Museum, Taiwan

116

Eight-faceted porcelain vase of mei-p'ing *shape,*
painted in underglaze blue with a design of
dragons amidst swirling waves.
Excavated in 1964 at Pao-ting in Hopei province.
(London etc. exhibition, cat. no. 369;
Australia exhibition, cat. no. 227).
Yüan dynasty : 14th century
Height : 51.5 cms
China

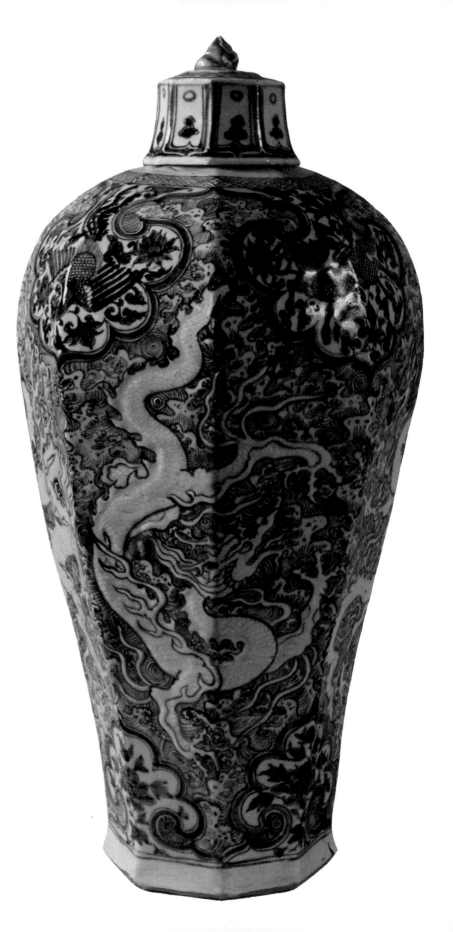

117
*Two-handled stoneware vase and stand of
eccentric and unusual form, covered with a
lavender blue glaze.* Chün *ware.*
*Excavated in 1972 from a site beneath the
north wall of Peking.*
Yüan dynasty : 13th century
Height : 63.8 cms
China

118 (*overleaf*)
*Stoneware jar with a design of two phoenixes
and a floral band on the shoulder. The painting,
in black, is on a white slip ground and details are
incised through the paint.* Tz'u-chou *ware.*
*Excavated from an underground storehouse at
Liang-hsiang, near Peking.*
(*London etc. exhibition, cat. no. 368;
Australia exhibition, cat. no. 231*).
Yüan dynasty.
Height : 36 cms
China

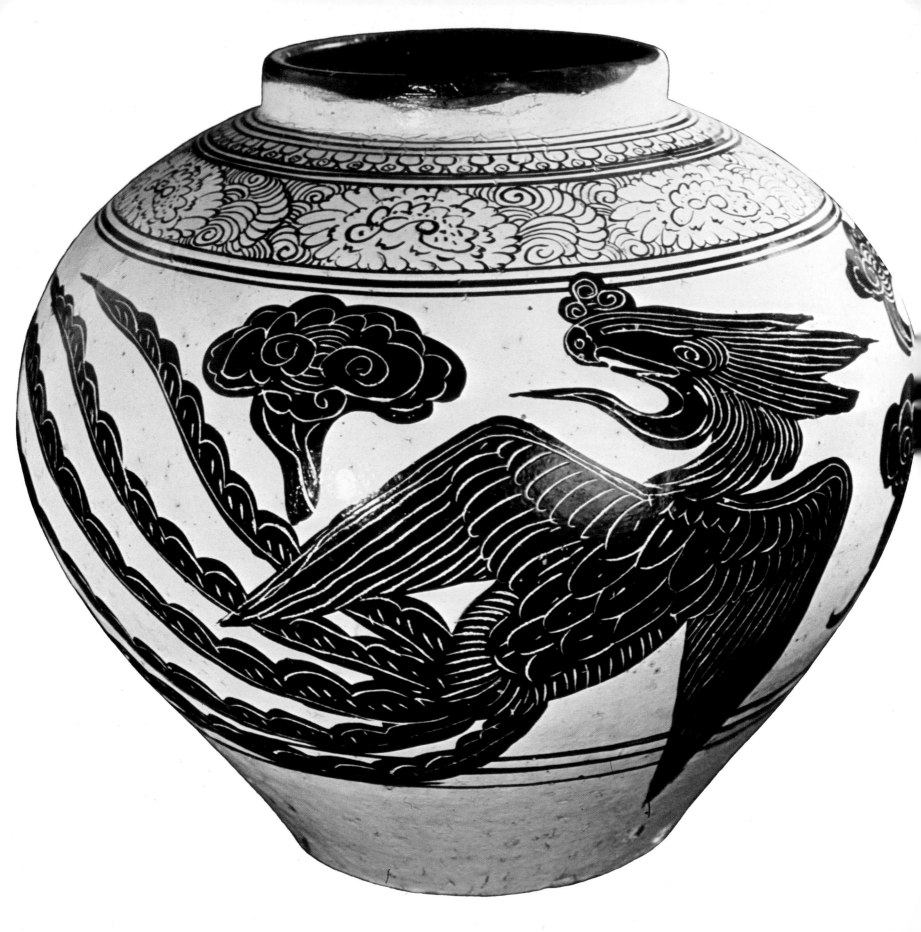

Photographic acknowledgements

For the illustrations in this book the author is indebted to the various
Museum authorities for supplying photographs or permission to arrange
for the photography of their objects, and to the following for the
provision of photographs:

British Museum: plate 48.

Howard Nelson: plates 26, 27, 30, 64, 69, 93.

Ian Thomas: plate 47.

India Office Library: plate 9.

Jennifer Harper: plate 3.

Joanna Tanlaw: plates 13, 14, 19, 24, 25, 41, 44, 50, 51, 56, 82, 83, 85,
 102, 113.

John Freeman: plate 2.

MacQuitty International Collection, The: plates 16, 17, 22, 23, 36, 49,
 52, 57, 60, 74, 80, 96.

Metropolitan Museum, New York: plate 43.

Museum of Far Eastern Antiquities, Stockholm: plates 33, 35.

Museum of Fine Arts, Boston: plate 104.

Peabody Museum, Salem: plate 10.

Percival David Foundation of Chinese Art, London: plate 108.

Radio Times Hulton Picture Library: plate 81.

Robert Harding Associates: plates 29, 31, 34, 39, 42, 55, 58, 61, 65, 66,
 67, 76, 77, 88, 90, 92, 94, 100, 109, 111, 112, 116, 117.

Victoria & Albert Museum: plates 1, 4, 5, 6, 7, 8, 40, 45, 70, 73, 86, 89,
 91, 97, 99, 101, 107, 110, 114.

William Rockhill Nelson Gallery, Kansas City: plate 79.

Willow Prizeman: plates 12, 72, 95.

Front cover illustration: Robert Harding Associates.

Endpapers: a view from the birthplace of Mao Tse-tung at Shaoshan in
 Hunan province. Photograph by Joanna Tanlaw.

Chronological table

circa 600,000 – 7000 BC	Palaeolithic period
circa 7000 – 1600 BC	Neolithic period
circa 1600 – 1027 BC	The Bronze Age : *Shang dynasty*
1027 – 771 BC	*Western Chou dynasty*
771 – 475 BC	*Spring and Autumn Annals*
475 – 221 BC	*Warring States*
221 – 207 BC	Ch'in dynasty
206 BC – AD 8	Han dynasty : *Western Han*
AD 8 – 25	*Wang Mang interregnum*
AD 25 – 220	*Eastern Han*
AD 220 – 581	Period of Division : *Northern and Southern dynasties*
AD 220 – 280	*Three Kingdoms*
AD 265 – 317	*Western Chin*
AD 317 – 420	South : *Eastern Chin*
AD 420 – 479	*Liu Sung*
AD 479 – 502	*Southern Ch'i*
AD 502 – 557	*Liang*
AD 557 – 589	*Ch'en*
AD 304 – 439	North : *Sixteen Kingdoms*
AD 386 – 535	*Northern Wei*
AD 535 – 557	*Western Wei*
AD 534 – 549	*Eastern Wei*
AD 549 – 577	*Northern Ch'i*
AD 557 – 581	*Northern Chou*
AD 581 – 618	Sui dynasty
AD 618 – 906	T'ang dynasty
AD 907 – 960	Five dynasties
AD 960 – 1127	Sung dynasty : *Northern Sung*
AD 1127 – 1279	*Southern Sung*
AD 947 – 1125	Liao dynasty (Manchuria and North-east China)
AD 1115 – 1234	Chin dynasty (north)
AD 1279 – 1368	Yüan dynasty
AD 1368 – 1644	Ming dynasty
AD 1644 – 1911	Ch'ing dynasty
AD 1912 – 1949	Republic
AD 1949 –	People's Republic

Classification of bronze vessels

Principal types of ritual vessels together
with appropriate old characters and their
modern equivalents

Vessels for	Food					Water	
	li	ting	hsien	kuei	tou	p'an	chien
Primary form							
Old character and modern equivalent							

Wine									
yu	hu	tsun	lei	fang-yi	chia	chüeh	ku	ho	kuang

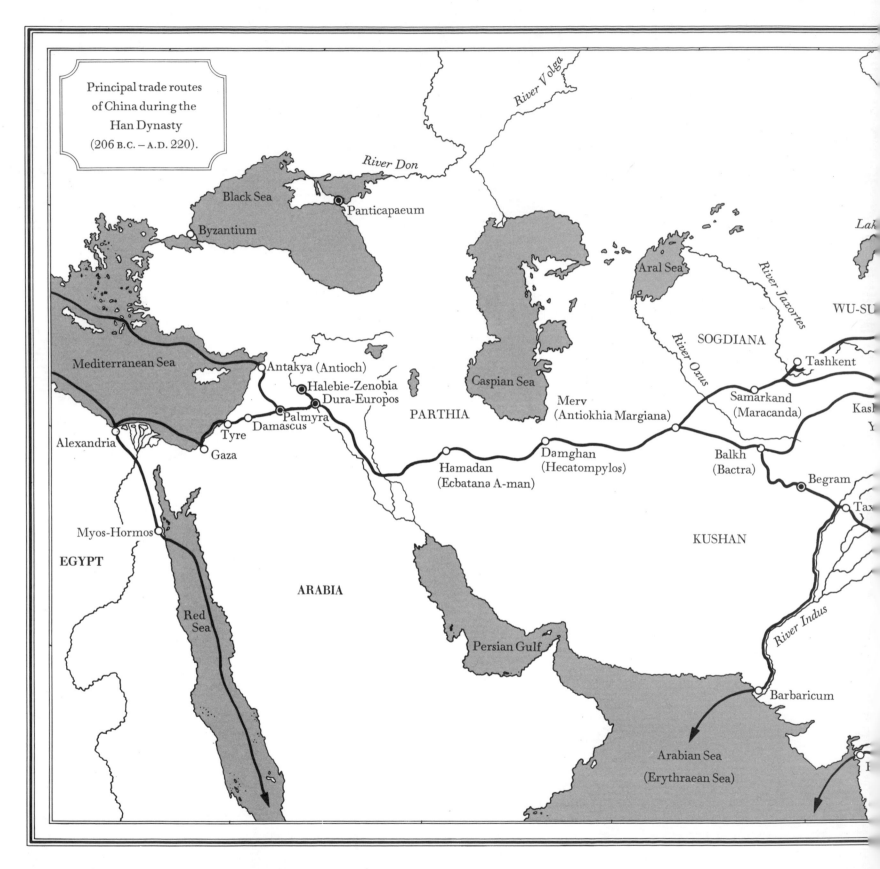

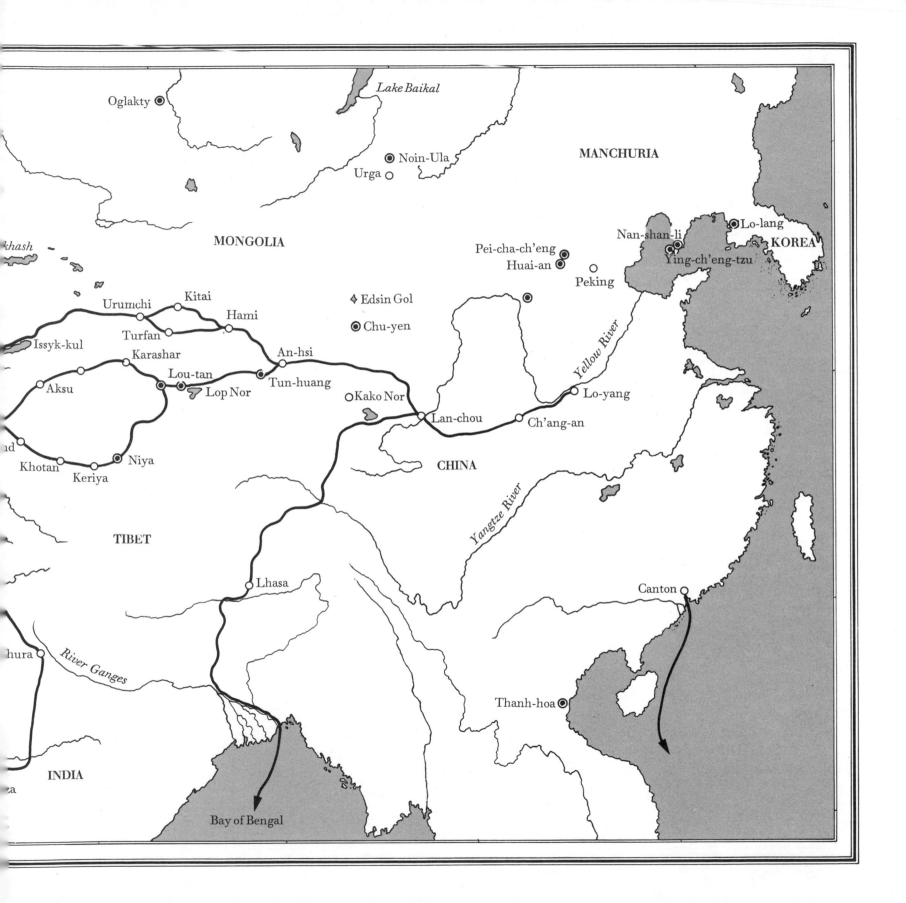

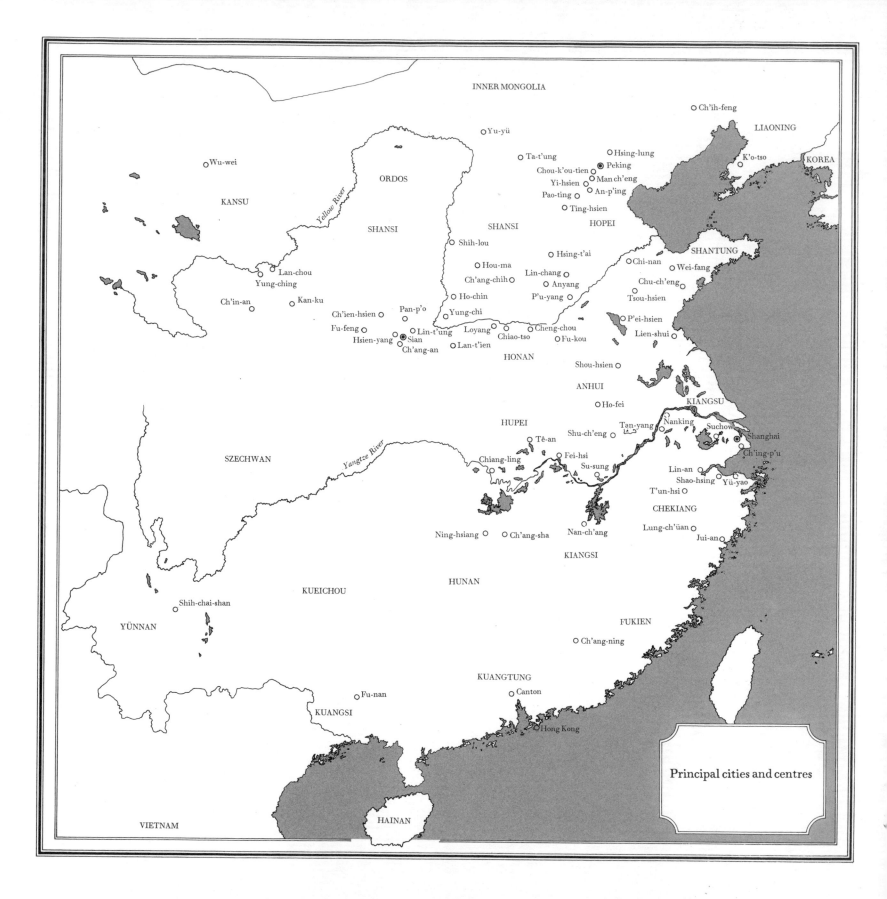

INNER MONGOLIA

○ Ch'ih-feng

LIAONING

○ Yu-yü

○ Wu-wei

○ Ta-t'ung ○ Hsing-lung ○ K'o-tso KOREA

ORDOS Chou-k'ou-tien ○ ◎ Peking

KANSU ○ Man ch'eng

Yi-hsien ○ ○ An-p'ing

Pao-ting ○

SHANSI ○ Ting-hsien SHANTUNG

SHANSI ○ Shih-lou HOPEI

○ Hsing-t'ai

Lan-chou ○ ○ ○ Hou-ma ○ Chi-nan ○ Wei-fang

Yung-ching Ch'ang-chih ○ Lin-chang ○

○ Anyang Chu-ch'eng ○

Ch'in-an ○ ○ Kan-ku ○ Ho-chin P'u-yang ○ Tsou-hsien ○

Ch'ien-hsien ○ ○ Pan-p'o ○ P'ei-hsien

Fu-feng ○ ○ Lin-t'ung ○ Yung-chi ○ Cheng-chou ○ Lien-shui

Hsien-yang ○ ◎ Sian Loyang ○ Chiao-tso ○ Fu-kou

Ch'ang-an ○ ○ Lan-t'ien

HONAN ○ Shou-hsien

ANHUI

KIANGSU

○ Ho-fei

HUPEI Tan-yang ○ ○ Nanking ○ Suchow

Tê-an ○ Shu-ch'eng ○ ◎ Shanghai

SZECHWAN Chiang-ling ○ ○ Fei-hsi ○ Ch'ing-p'u

Su-sung ○ ○ Lin-an

Shao-hsing ○ ○ Yü-yao

T'un-hsi ○

CHEKIANG

Ning-hsiang ○ ○ Ch'ang-sha ○ Nan-ch'ang Lung-ch'üan ○

○ Jui-an

KIANGSI

KUEICHOU HUNAN

○ Shih-chai-shan

YÜNNAN FUKIEN

○ Ch'ang-ning

KUANGTUNG

○ Fu-nan ○ Canton

KUANGSI ○ Hong Kong

VIETNAM HAINAN

Principal cities and centres

General bibliography

History

Creel, H. G., *The Birth of China*, first printed 1937, 4th ed. New York 1961.

Eberhard, W., *A History of China*, London 1950.

Fitzgerald, C. P., *China: A Short Cultural History*, first published 1935, 4th revised ed. London 1976.

Goodrich, L. C., *A Short History of the Chinese People*, London 1969 (revised ed.).

Herrman, A., *An Historical Atlas of China*, Edinburgh 1966.

Latourette, K. S., *The Chinese: Their History and Culture*, New York 1964.

Lattimore, O., *Inner Asian Frontiers of China*, New York 1964.

Loewe, M., *Everyday Life in Early Imperial China*, London 1968.

Needham, J., *Science and Civilization in China*, Vols. I to IV. Cambridge 1954–72

Reischauer, E. O. and Fairbank, J. K., *East Asia: The Great Tradition*, Boston 1960.

Reischauer, E. O., Fairbank, J. K. and Craig, A. M., *East Asia: The Modern Transformation*, Boston 1965.

Philosophy and Religion

de Bary, W. D. (ed.), *Sources of the Chinese Tradition*, first published 1960, 8th ed. in 2 vols. New York 1971.

Ch'en, K. K. S., *Buddhism in China*, Princeton 1964.

Fung Yu-lan, *A Short History of Chinese Philosophy* (ed. by D. Bodde), New York 1960.

Waley, A., *Three Ways of Thought in Ancient China*, London 1946.

Wright, A. F. (ed.), *Studies in Chinese Thought*, Chicago 1953.

Wright, A. F. (ed.), *The Confucian Persuasion*, Stanford 1960.

Wright, A. F. and Twitchett, D., *Confucian Personalities*, Stanford 1962.

Zürcher, E., *The Buddhist Conquest of China*, 2nd ed. in 2 vols., Leiden 1972.

Art

Akiyama, T. et al., *Arts of China: Neolithic Cultures to the T'ang Dynasty: Recent Discoveries*, Tokyo and Palo Alto 1968.

Akiyama, T. et al., *Arts of China: Buddhist Cave Temples: New Researches*, Tokyo and Palo Alto 1969.

Cahill, J., *Chinese Painting*, Geneva 1960.

Cheng Te-k'un, *Archaeology in China*, Vols. I to III, Cambridge 1959–63.

China: Cultural Properties Commission, *Wen-hua ta-ko-ming ch'i-chien ch'u-t'u wen-wu* (Cultural Relics Unearthed During The Great Cultural Revolution), Peking 1972.

China: Foreign Languages Press, *Historical Relics Unearthed in New China*, Peking 1972.

China: Hunan Provincial Museum, *Ch'ang-sha ma-wang-tui i-hao han-mu fa-chüeh chien-pao* (Report on the excavation of the no. 1 Han tomb at Mawangtui, Ch'ang-sha), 2 vols., Peking 1972.

China: Sinkiang Uighur Autonomous Region Museum, *Ssu-ch'ou chih lu: han t'ang chih-wu* (The Silk Road: woven materials of the Han and T'ang dynasties), Peking 1972.

China: Sinkiang Uighur Autonomous Region Museum, *Hsin-chiang ch'u-t'u wen-wu* (Cultural Relics Unearthed in Sinkiang), Peking 1975.

China: Wen Wu Press, *Selection of Ancient Chinese Bronzes*, Peking 1976.

Feddersen, M., *Chinese Decorative Art*, London 1961.

Fontein, J. and Tung Wu, *Unearthing China's Past*, Boston 1973.

Garner, Sir H., *Oriental Blue and White*, 3rd. ed. London 1970.

Gompertz, G. St. G. M., *Chinese Celadon Wares*, London 1958.

Hobson, R. L., *The Ceramic Art of China and Other Countries of the Far East*, London 1945.

Jenyns, R. S. and Watson, W., *Chinese Art: The Minor Arts*, Vols. I and II, Fribourg 1963.

Lee, S., *Chinese Landscape Painting*, New York 1962.

Lee, S. and Ho, Wai-kam, *Chinese Art Under the Mongols: The Yüan Dynasty*, Cleveland 1968.

London: Oriental Ceramic Society, *The Ceramic Art of China*, exhibition catalogue, London 1972.

London: Oriental Ceramic Society, *Chinese Jade Throughout the Ages*, exhibition catalogue, London 1975.

London: Royal Academy, *The Genius of China*, catalogue of the exhibition of Archaeological Finds in the People's Republic of China, London 1973.

Medley, M., *A Handbook of Chinese Art for Collectors and Students*, London 1964 (2nd ed. 1973).

Medley, M., *Yüan Porcelain and Stoneware*, London 1975.

Medley, M., *The Chinese Potter*, Oxford 1976.

Sickman, L. and Soper, A., *The Art and Architecture of China*, Harmondsworth 1968 (paperback ed. 1971).

Sullivan, M., *The Birth of Landscape Painting in China*, Berkeley and Los Angeles 1962.

Watson, W., *China Before the Han Dynasty*, London 1961.

Watson, W., *Ancient Chinese Bronzes*, London 1962.

Watson, W., *Early Civilization in China*, London 1966.

Willets, W., *Chinese Art*, 2 vols., Harmondsworth 1958.

Index